EVEREST

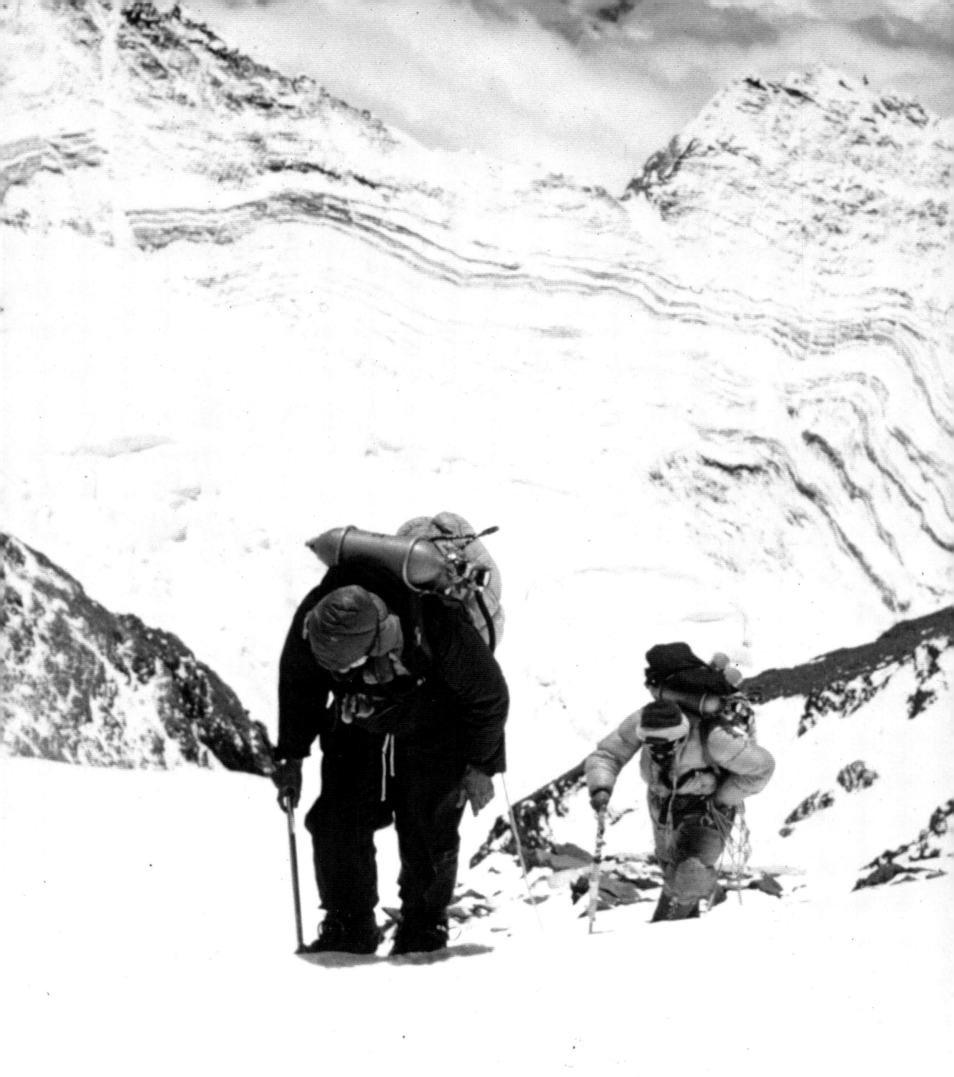

EVEREST

AMMONITE
PRESS

**Royal
Geographical
Society**
with IBG

Advancing geography
and geographical learning

First published 2013 by
Ammonite Press
an imprint of AE Publications Ltd,
166 High Street, Lewes, East Sussex, BN7 1XU,
United Kingdom

Text © AE Publications Ltd, 2013
Foreword © Jan Morris, 2013
Introduction and images © Royal Geographical Society, 2013
Copyright © in the Work AE Publications Ltd, 2013

ISBN 978-1-78145-044-4

British Cataloguing in Publication Data. A catalogue record of this book is
available from the British Library.

Editors: Ian Penberthy and George Lewis
Managing Editor: Richard Wiles
Designer: Robin Shields
Cover design: Laurence Stevens, LSD Studios
Publisher: Jonathan Bailey

Typeset in Foundry Monoline

Colour reproduction by GMC Reprographics
Printed in China

Page two: Edmund Hillary and Tenzing Norgay
approaching the Southeast Ridge at 27,300 feet
(8,321 metres).

Contents

Foreword

I was a rank outsider with the 1953 British Everest Expedition, the first ever to reach the top of the world. I was no climber, was not particularly interested in mountaineering and was there merely as a reporter. My only task was to see that news of the expedition went home fast, safely and exclusively to 'The Times' of London. The assignment was any journalist's dream; I was young and highly ambitious, and I did the job in a condition of perpetually delighted excitement. All I wanted was what we then called a scoop, and I got one.

Sixty years on, I look back on the experience differently. Now I recall it allegorically, lyrically perhaps, even a touch poignantly, because the coincidence of its success with the distant Coronation of Queen Elizabeth II seems to me now a last hurrah of British Imperial glory.

Essentially, though, I think of Everest '53 as an innocent adventure: all its protagonists, it seems to me, were good people. I think of it as essentially decent: Europeans and Asians, Sherpas and Englishmen, New Zealanders and Welshmen, scholars and soldiers and scientists all climbed and worked as friends upon that mountain. And above all of us, night and day, in weather fair or foul, with its plume of driven snow streaming tremendously from its Summit, the great mountain itself looked down on us benignly — for not a soul was lost, nor a reputation sullied, on that happiest of adventures.

And to my mind it is this grand allegory, Nature at its most tremendous surveying the myriad puzzling intentions of humankind below, that is the ultimate subject of this collection of images.

Jan Morris, CBE

The reconnaissance expedition's camp at 20,000 feet (6,096 metres), 1921.

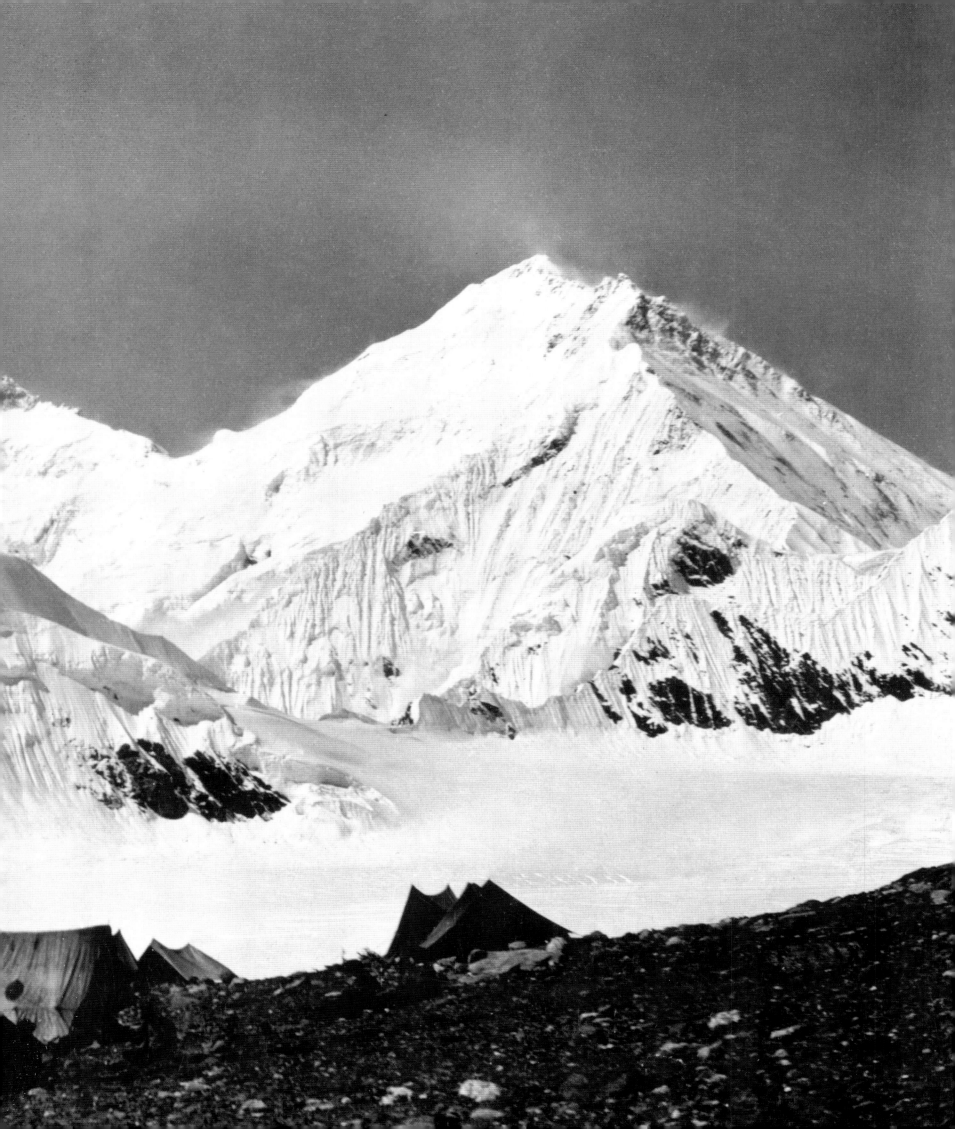

Introduction

The Royal Geographical Society (with IBG) has been synonymous, since its formation in 1830, with scientific exploration and research to understand our world. In the first half of the 20th century, a key focus was on the attempts to map and to reach the Summit of Mount Everest. The first British expedition, one intended for reconnaissance purposes in 1921, emanated from the foundation of a joint committee between the Alpine Club, London, and the Society, which would continue to plan and execute joint expeditions, culminating in the successful ascent of Everest in 1953.

From those early beginnings, the expertise and interests of both organisations were combined while still accommodating the specific needs of each: expert mountaineering in the case of the Alpine Club; surveying and geographical analysis in the case of the Society, whose remit is to advance geographical science; and jointly to achieve the ultimate goal of reaching the Summit. Skills and aptitude, new technologies, planning and teamwork — with the support of essential local expertise from generations of Sherpas — were all tested in the Himalayan mountain arena and developed over that 32-year span.

Today, it is perhaps the historical photography of Everest that best captures our imagination and enables us to understand this evolution and use of shared expertise and human endeavour. As a method of visual record, the Society had long seen the benefit of the photographic image, but as late as the 1920s it took the skill and passionate encouragement of Captain John Noel to convince those senior climbers among the 1922 party, who viewed the camera with suspicion and saw 'snaps' as being a rather vulgar and unnecessary addition to their climb, that the photographic image was an essential method of communicating their activities to the wider world.

Noel — an innovator in high-altitude photography and film-making — set the gold standard, capturing both the technical art of the climb and also the striking beauty of the Himalayan landscape. Beyond the realms of the expert mountaineer, geographer and geologist, his work was the first to create an expectation from the public for images of Everest ascents, which would arguably culminate in the impact of the iconic images of Tenzing Norgay and Edmund Hillary at the Summit of Everest, 60 years ago on 29th

May, 1953, coinciding with the Coronation of Her Majesty The Queen, Patron of the Society. Lectures held at the Royal Festival Hall and the Central Hall, Westminster to mark the achievements of the 1953 expedition were the first opportunity for a world eager to view the magnificent images captured by Alfred Gregory, the official stills photographer to the expedition. He had worked on the mountain with the support of many others, including George Lowe, Charles Evans and Edmund Hillary, who had taken cameras to record the ascent.

Gregory, an accomplished climber, worked closely with James Morris (whose text his pictures would illustrate for 'The Times' newspaper) and alongside Tom Stobart who, as cameraman, recorded the official ciné film of the event, 'The Conquest of Everest', which brought the expedition to life for cinema audiences.

The practical concerns that faced Gregory were daunting: the need to sleep with his cameras to keep them warm and whether his decision to use 35mm film (chosen for reasons of camera weight and flexibility) would deliver the excellence he sought in the final prints. His preoccupation, however, was to ensure that he achieved correct exposure and focus at high altitudes to produce perfect images, at a time when cameras with automatic systems simply did not exist. As Noel and others had experienced before him, the impact of the mountain landscape had a remarkable aesthetic effect on Gregory's work, his photography responding to the dark and light of the changing vista as men moved against the white canvas.

As with so many of the images captured by earlier photographers between 1921 and 1953, Gregory's work echoes their unique blend of historical record and great aesthetic beauty. Perhaps the greatest legacy that he, Noel, et al have left, however, is to provide future generations of photographers with fresh inspiration as well as continuing to generate awe and wonder in us all at their original achievements.

This striking book provides an opportunity for us all to experience a visual chronology from 1921 onwards and to compare the work of many photographers — amateur and professional — that the Society is proud to hold in its internationally important Everest collection.

A happy Tenzing Norgay (L) and Edmund Hillary after their successful ascent of Everest.

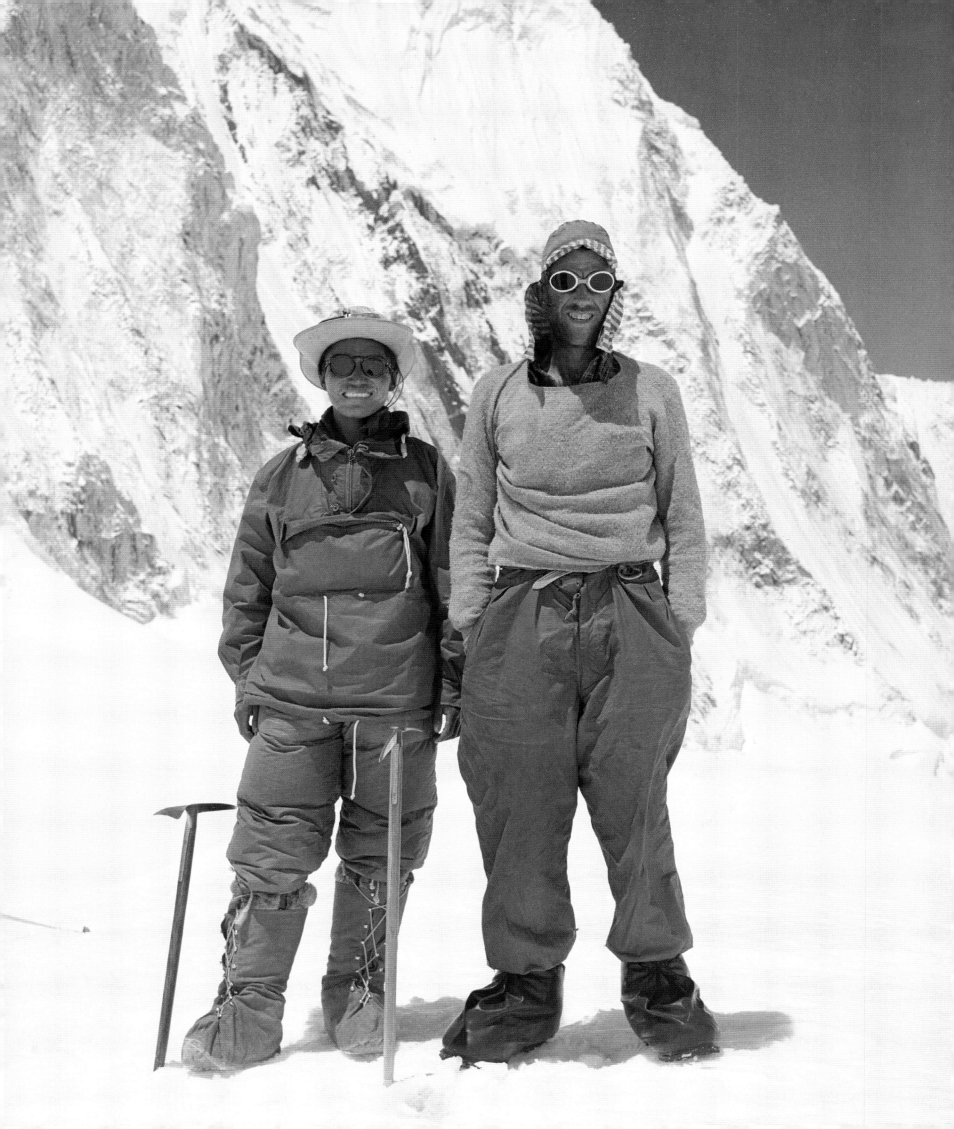

1921 Expedition

In 1921, very little was known about Mount Everest, on the border between Tibet and Nepal, apart from the fact that it was the highest mountain in the world (then calculated at 29,002 feet/8,840 metres). No one knew whether human beings could even climb at that height, but the Everest Committee formed by the Alpine Club and Royal Geographical Society was determined that the peak should be conquered for Britain. Accordingly, a reconnaissance expedition was sent to the mountain to seek a route to the top.

It took a month of trekking on foot and horseback through Tibet to reach Everest. On the way, illness struck down climbing leader Harold Raeburn and experienced Himalayan climber Alexander Kellas (who died before reaching the mountain). That left brilliant young climber George Mallory and the inexperienced Guy Bullock to find a potential route to the top, while the remainder of the expedition carried out surveying work in the region.

With Nepal closed to Westerners, Mallory and Bullock made an extensive study of the mountain's northern aspect, climbing several peaks in the process and naming many others, including Pumori, Nuptse, Changtse and Lhotse. Eventually, they settled on the Northeast Ridge, attained via the North Ridge from the North Col, between the latter and Changtse. Although they were able to reach the North Col from the Rongbuk Glacier, the approach of winter forestalled any further progress until the following year.

A photograph taken by George Mallory, showing the menacing ice wall of Everest's 10,500-foot (3,200-metre) Kangshung Face. The Southeast Ridge and South Summit can be seen (top L) as can the imposing Northeast Ridge leading up to the Summit (R).

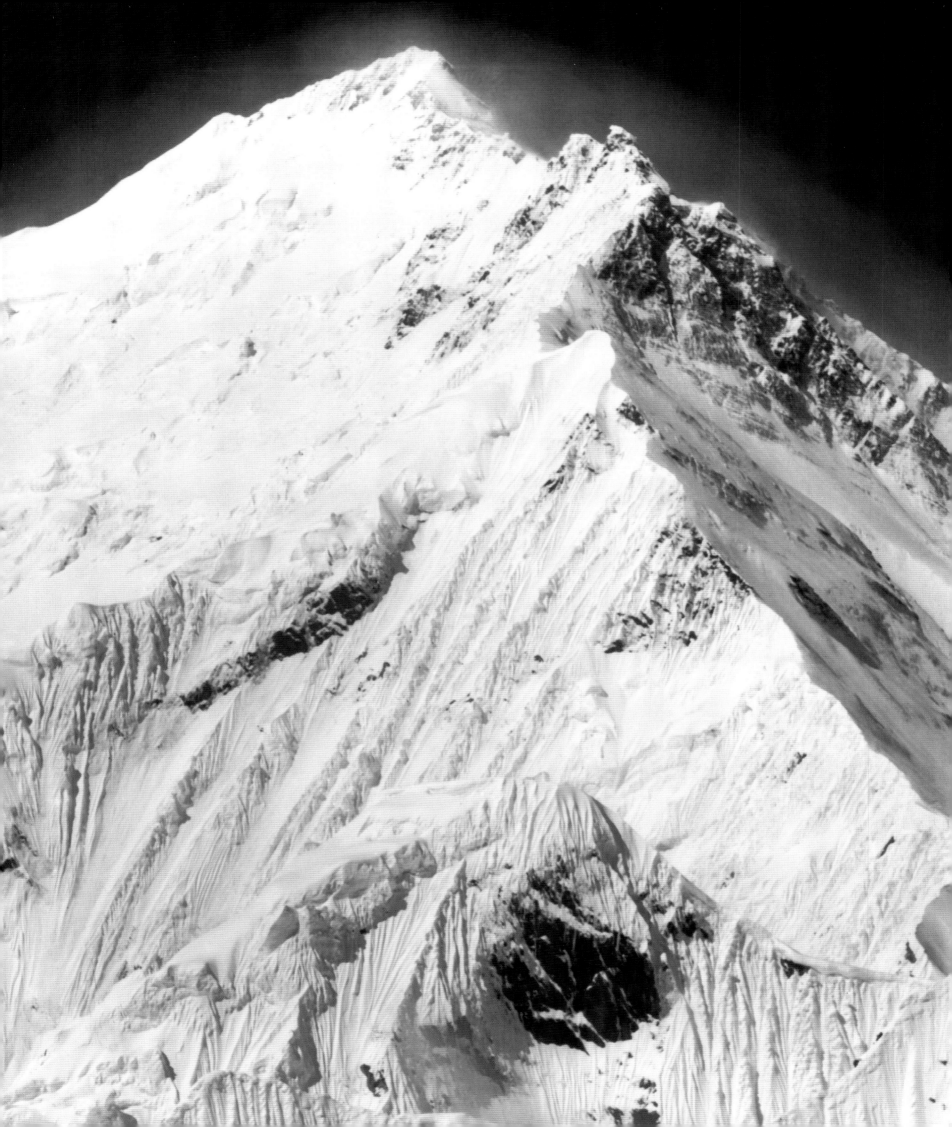

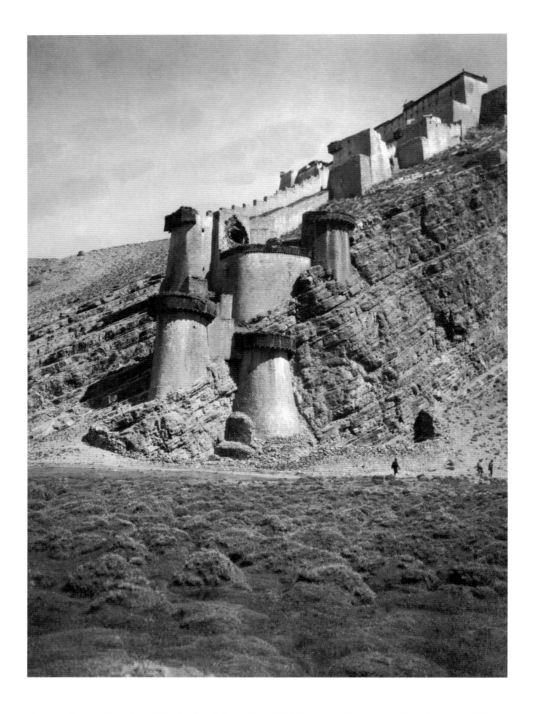

Kampa Dzong (Gamba), Tibet, about 30 miles (48 kilometres) north of the border with Sikkim, the former British protectorate, now a landlocked Indian state. Mountaineers taking the eastern approach to Mount Everest pass through this ancient fortress settlement, which lies about 200 miles (320 kilometres) from the summit.

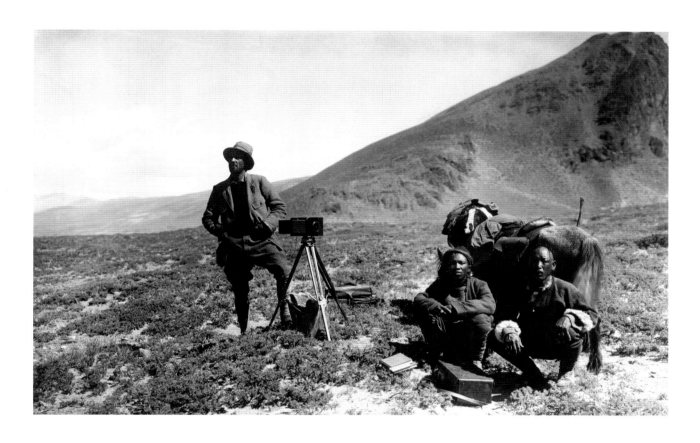

In 1921, Major Edward Oliver Wheeler, a Canadian in the British Army, surveyed possible climbing routes to the Summit of Mount Everest, making detailed maps and taking numerous photographs of the terrain.

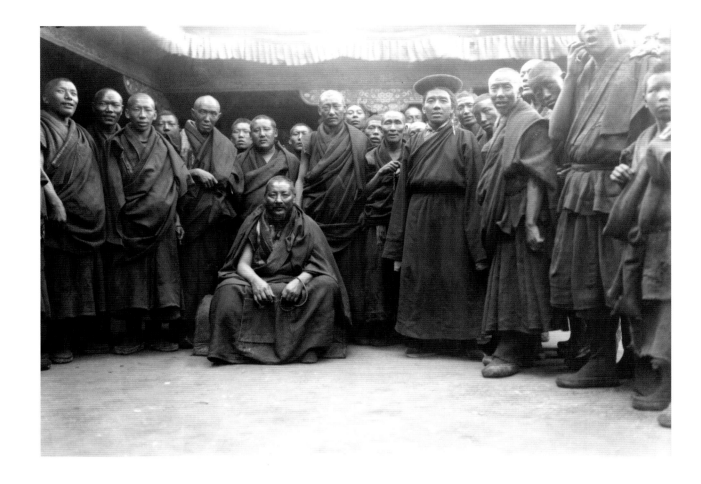

Tibetan Buddhist monks in the remote monastery at Shekar Dzong (also known as Xêgar), in the foothills of Mount Everest, that was visited by the 1921 Reconnaissance Expedition.

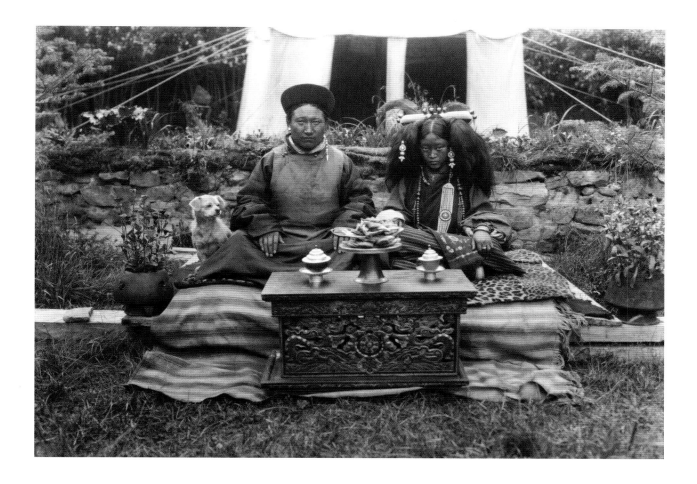

The dzongpen of Kharta and his wife. Kharta is a fairly large district of Tibet to the east of Mount Everest; the dzongpens were local administrators appointed by Lhasa to collect taxes and maintain order. All of the expeditions passing through Tibet paid their respects to the dzongpens.

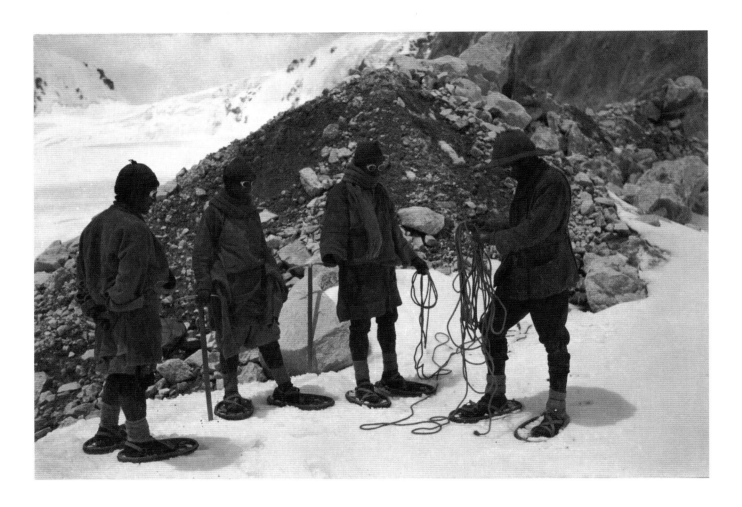

Guy Bullock and porters, wearing snowshoes for the first time, prepare their kit for an exploratory climb.

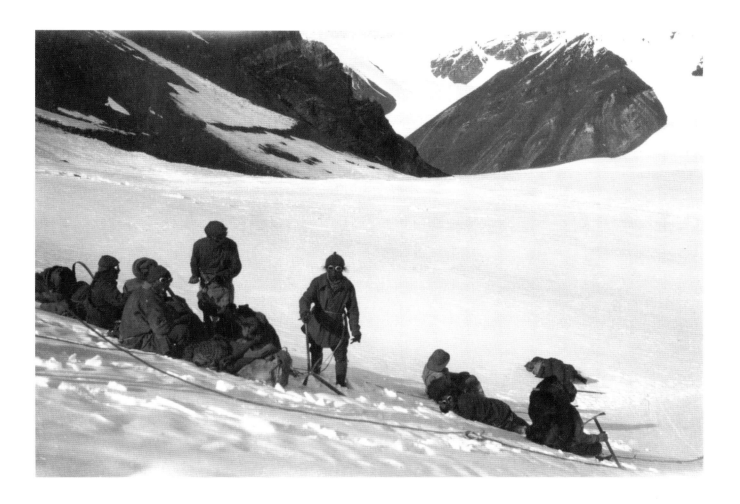

A brief pause in the snow before tackling the ridge ahead. Stops were necessary in this difficult terrain, but could never be too long for fear of frostbite.

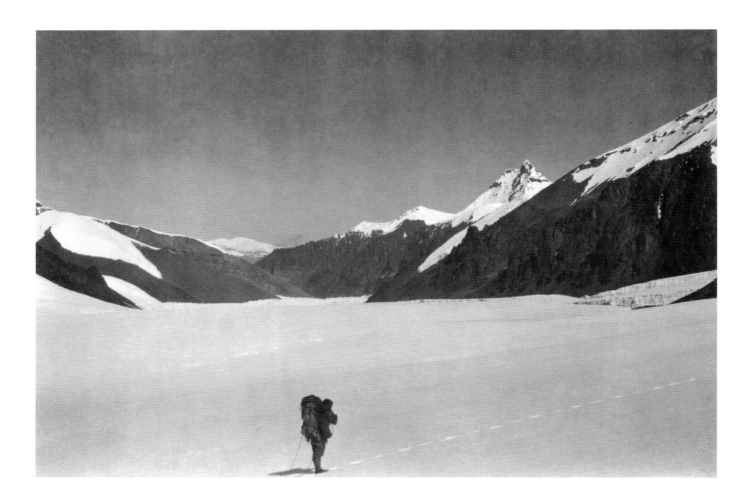

This climber cuts a lonely figure in the mountainous snowscape, making it easy to forget that the other members of the team (including, of course, the photographer) are just out of shot.

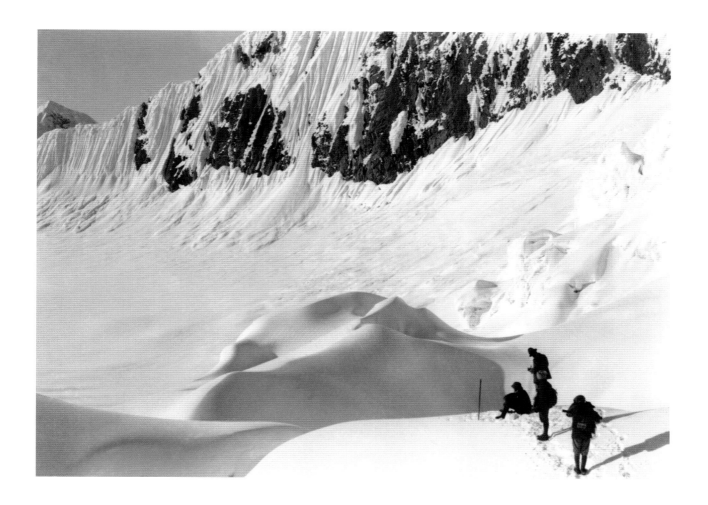

Members of the 1921 expedition pause beneath a sheer rock face to assess the challenges of the snow-covered depression that lies immediately ahead of them.

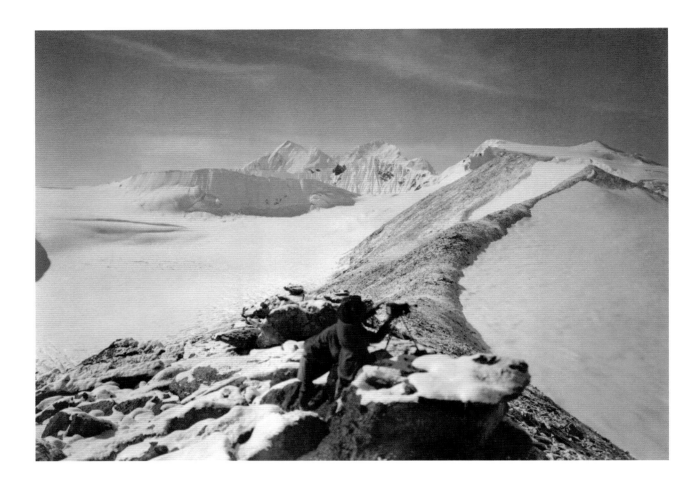

On a ridge looking eastward toward the summits of Chomo Lonzo and Makalu, visible in the centre of the photograph, which was taken by expedition leader Charles Howard-Bury.

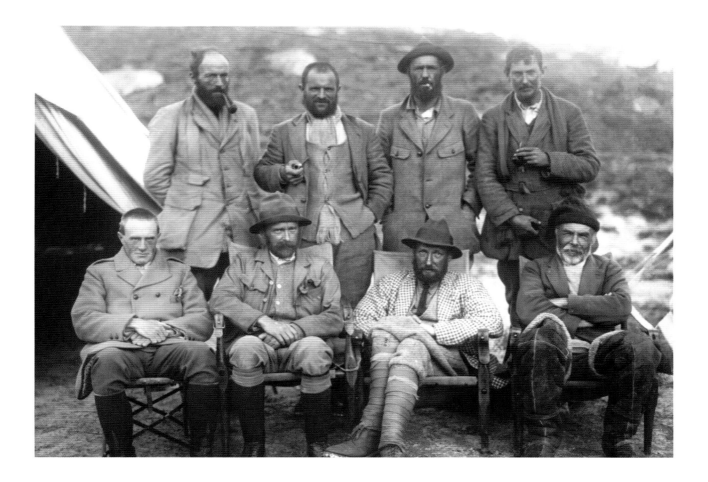

This coloured photograph of the 1921 expedition, taken by John Noel, shows (standing, L–R) Guy Bullock, Henry Morshead, Edward Oliver Wheeler, George Mallory; (sitting, L–R) Alexander Heron, Sandy Wollaston, Charles Howard-Bury, Harold Raeburn.

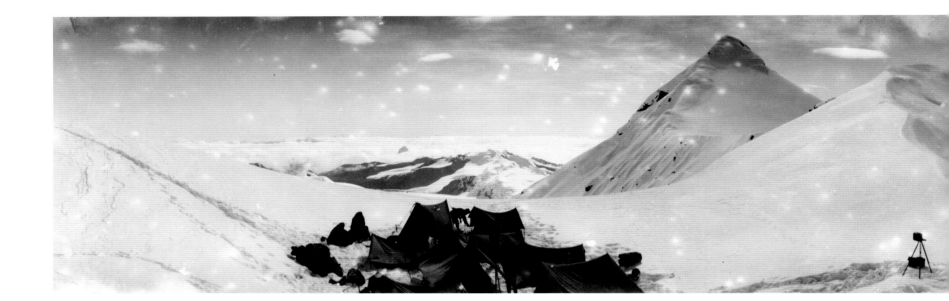

'Windy Col Camp' at 22,500 feet (6,858 metres) on the Lhakpa La Col, at the head of the Kharta Glacier. The viewpoint looks eastward, towards China. From this point, Mallory and his team could see the North Col (far R). The North Ridge of Mount Everest can be seen rising leftward to the Northeast Ridge.

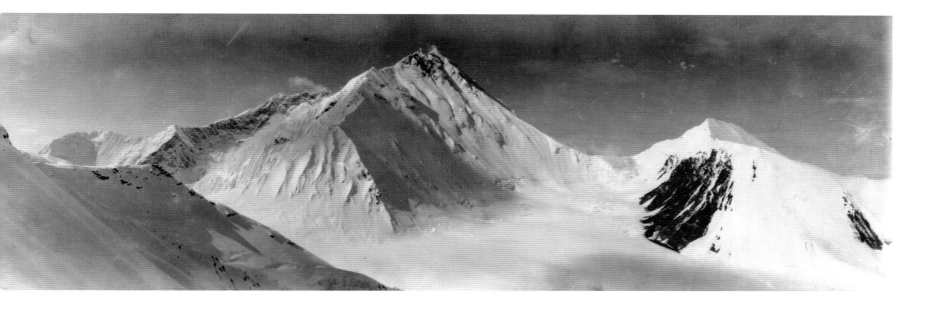

George Mallory (L) and old schoolfriend Guy Bullock leaving Pagri, Tibet, on the backs of their mules.

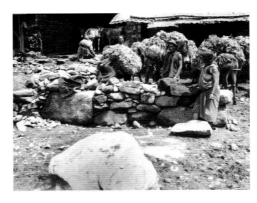

Tibetan merchants transporting bales of wool along the trade route between their homeland and Sikkim.

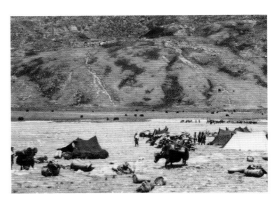

Tibetan camps in the upper valley of the Teesta River, which rises beneath Mount Kanchenjunga.

Gyalzen Kazi (L) and Chittan Wangdi, the Tibetan interpreters on the 1921 expedition.

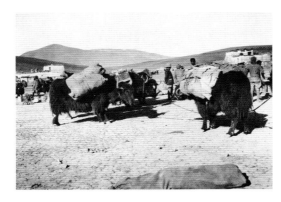

Mules were useful in the foothills, but at higher altitudes yaks were more resilient.

Alexander Kellas, who died of a heart attack en route to Everest in 1921.

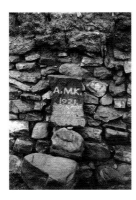

The headstone over Kellas's grave outside Kampa Dzong. A Himalayan peak was named in his memory.

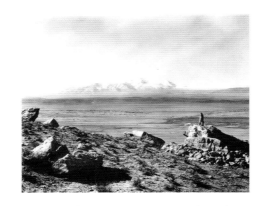

A panorama of the landscape around Alexander Kellas's grave in sight of Mount Everest.

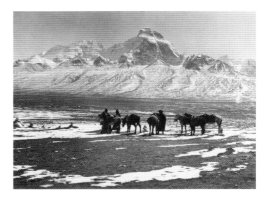

Mules and horses at the height of their usefulness: beyond the plain, the terrain was too steep.

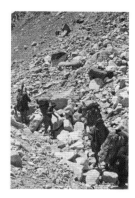

Clambering over scree: not the hardest part of the ascent, but tricky and uncomfortable to cross.

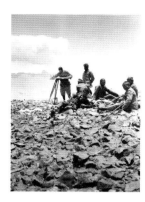

Henry Morshead (L), chief surveyor on the 1921 expedition, plane tabling the terrain.

George Mallory climbing down a rock ridge.

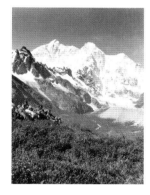

Shepherds and porters relax in the Kama Valley with the three peaks of Chomo Lonzo in the background.

The camp at 16,400 feet (4,998 metres) beneath imposing Makalu (27,825 feet/8,481 metres).

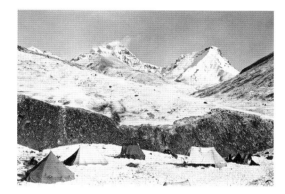

A view toward the Summit of Mount Everest from a camp at 17,000 feet (5,181 metres) in Kharta Valley.

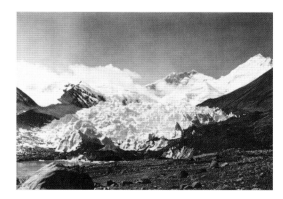

Kharta Glacier at about 19,000 feet (5,791 metres), with Mount Everest in the background (R).

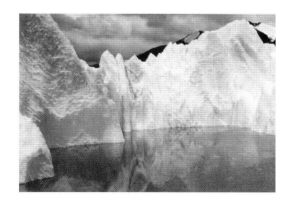

Even in the heights of the Himalayas, not all the water was frozen: this lake is enclosed by banks of ice.

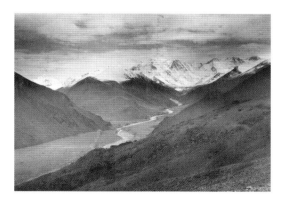

The view back down south toward Kampa Dzong from just below 26,000 feet (7,925 metres).

1922 Expedition

A British expedition returned to Everest in 1922 with the object of reaching the Summit. It included George Mallory and Henry Morshead from the 1921 expedition, along with experienced alpinist George Finch. Because of the long approach march and the onset of the monsoon in late May/early June, time on the mountain was limited. This led to two hasty attempts being made on the Summit from a camp in the lee of the North Col.

Although regarded with some scepticism by many climbers, oxygen equipment had been taken along as a high-altitude aid. However, the first attempt on the Summit, led by Mallory, eschewed its use. The four climbers started up the North Ridge and were immediately battered by strong icy winds. They camped overnight at 25,000 feet (7,620 metres), the highest any human being had ever been, and then continued the next day (minus Morshead who was suffering from exposure) to 26,985 feet (8,225 metres). At this point, mindful that they had to escort Morshead down, they turned back.

As they descended, they met Finch, novice climber Geoffrey Bruce and Ghurka Tejbir on their way up, using oxygen. Later that day, a storm blew up, pinning down this trio for two nights. But then Finch and Bruce were able to continue up to 27,300 feet (8,323 metres). Mallory was so impressed that he vowed to use oxygen in future.

It was during this expedition that the first deaths occurred on the mountain, nine Sherpas being swept into a crevasse by an avalanche, which killed seven.

The 1922 expedition's Camp IV on the North Col. It was from here that two rushed attempts were made on the Summit, one using oxygen and one without, but neither was successful, although a height record of 27,300 feet (8,323 metres) was achieved.

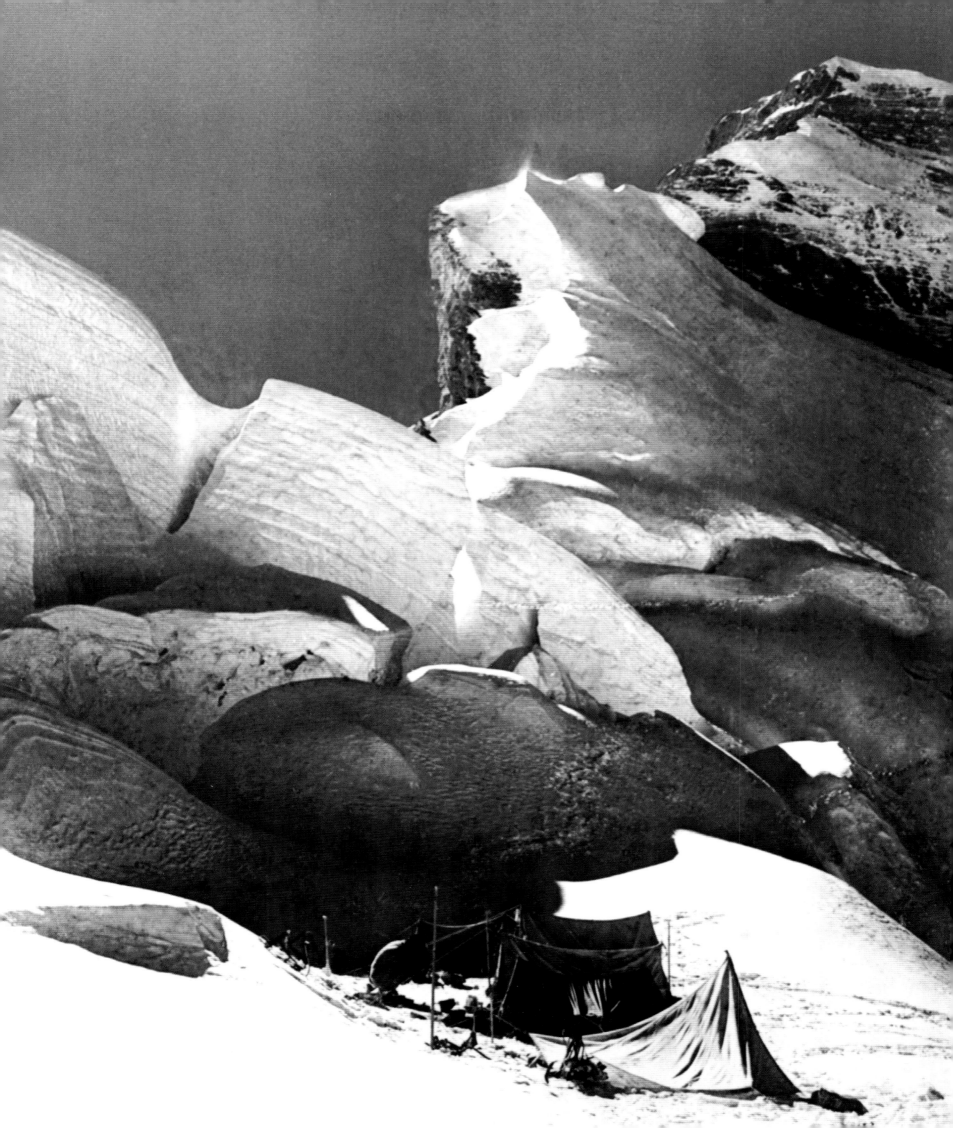

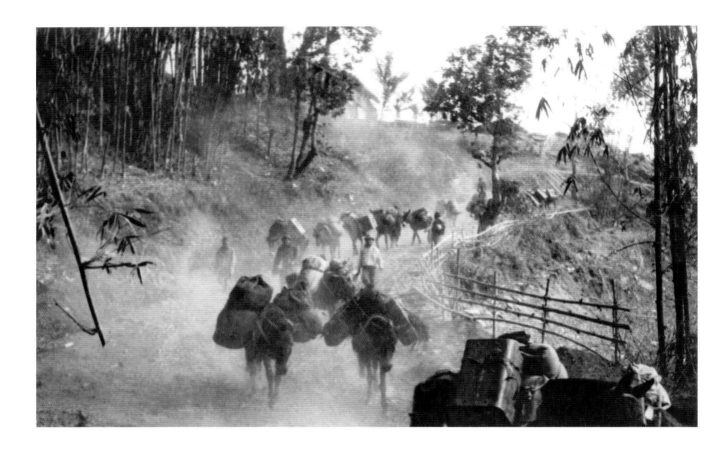

The 1922 expedition's pack train passes through Sikkim en route to Tibet. At the time, this was the only way that the mountaineers could approach Mount Everest, because Nepal was closed to foreigners.

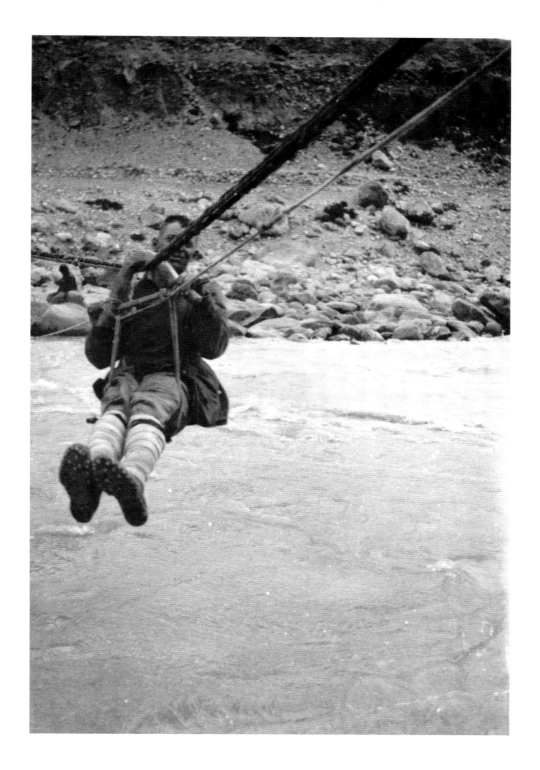

Howard Somervell crosses a rope bridge at Kharkung, Tibet. Simply getting to the mountain was a major undertaking in itself.

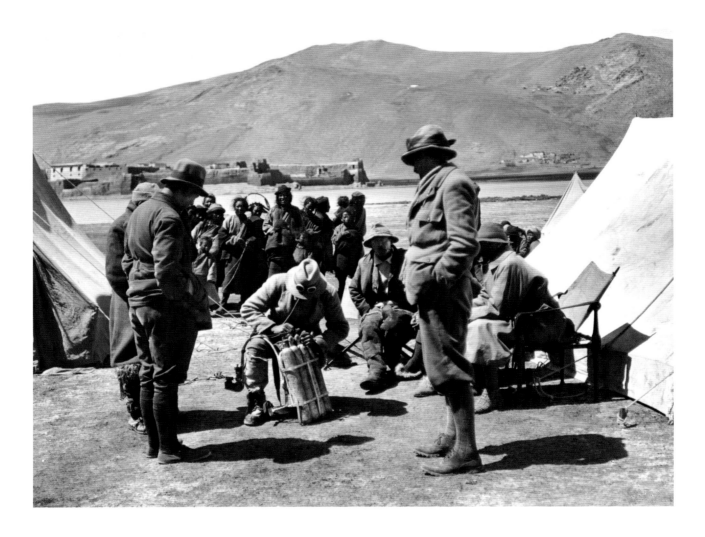

George Finch (standing, R) attempts to convince his fellow climbers of the benefits of the breathing apparatus. It was heavy and unwieldy, and they remained sceptical. Some felt its use was unethical.

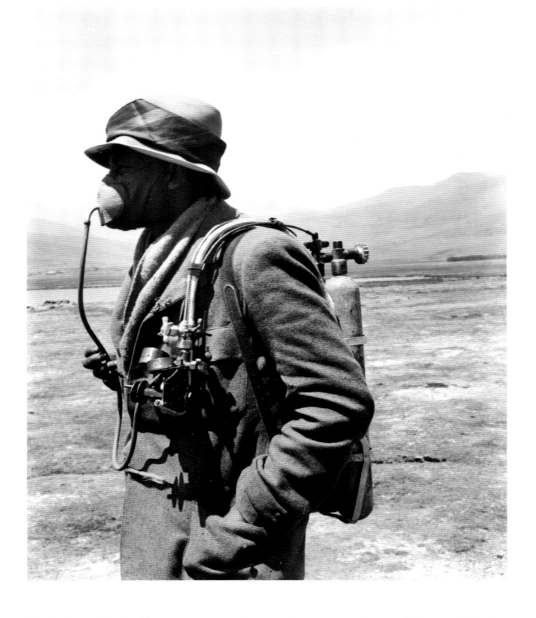

Finch demonstrates the oxygen apparatus used by some members of the expedition to overcome the breathing problems experienced at high altitudes.

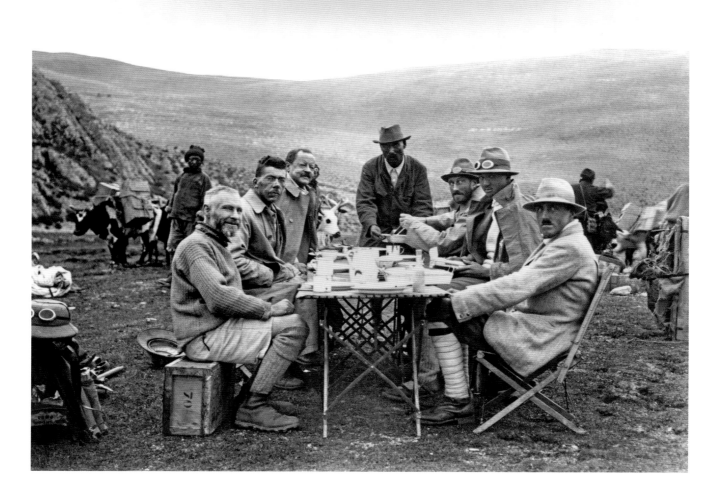

A low-altitude breakfast during the early part of the 1922 expedition. Seated L–R are: Arthur Wakefield, C. John Morris, expedition leader Brigadier-General Charles G. Bruce, Karma Paul (a Sherpa who acted as the expedition's interpreter), Geoffrey Bruce, Gurkha officer Tejbir and Edward F. 'Teddy' Norton.

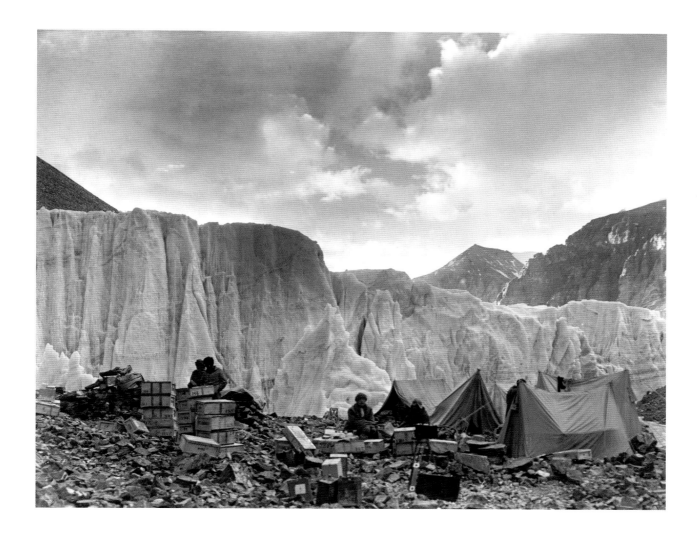

Camp II at 16,000 feet (4,877 metres). Mallory described it thus: "We were surrounded on three sides by this amazing world of ice. We lay in the shelter of a vertical cliff not less than 60 feet [18 metres] high, sombrely cold in the evening shadows, dazzling white in the morning sun."

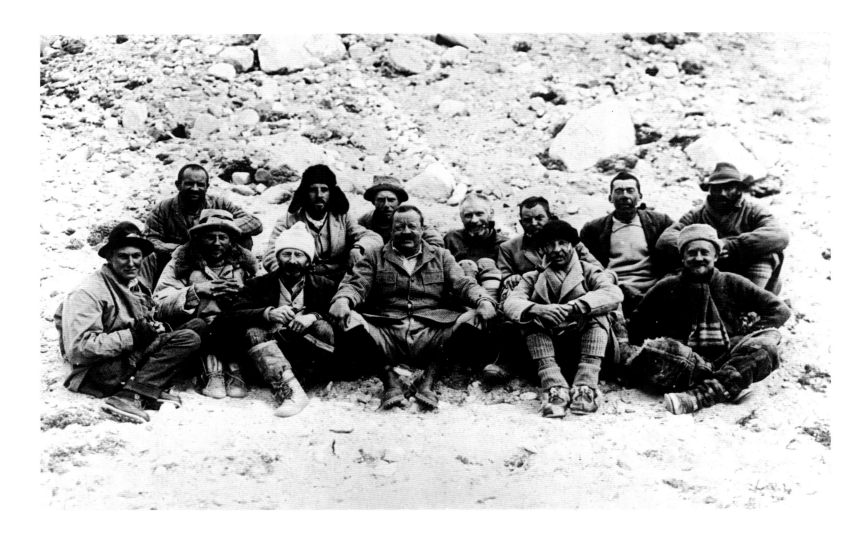

Expedition members at Base Camp on 3rd May, 1922. Back row: (L–R) Henry Morshead, John Geoffrey Bruce, John Noel, Arthur Wakefield, Howard Somervell, John Morris, Teddy Norton. Front row: (L–R) George Mallory, George Finch, Tom Longstaff, Brigadier-General Charles Bruce, Edward Strutt, Colin Crawford.

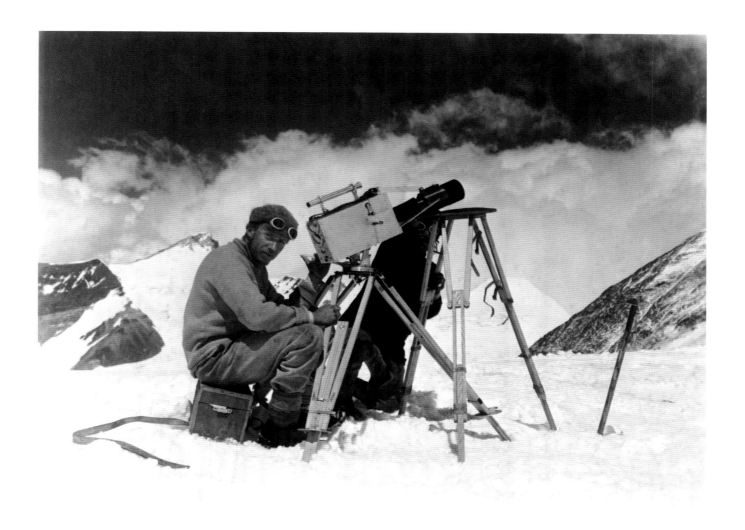

John Noel was the official photographer on both the 1922 and 1924 Everest expeditions. He was known by John Bruce, leader of the former expedition, as 'St Noel of the Cameras'.

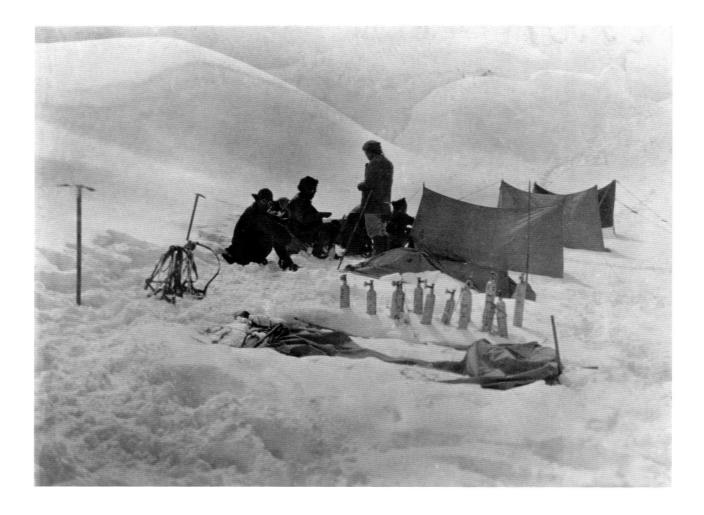

A camp in the snow, photographed by George Finch. Note the line-up of combustible oxygen cylinders, stored safely outside the tents.

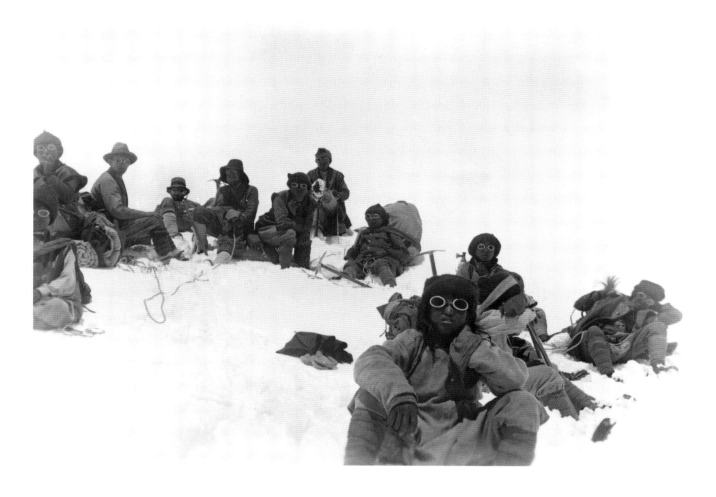

The climbers and Sherpas stop for a rest in a photograph taken by John Noel.

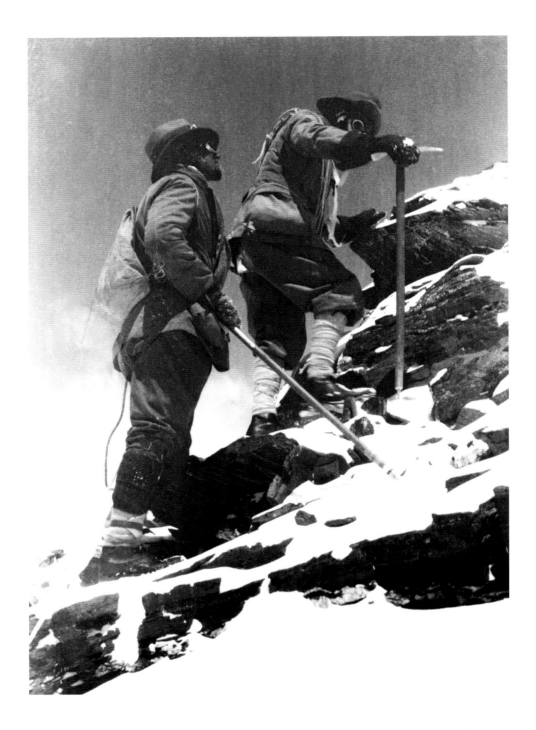

Mallory and Norton at the highest point they reached, 26,985 feet (8,225 metres) above sea level on the Northeast Ridge of Mount Everest.

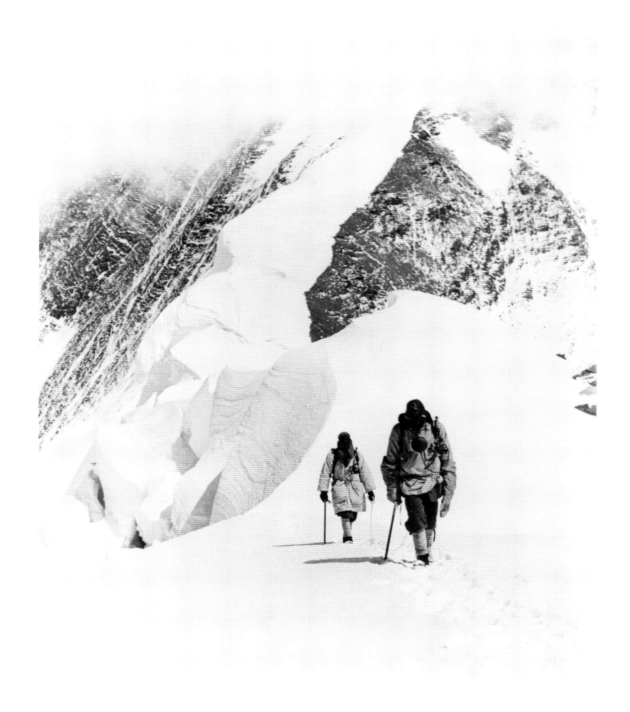

George Finch and Geoffrey Bruce of the second climbing party on their way back to Camp IV after their record-breaking climb to 27,300 feet (8,323 metres) assisted by supplementary oxygen.

Nepalese people at a summer grazing camp in the Arun River Valley.

Accompanied by two children, a Tibetan woman spins wool in the doorway of her home.

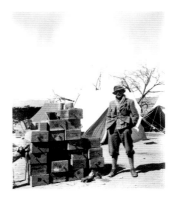

George Finch with the oxygen equipment that other members of the expedition thought unethical.

John Morris in front of the tent he shared with George Mallory, who took this photograph.

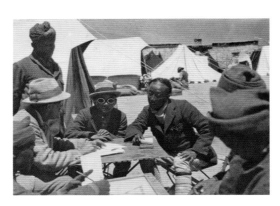

Seated, L–R: Charles Bruce, interpreter Karma Paul and head Sherpa Gyalzen Kazi at Kampa Dzong.

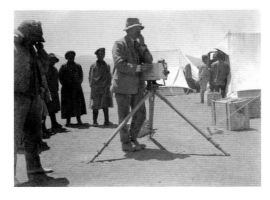

John Noel and the movie camera with which he made the film of the expedition.

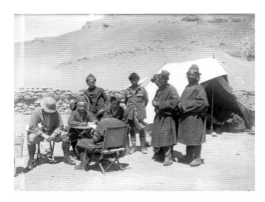

Charles Bruce (L) in discussion with local dzongpens near Kampa Dzong.

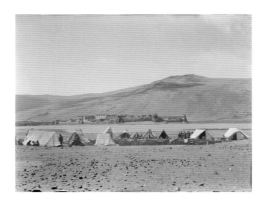

The expedition pitched camp for a night outside the walled fortress of Tinki Dzong, Tibet.

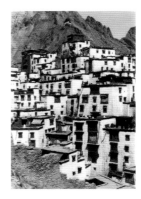

Shekar Dzong (Xêgar): the white walls give the town its name, which means 'shining glass' in Tibetan.

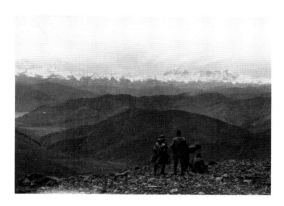

Mount Everest (L) from the Pangla Pass, about 17,000 feet (5,181 metres) above sea level.

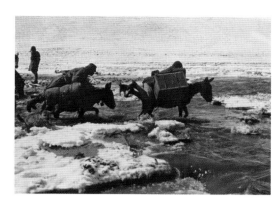

Pack mules fording a fast-flowing, but shallow seasonal stream on the route from Pagri.

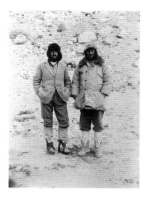

Geoffrey Bruce (L) and George Finch of the 1922 expedition's second climbing party.

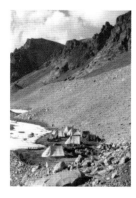

Base Camp, established on the rocky terminal moraine of the Rongbuk Glacier.

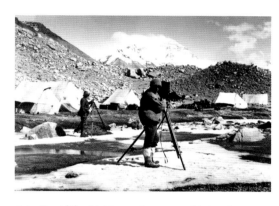

John Noel (R) with his movie camera filming Base Camp on the Rongbuk Glacier.

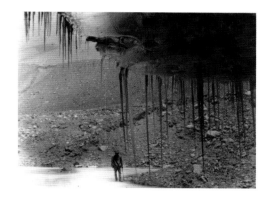

Icicles cling to an overhanging rock as an expedition member walks by the scree.

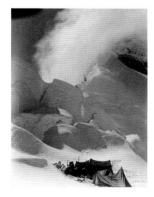

The capricious mountain weather makes itself felt at Camp IV on the North Col.

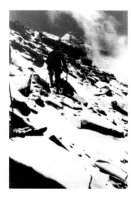

The highest point reached by Mallory and Norton: the summit tantalisingly in view, but out of reach.

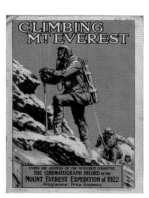

The cover of the programme for John Noel's film of the 1922 expedition.

1924 Expedition

As in 1922, a shortage of time had a major effect on the 1924 Everest expedition, and this was compounded by bad weather. The porters began to suffer from exposure and some became stranded on the North Col, having to be rescued by weary climbers led by George Mallory.

Again, two attempts were made on the Summit in early June, the first without oxygen by Teddy Norton and Howard Somervell, but the latter was forced to turn back as they made their way diagonally across the face below the Northeast Ridge. Norton carried on alone, reaching 28,126 feet (8,573 metres) before finally giving in. No one would climb above that height without oxygen for another 54 years.

Two days later, a determined Mallory set out for another crack at the Summit. He had decided to use oxygen and because of this he was accompanied by young inexperienced climber Sandy Irvine, who seemed to be able to get the best from the equipment. The pair spent the night at Camp VI, just below 27,000 feet (8,230 metres) and next morning (8th June) were seen briefly climbing upward before clouds rolled in and obscured them. They were never seen alive again.

In 1999, an American expedition came across Mallory's preserved body on the slope below the Northeast Ridge with signs that he had been severely injured in a fall. No trace of Irvine has been found, and no one knows whether they reached the Summit, although it seems unlikely, particularly given Irvine's lack of experience.

It would be nine years before another British expedition set foot on the world's highest mountain.

Members of the 1924 expedition moving through the dramatic ice pinnacles of the East Rongbuk Glacier on a fine day. The weather, however, would wreak havoc with their plans.

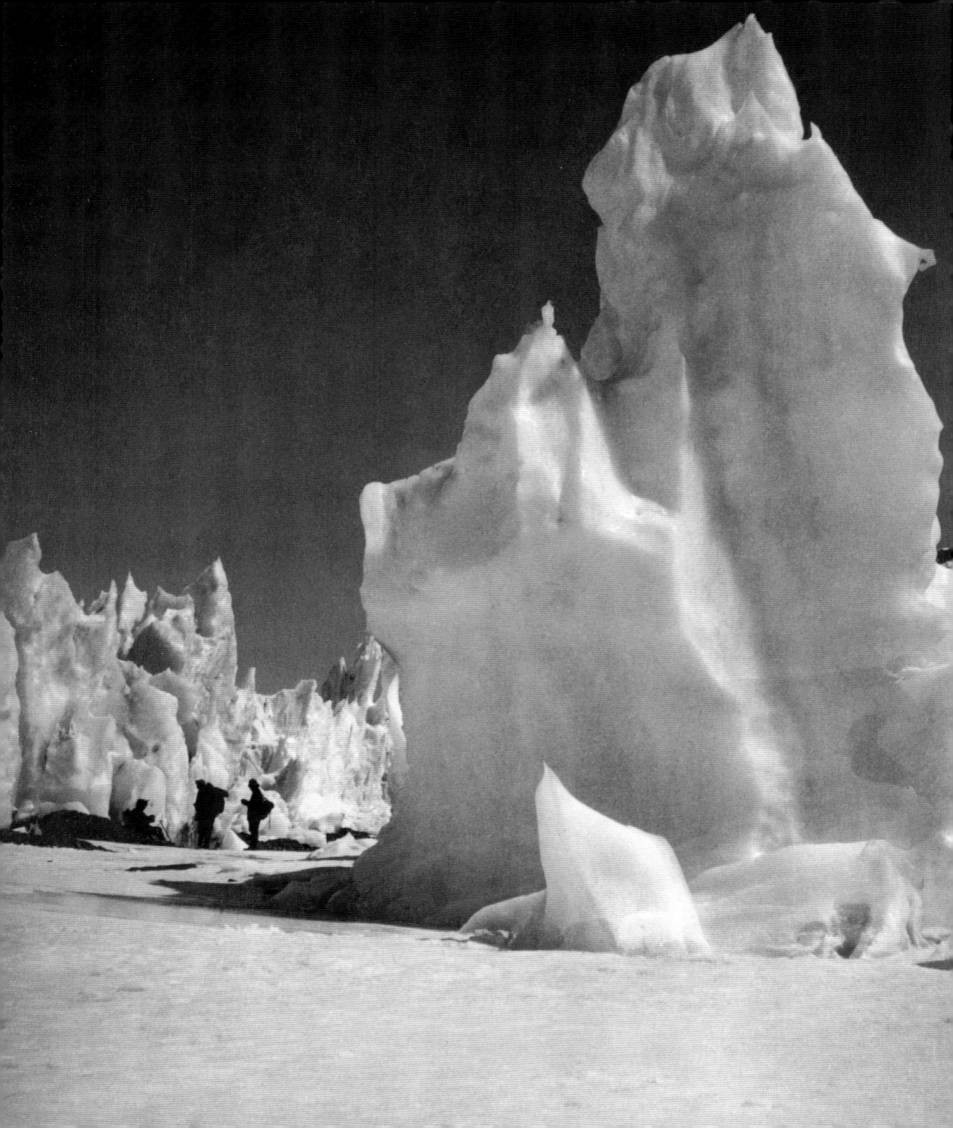

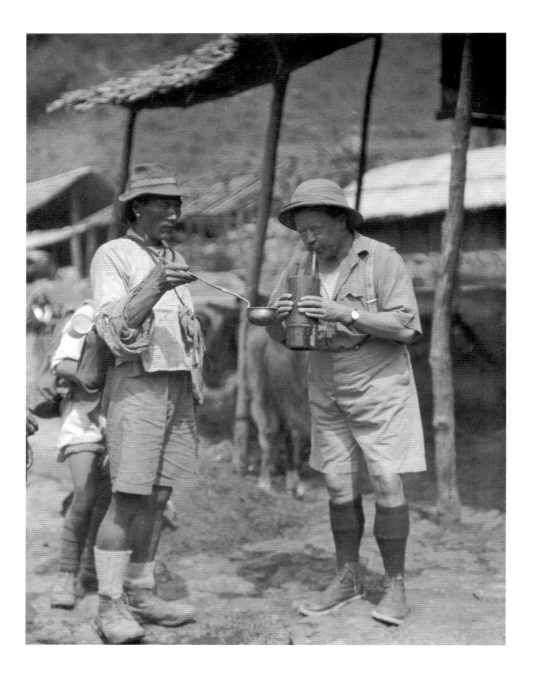

Brigadier-General Charles Bruce drinking chang from a bamboo barrel called a dhungro through a narrow bamboo pipe called the pipsing. Popular throughout Tibet and Sikkim, chang is a beer-like beverage made from fermented barley and served with hot water.

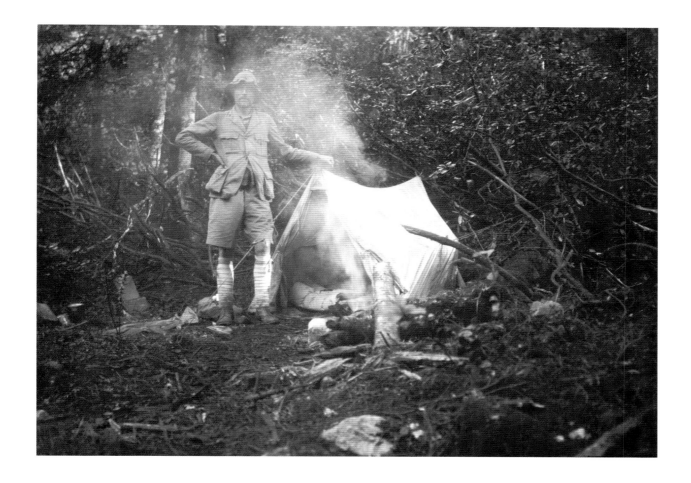

Geologist Noel Odell, responsible for the oxygen equipment and supplies on the 1924 expedition, outside his tent in the forest of the Zemu Valley in Sikkim.

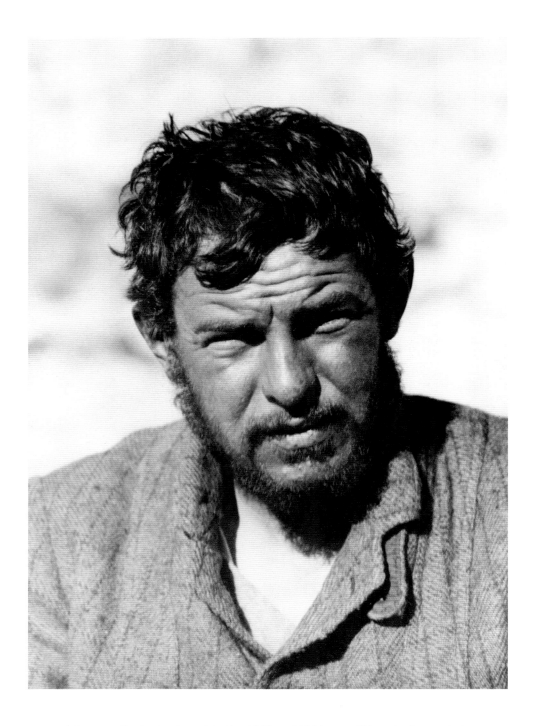

Howard Somervell, who took part in the 1922 and 1924 expeditions to Everest. A surgeon and experienced alpine climber, he accompanied Edward Norton to 28,000 feet (8,530 metres) in 1924's attempt on the Summit.

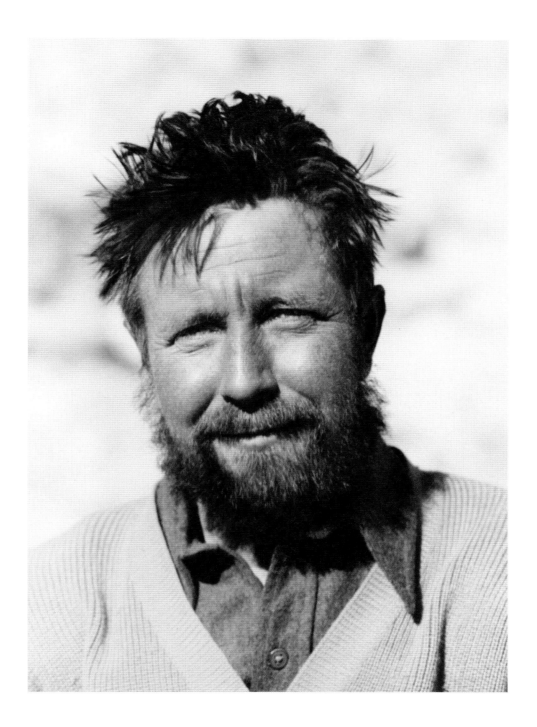

Bentley Beetham, whom John Noel described as "a man with a marvel of pace and endurance on the mountains." Plagued by illness, he was unable to contribute much in the latter stages of the 1924 expedition, but instead took a series of stunning photographs.

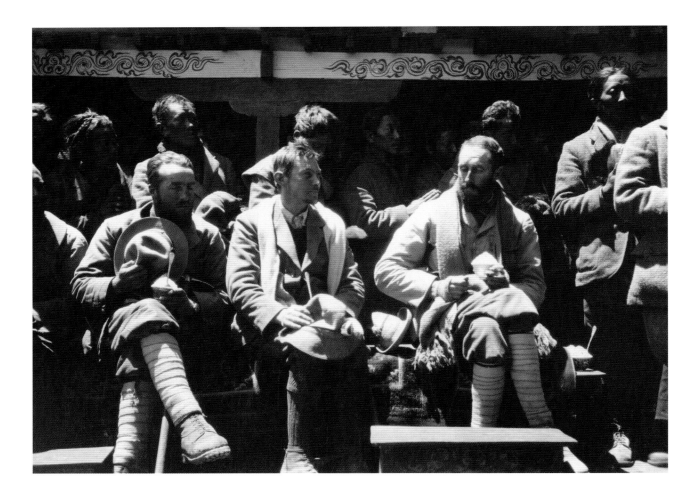

Expedition members pay their respects at Rongbuk Monastery, which lies to the north of Mount Everest at the end of the Dzakar Chu Valley, 16,340 feet (4,980 metres) above sea level.

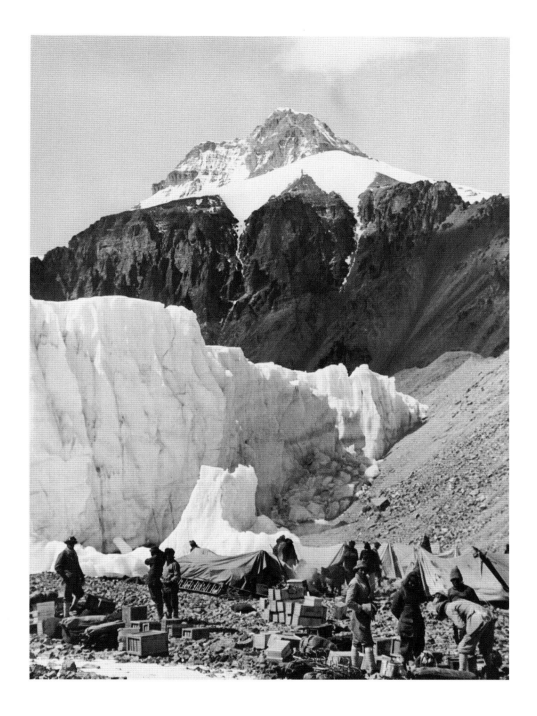

Camp II on the East Rongbuk Glacier. The peak in the background is Mount Kellas, named after Dr Alexander Kellas, who died of a heart attack on the 1921 expedition. In the foreground is George Mallory (fourth R).

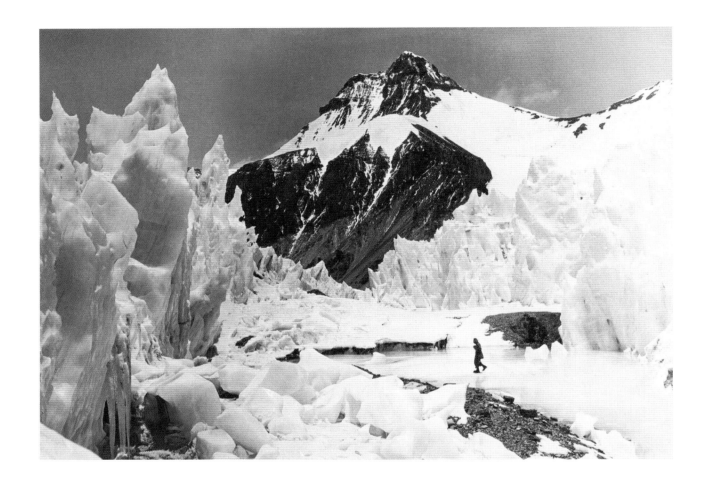

Flanked by pinnacles of ice, a member of the 1924 expedition makes his way carefully across the East Rongbuk Glacier. This difficult terrain was the only available route to the summit of Everest.

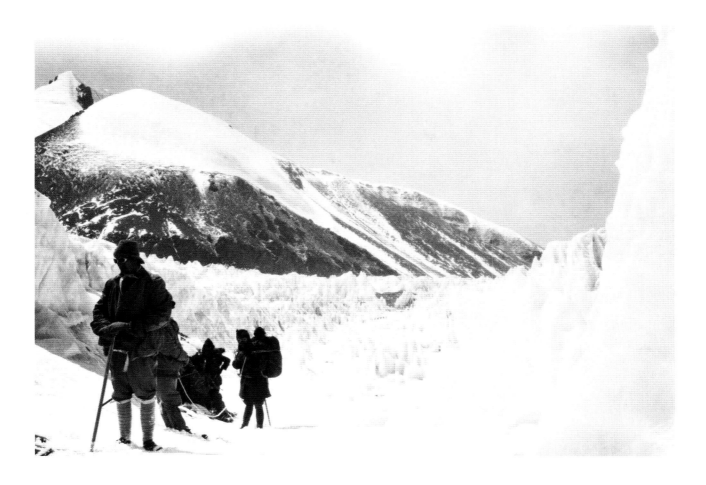

Expedition leaders ascend The Trough, a traversable depression in the East Rongbuk Glacier. This photograph was taken on 5th May, 1924 by the doomed Sandy Irvine.

On their climb to Camp IV on the North Col, the men of the 1924 expedition are dwarfed by the ice wall towering 1,000 feet (305 metres) above them.

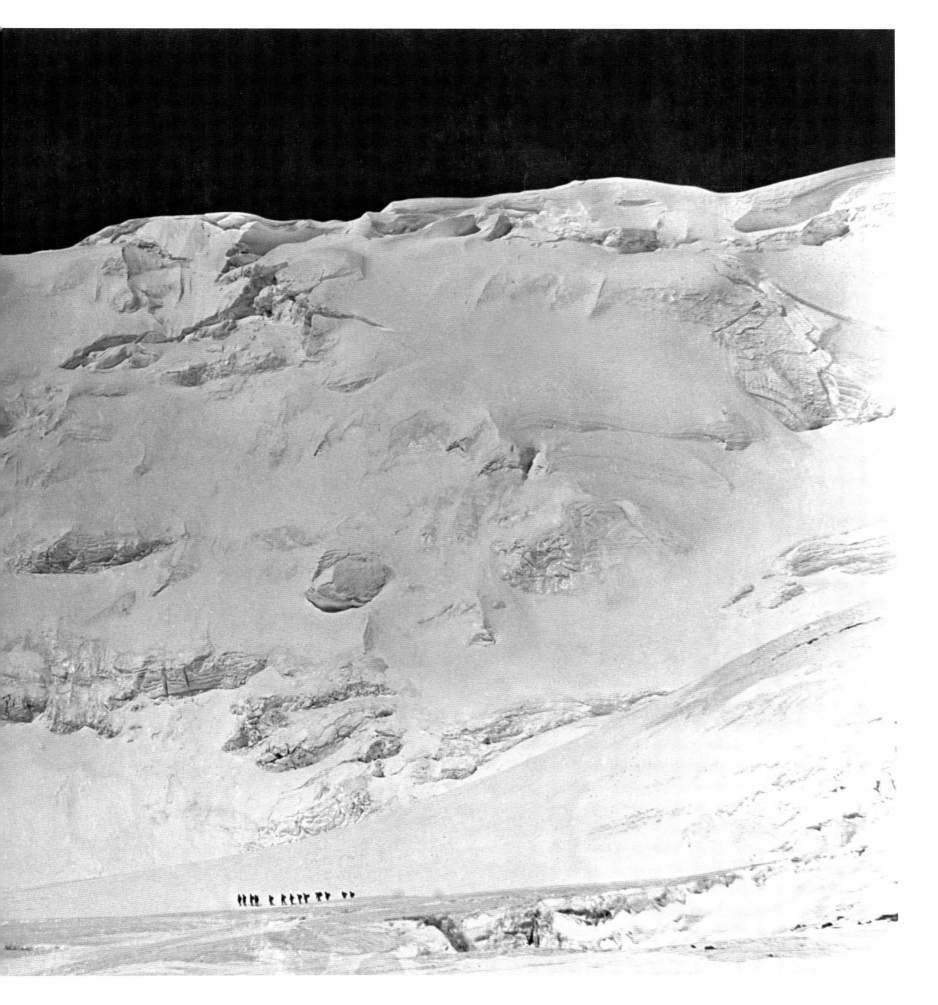

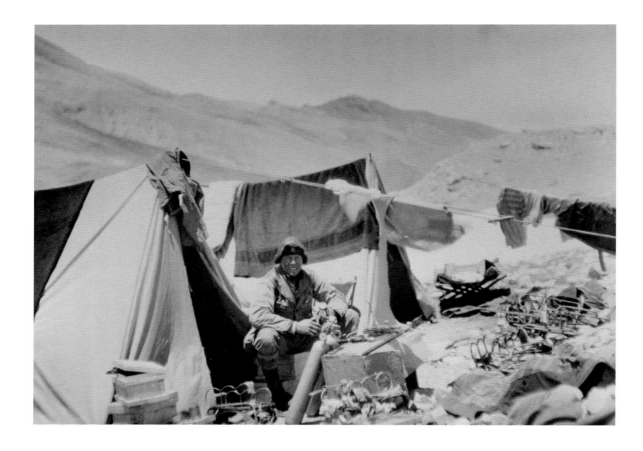

Sandy Irvine working on an oxygen cylinder. The 21-year-old was a relatively inexperienced climber, but had boundless enthusiasm and a natural mechanical ability that proved invaluable with the temperamental oxygen equipment. It was this skill that led Mallory to choose him as a companion in the ill-fated attempt at reaching the Summit.

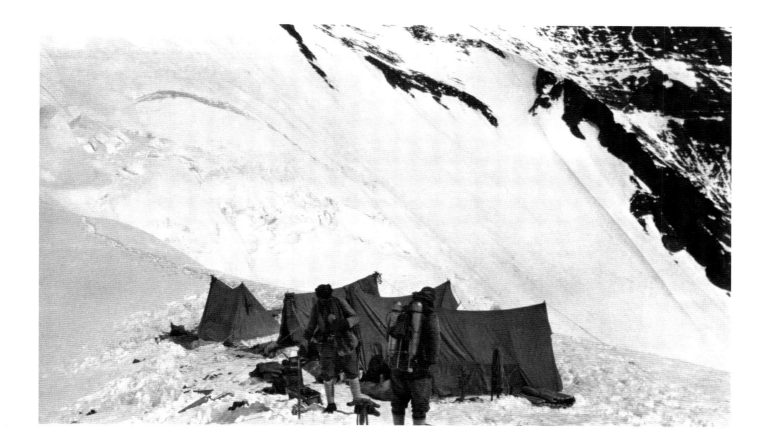

The last photograph of George Mallory (L) and Sandy Irvine as they prepare to leave the North Col for their attempt on the Summit of Mount Everest. Shortly afterwards, they disappeared into the mist and never returned, leaving unanswered the question of whether they had conquered the mountain before it had claimed their lives.

Crossing a boulder-strewn river in the Rhenock district of eastern Sikkim.

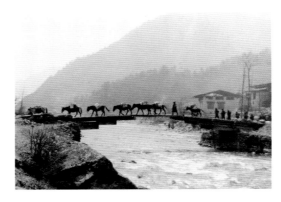

The second transport party crossing a river in the Chumbi Valley of Tibet.

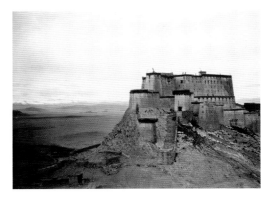

The ancient Tibetan fortress of Kampa Dzong (Gamba), near the border with Sikkim.

A cairn of mani stones inscribed with Buddhist mantras and devotional prayers.

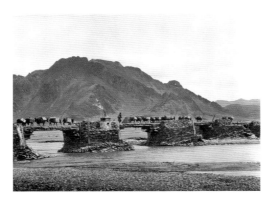

A mule train crosses a wood-and-stone bridge over a river near Sakya in southern Tibet.

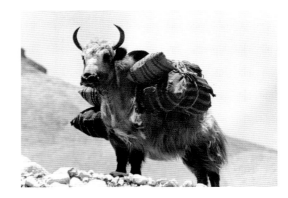

Yaks are stronger than oxen and their lung capacity is greater, making them ideal mountain pack animals.

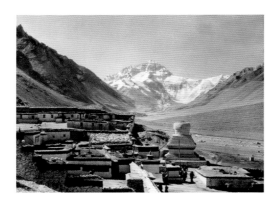

Rongbuk, a Tibetan Buddhist monastery; in the background is Mount Everest.

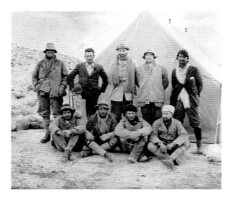

L–R (back): Irvine, Mallory, Norton, Odell, Macdonald; (front) Shebbeare, Bruce, Somervell, Beetham.

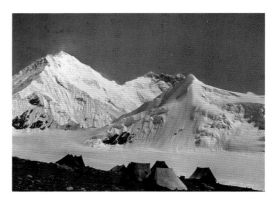

A view from Base Camp of the forbidding summit of Mount Everest.

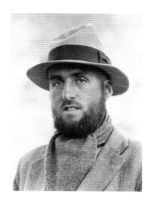

Geoffrey Bruce was a Gurkha officer who spoke some of the local languages of the Himalayas.

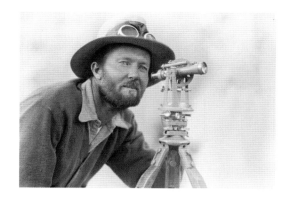

John Hazard was a former sapper whose engineering skills were vital to the expedition.

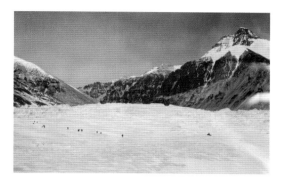

Like a line of ants, members of the 1924 expedition cross the Rongbuk Glacier.

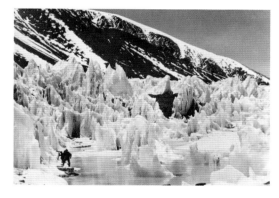

Flanked by pinnacles of ice, climbers edge along the side of a flow of meltwater.

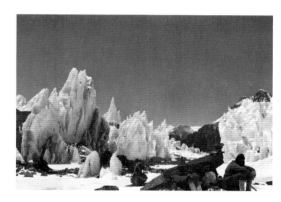

Noel Odell took this photograph of his party flanked by ice pinnacles in The Trough.

Up the 'chimney' (a term for a vertical opening that is narrow, but wide enough to climb up).

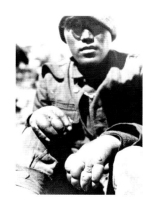

Namgya, a porter, shows the frostbite he acquired while stranded for a time on the North Col.

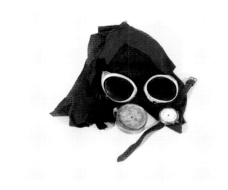

Mallory's frozen body was discovered in 1999, along with his goggles, watch, altimeter and scarf.

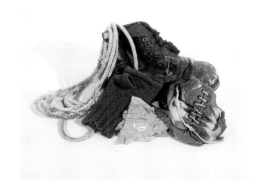

Fragments: Mallory's boots, fingerless gloves, a climbing rope and a piece of cloth.

1933 Expedition

In 1933, yet another grand British expedition wended its way towards Mount Everest from the Tibetan plateau. In the space of nine years, new players had entered the game, among them Eric Shipton, who had climbed in Britain, the Alps and Kenya. He would play a major role in subsequent Everest expeditions. With him were other experienced climbers: Frank Smythe and Percy Wyn-Harris.

The expedition managed to position their final camp at 27,400 feet (8,354 metres) on the North Face, giving the teams who would make the final attempts on the summit a much better chance of success. First to go were Wyn-Harris and Lawrence Wager, who set off diagonally across the North Face, working their way slowly up towards the Northeast Ridge. On the way, they came across the ice axe that had belonged to Sandy Irvine, who had disappeared in 1924. Eventually, they followed the route used by Teddy Norton in 1924, but like him were forced to turn back when they encountered the vertical walls of the Great Couloir to the east of the Summit.

A second attempt was made by Smythe and Shipton after they had spent two nights waiting at the top camp while a storm raged about them, although the latter was forced to turn back early and Smythe got no further than Wyn-Harris and Wager. Both attempts had been made without oxygen and both had reached beyond 28,000 feet (8,530 metres), although they had not beaten Norton's altitude record set in 1924.

Lawrence 'Waggers' Wager leads a party of Sherpas through one of the troughs that extended for over a mile (1.6 kilometres) and provided a route to the mountain through the East Rongbuk Glacier.

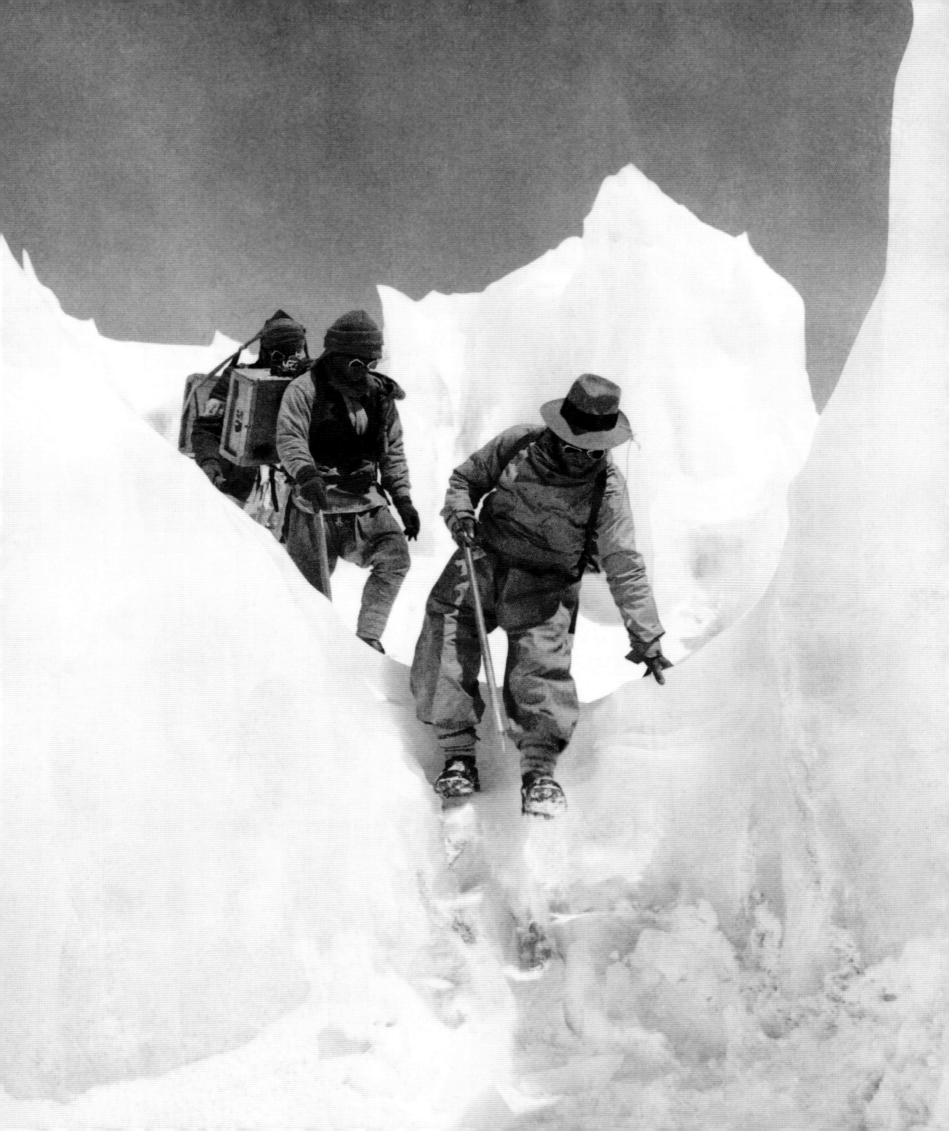

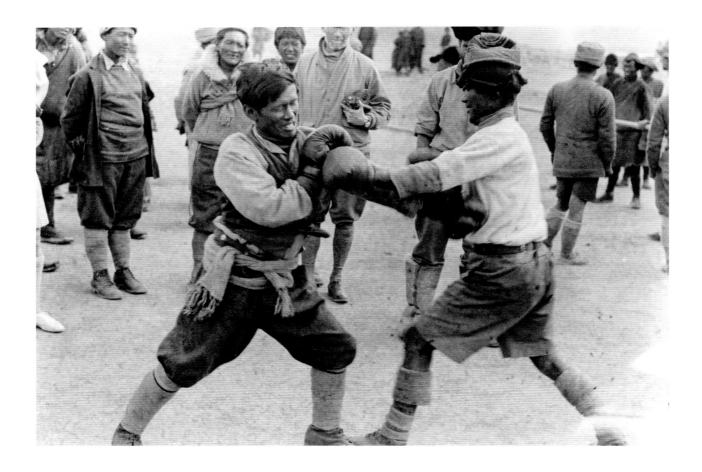

At Tingri Dzong, Hugh Boustead, a former Army boxing champion, introduced the expedition's porters to the noble art as practised in the West with gloves: it was a hit in more than one sense.

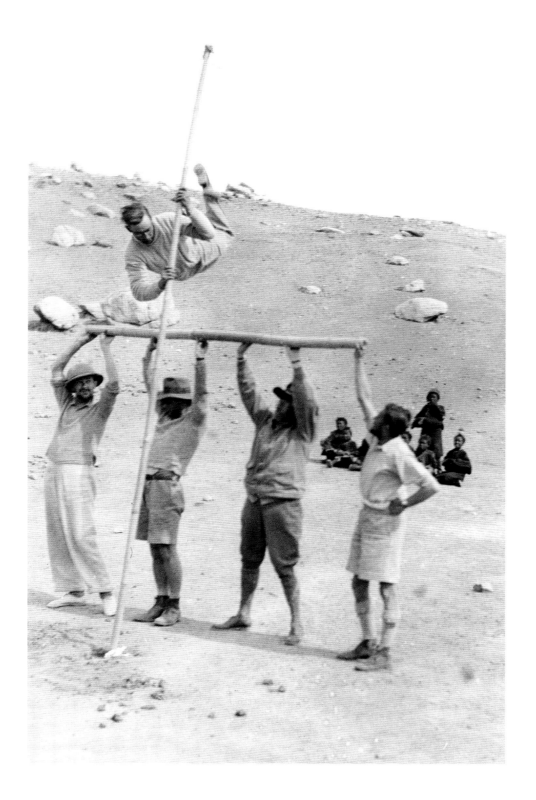

While at Tingri Dzong, Jack Longland took the opportunity to demonstrate to the Tibetan townspeople his skill at pole-vaulting. It soon caught on with them, and, although there were a few mishaps, Hugh Ruttledge later recalled that "…some very remarkable jumping, or rather falling, was observed. But these men are unkillable."

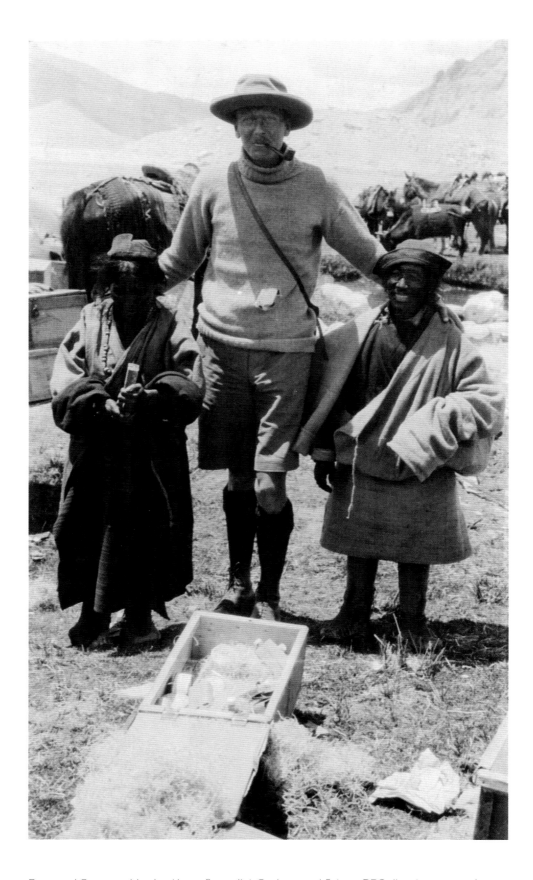

Raymond Greene, elder brother of novelist Graham and future BBC director-general Hugh, was the medical officer on the 1933 Mount Everest expedition. Here he is seen with two Tibetan villagers.

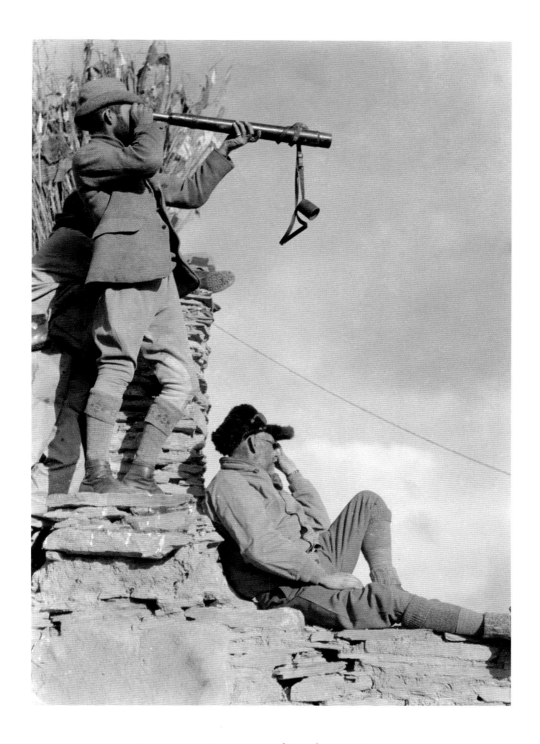

From the summit battlements at Shekar Dzong (Xêgar), expedition leader Hugh Ruttledge (seated) and other team members reconnoitre Mount Everest, around 50 miles (80 kilometres) distant, picking out features such as the North Ridge.

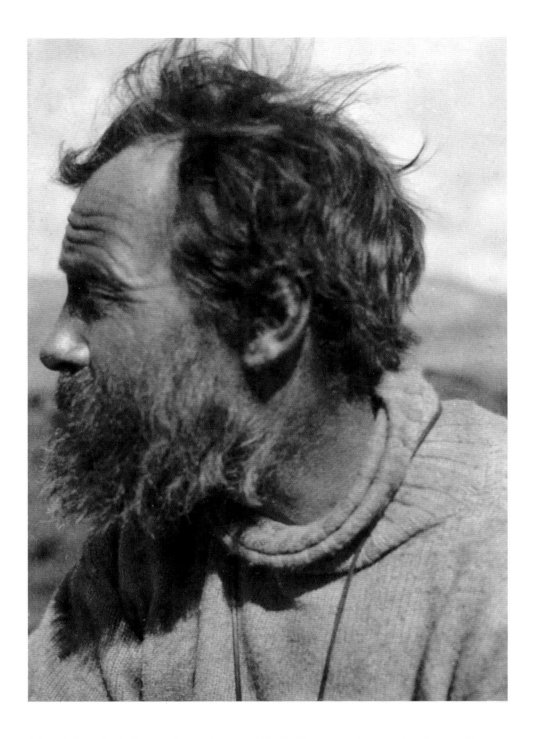

Edward Oswald Shebbeare, known to all as 'Shebby', had been transport officer on the 1924 expedition and was chosen by Hugh Ruttledge as his deputy in 1933.

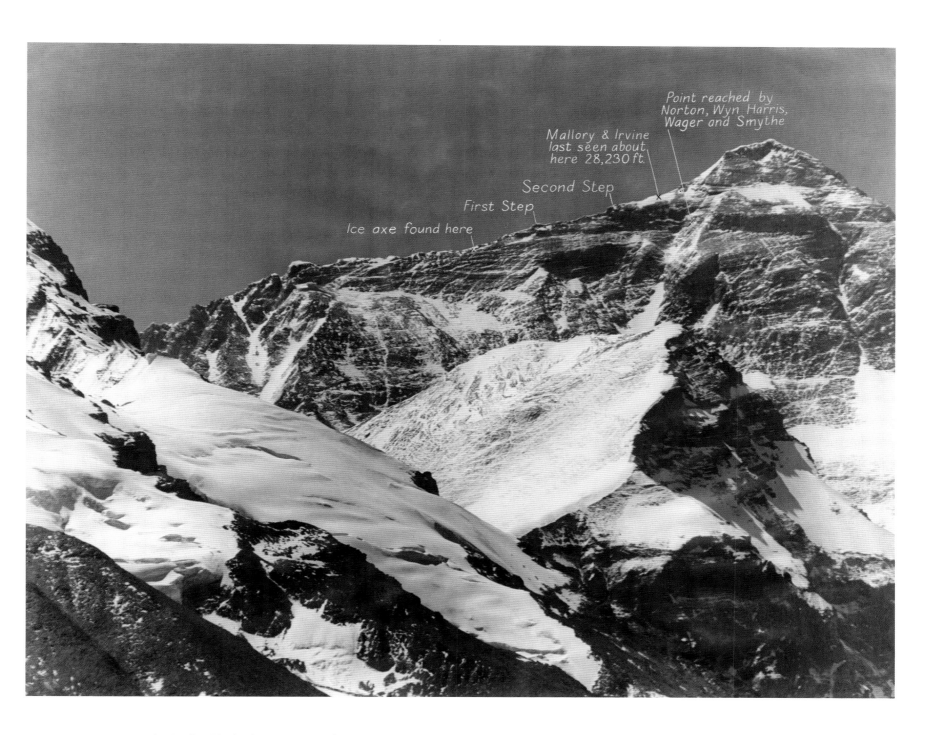

Point reached by
Norton, Wyn Harris,
Wager and Smythe

Mallory & Irvine
last seen about
here 28,230 ft.

Second Step

First Step

Ice axe found here

John Noel's 1933 landscape image of Mount Everest, annotated to mark the sites of momentous and tragic events in the history of attempts to conquer the world's highest summit.

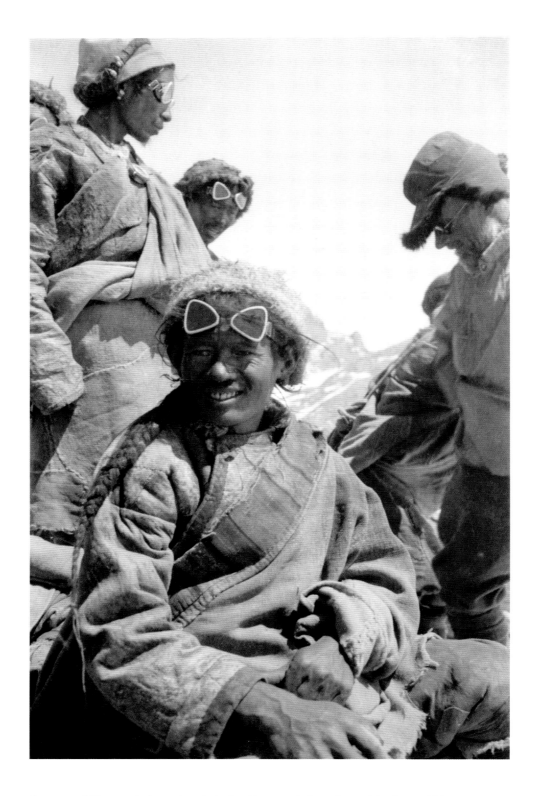

A group of Sherpas takes a break during the march from Camp I to Camp II. The expedition provided them with boots and suitable clothing, including snow goggles, which were essential above Camp II to prevent snow blindness. The man nearest the camera wears his hair in the traditional Sherpa pigtail.

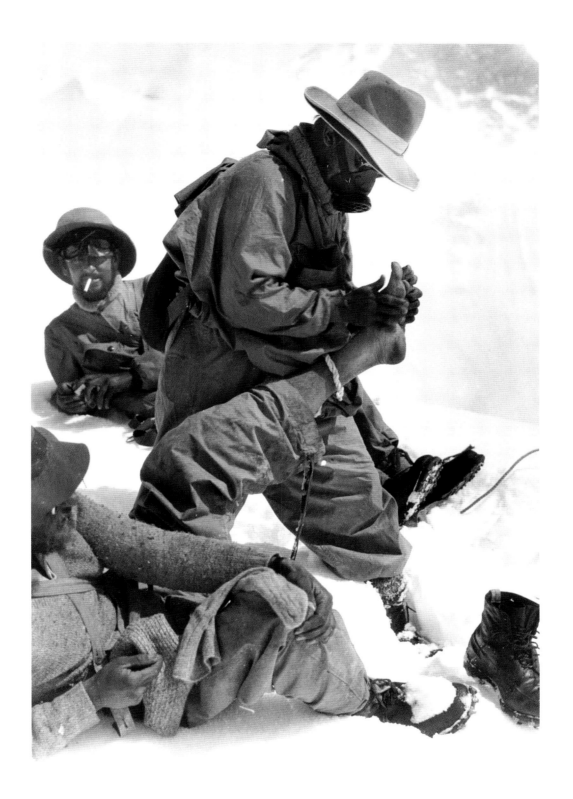

Although the climbers' boots were specially designed, and lined with asbestos and felt to ward off the cold, frostbite was a constant concern and feet were checked regularly for early signs.

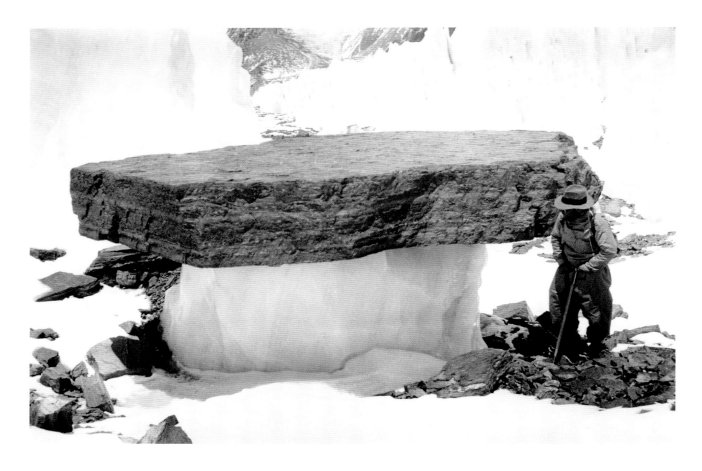

Lawrence Wager examines a glacier table: the rock shades the ice from the sun so that it does not melt.

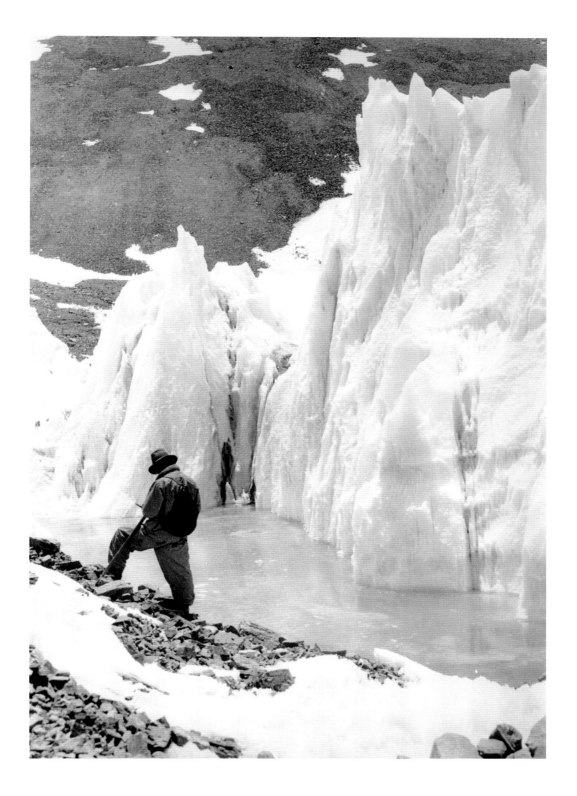

Eric Shipton, in one of the troughs of the glacier. Later, he accompanied Frank Smythe on a Summit bid, but they had to turn back at the First Step at 27,890 feet (8,500 metres). Shipton would become the only man to take part in all four Everest expeditions of the 1930s.

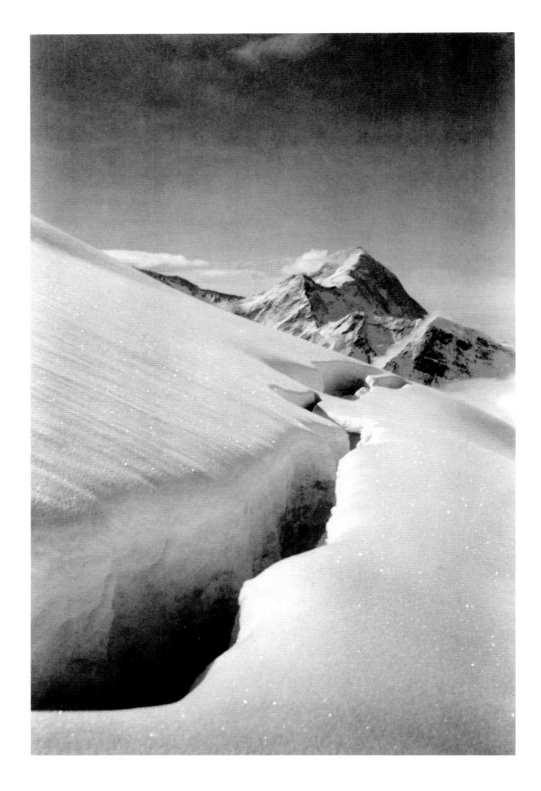

At 27,825 feet (8,481 metres) above sea level, Makalu is the fifth highest mountain in the world, only 1,204 feet (367 metres) lower than Mount Everest, which stands 12 miles (19 kilometres) away to the northwest.

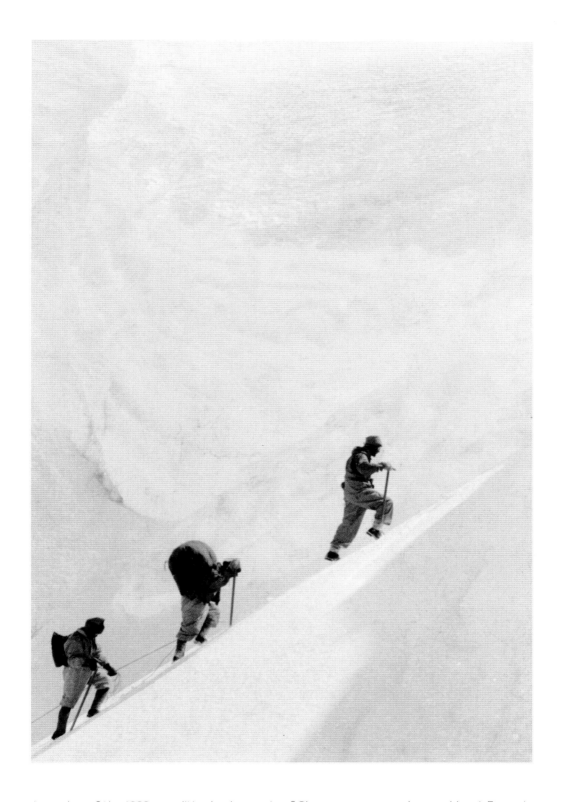

A member of the 1933 expedition leads a party of Sherpas up a snow slope on Mount Everest. The 'sahibs', as the climbers were known to the local people, took great pains to ensure the safety of the Sherpas, particularly after the 1922 expedition, when nine of them were swept into a crevasse and seven died.

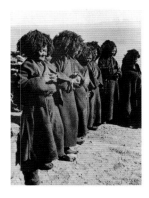

Buddhist nuns at Taktsang Palphug Monastery (aka 'The Tiger's Nest') in the upper Paro Valley, Bhutan.

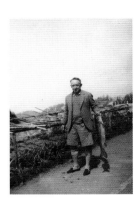

Colin Crawford, translator and organisational officer, proudly displays one that didn't get away.

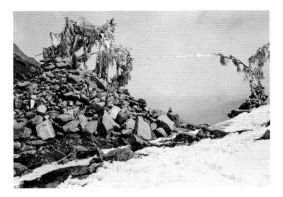

Buddhist prayer flags on top of a cairn in the Nathu La mountain pass that connects Sikkim and Tibet.

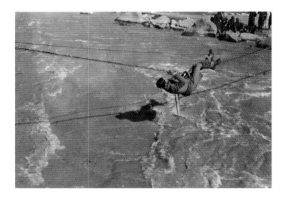

John Laurence 'Jack' Longland crosses a rope bridge over a river in Tibet.

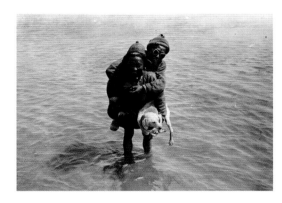

One man and his dog cross a river in Tibet on the back of a native porter.

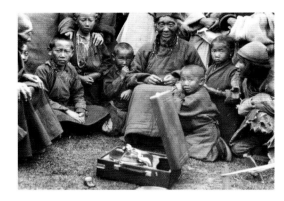

Tibetans at Kharta Shikar listen to a gramophone recording of Lewis Carroll's poem 'Father William'.

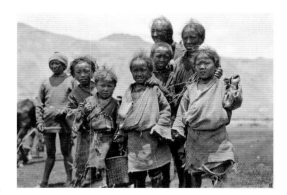

Some of the Tibetan children encountered on the trail between Tashi Dzom and Shigatse, Tibet.

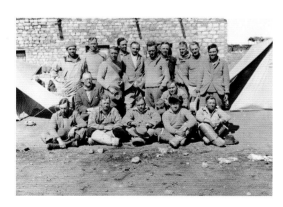

Class of '33: the full 16-man party photographed by Frank Smythe at Pagri, Tibet.

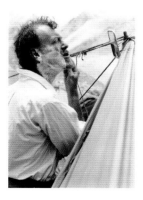

Keeping up appearances: Raymond Greene, senior doctor on the team, freshens up with a shave.

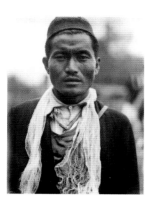

Leiva, the chief sirdar (head Sherpa) on the 1933 expedition.

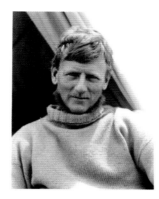

Self-portrait of Frank Smythe, a distinguished climber as well as the expedition's official photographer.

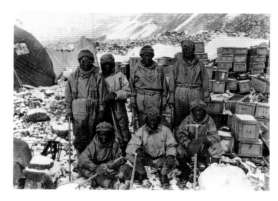

Some of the 'Tigers' – the Sherpas who had shown the greatest strength and endurance on the climb.

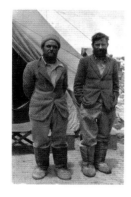

Percy Wyn-Harris (L) and Lawrence Wager led the first assault on the Summit in 1933.

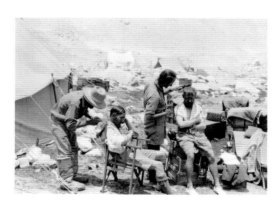

At Base Camp, the world's highest barber's: short backs and sides all round.

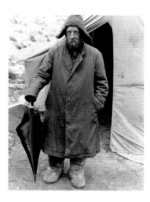

No Englishman leaves home without one: Shebby Shebbeare with trusty umbrella.

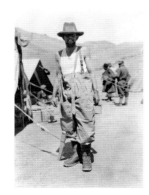

Hugh Boustead was a veteran of the 1926 exploration of Zemu Gap on the shoulder of Kanchenjunga.

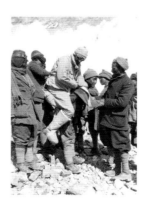

An ailing Eugene 'Bill' Birnie, the expedition's transport officer, is carried down to Base Camp by Sherpas.

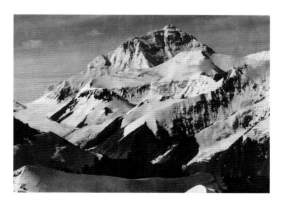

Mount Everest seen from a peak 22,000 feet (6,705 metres) above Base Camp.

1935 Expedition

The late granting of permission by the Tibetan authorities to allow an expedition in 1935 led to the decision to mount a reconnaissance in the region of Mount Everest to gain information that would be of use to an expedition in 1936. Its leader, Eric Shipton, strongly believed that massive expensive expeditions, such as those mounted previously, were a mistake and that a lightly-equipped and manned effort that could largely live off the land stood a much better chance of success. Accordingly, in addition to Shipton himself, only six Westerners made up the team.

In the course of their explorations, they made first-time ascents of no fewer than 26 peaks and were surprised to see the upper slopes of Everest free of monsoon snow, despite the fact that it was the middle of June. By the time they had established themselves on the mountain, however, that situation had changed.

While working their way up to the North Col, they discovered the body of Maurice Wilson, a former army officer who had made an illicit solo attempt to climb the mountain in 1934.

Although a camp was established on the North Col, the snow conditions made further progress on the mountain impossible and the expedition retreated to continue their explorations in the vicinity of Everest. During one of these, they were able to look into the Western Cwm, first seen by Mallory and Bullock in 1921. Shipton expressed his opinion that it looked like a possible route to the Summit, but access was through Nepal, still closed to outsiders. Little did he know that the mountain would be conquered by that route nearly 20 years later.

Eric Shipton and a group of Sherpas take a break by a glacier lake on the Rongbuk Glacier. Shipton took part in all four British Everest expeditions of the 1930s, as well as the 1951 and 1952 reconnaissance and training expeditions.

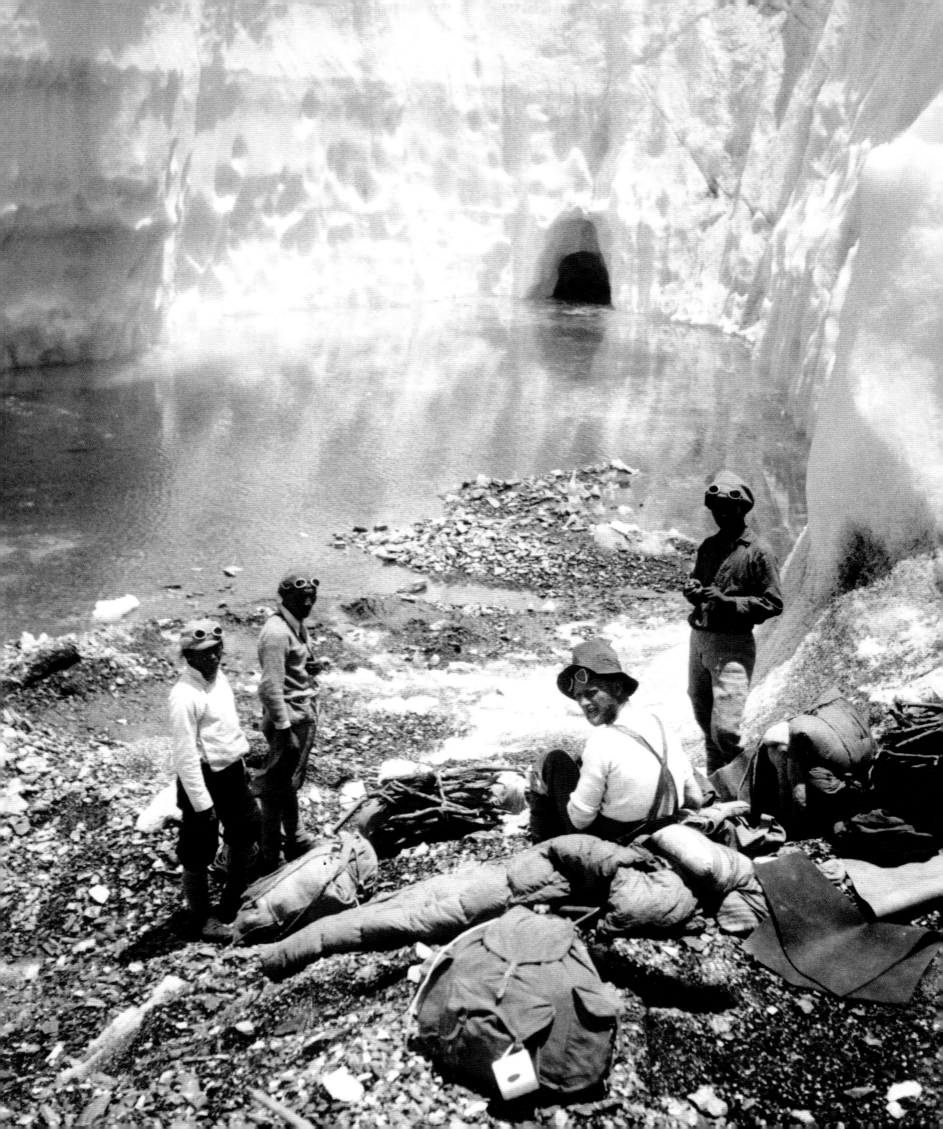

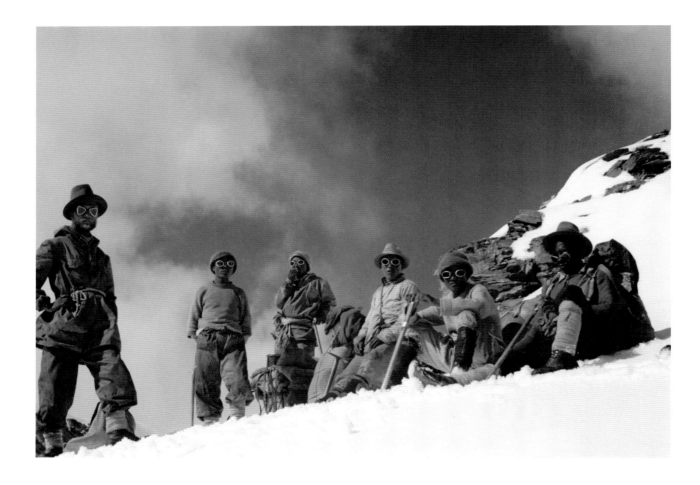

Eric Shipton (L) and a group of Sherpas, including a young Tenzing Norgay, rest while surveying the Nyonno Ri range, east of Mount Everest. It was suggested that had Shipton not spent time on this survey, he could have pushed on to Everest while the weather was good to make an attempt on the Summit. His contract, however, expressly forbade him from doing so.

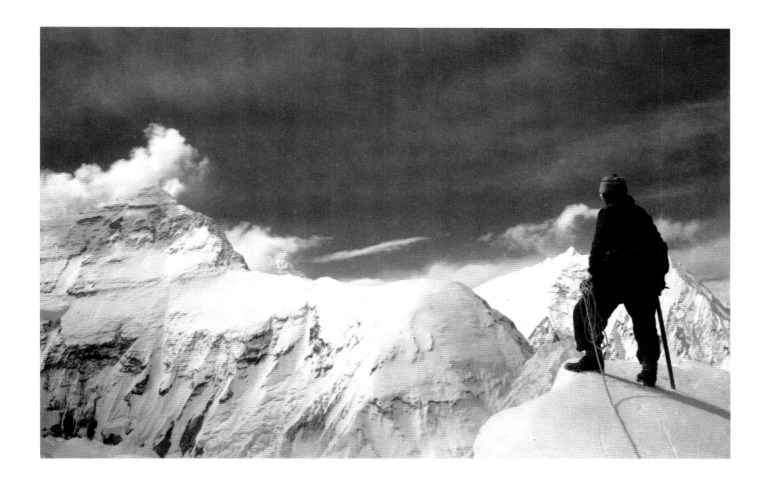

Eric Shipton, leader of the 1935 reconnaissance expedition to Everest, stands on the summit of a 21,120-foot (6,437-metre) peak above the Rongbuk Glacier, looking out at the North Face and West Ridge of Everest (L) and Nuptse (C). The mountains are thick with monsoon snow.

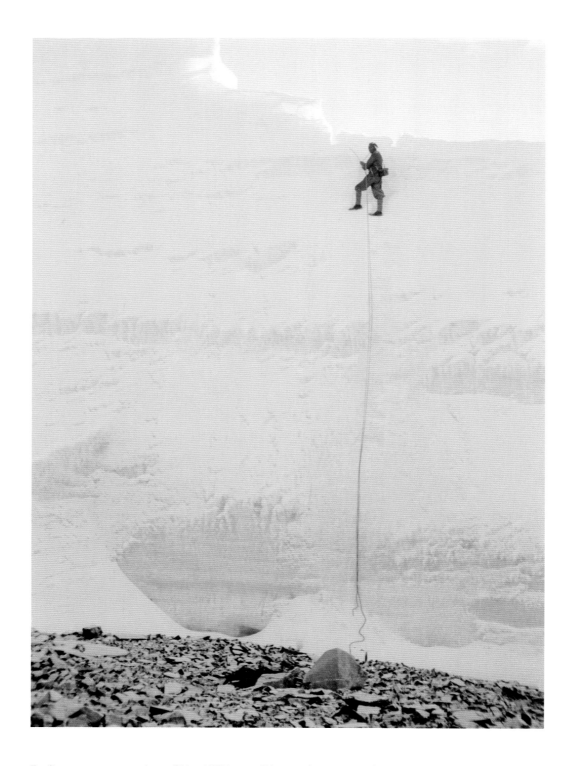

Trailing a rope, a member of the 1935 expedition scales a vertical ice wall. In those days, ropes were made from natural fibres and were heavy, adding to a climber's difficulties. By the time of the successful 1953 expedition, lightweight nylon ropes were in use.

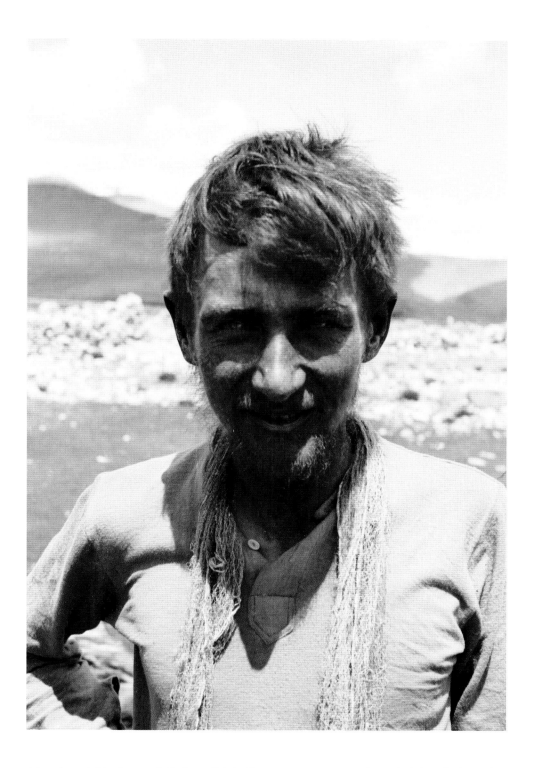

A teacher at Marlborough College, Edwin Kempson was an experienced alpine climber who took part in both 1935 and 1936 expeditions. During 1935, he and Michael Spender carried out a lot of survey work in the Everest region.

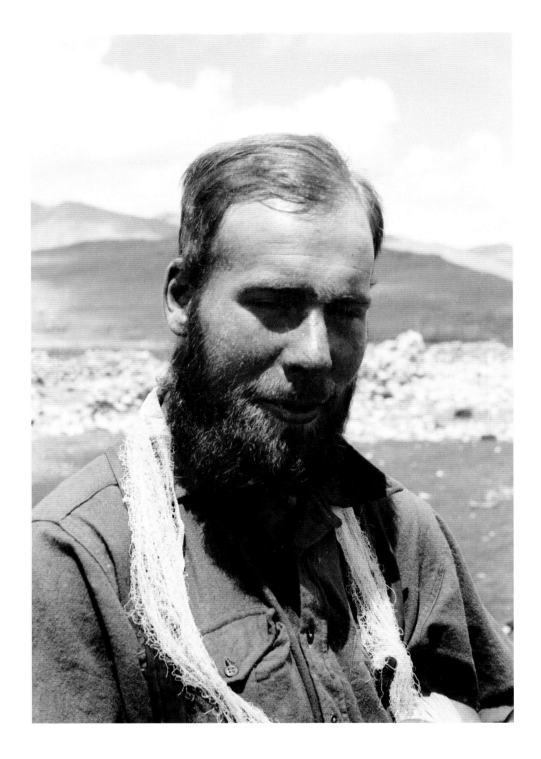

Edmund Wigram, a doctor and experienced alpine climber, who climbed 20 peaks above 20,000 feet (6,096 metres) during the 1935 reconnaissance expedition. He also took part in the 1936 expedition, but illness prevented him from going beyond the North Col.

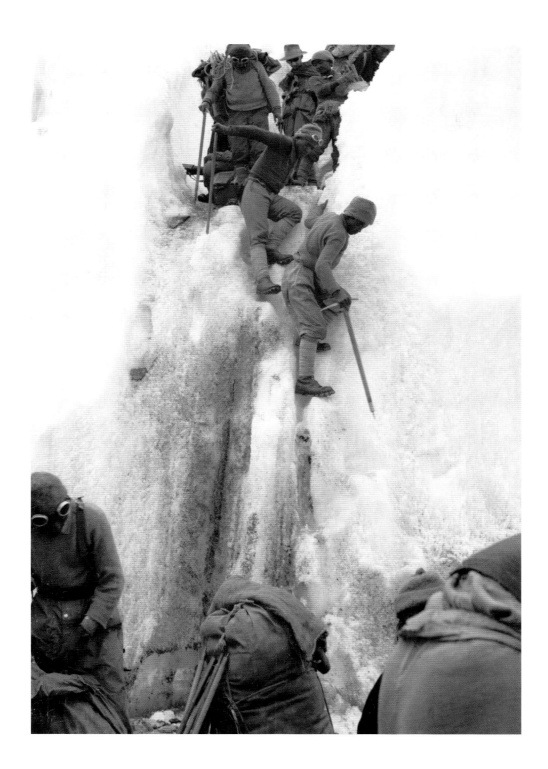

Sherpas make their way gingerly down an ice pinnacle on the East Rongbuk Glacier. George Mallory had pioneered this route in 1921, and to this day it is used by expeditions seeking to climb Everest via the North Col and Northeast Ridge from Tibet.

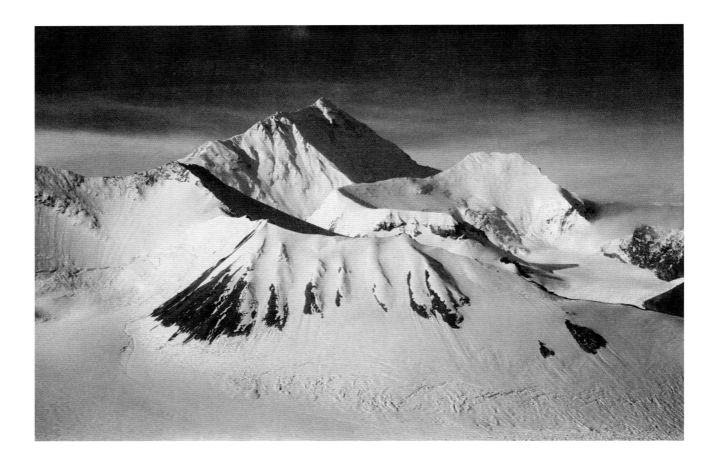

Mount Everest seen from the northeast at a height of 22,740 feet (6,931 metres) and cloaked in monsoon snow. Shipton's expedition had arrived too late in the year to contemplate a serious attempt on the mountain, but did make 26 first ascents of other peaks above 20,000 feet (6,096 metres) in the area.

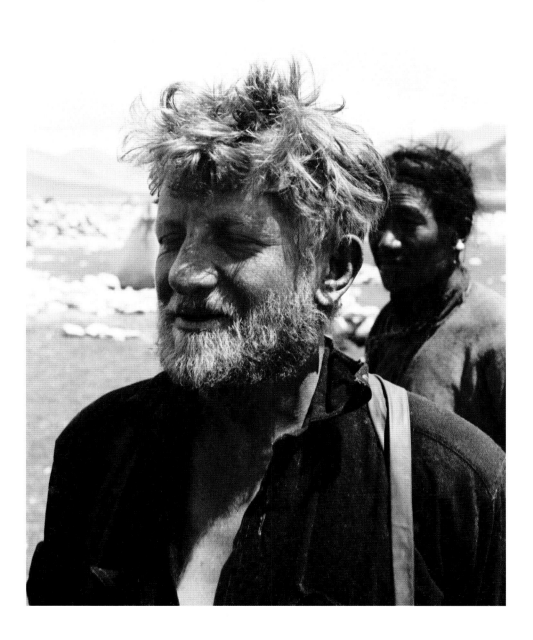

A New Zealander, Leslie 'Dan' Bryant was a popular member of the 1935 reconnaissance expedition. He was valued for his ice climbing skills and for his humour. Many of the photographs from the expedition were taken by him.

A member of the expedition, possibly Eric Shipton, scales the summit of Kellas Rock Peak, at a height of about 23,000 feet (7,010 metres) above sea level.

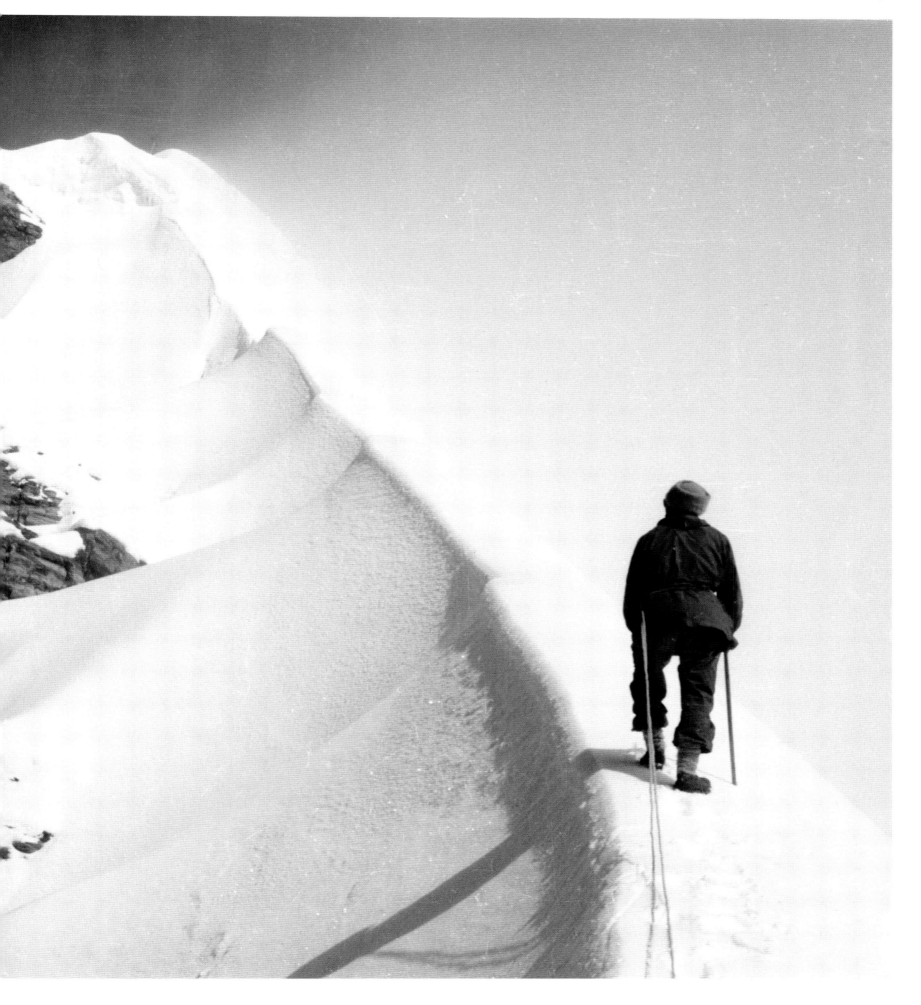

Michael Spender was the 1935 expedition's surveyor, and he mapped all 26 peaks over 20,000 feet (6,096 metres) that were climbed for the first time. He died in an air crash during the last week of the Second World War.

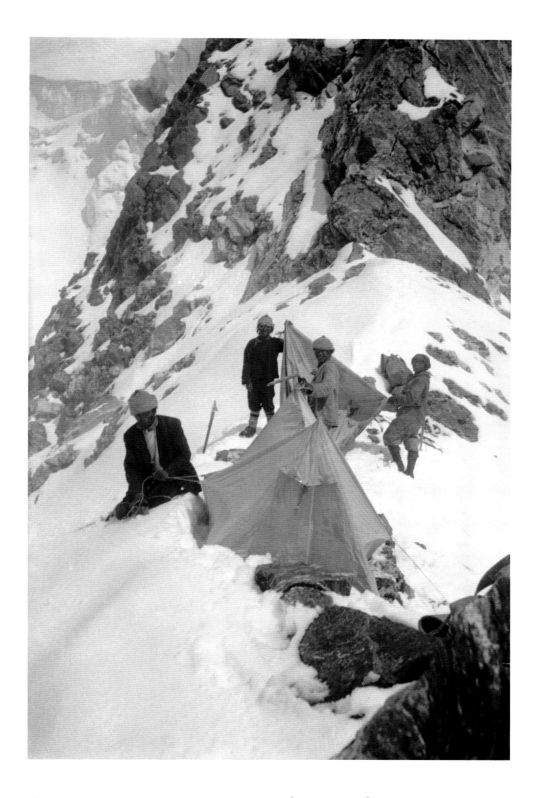

Sherpas erect tents at a camp on a 20,200-foot (6,1546-metre) peak in the Kharta Chu Valley. The expedition marked 20-year-old Tenzing Norgay's first experience as a high-altitude porter.

The 1935 team and all their equipment during a brief stop in a Tibetan village.

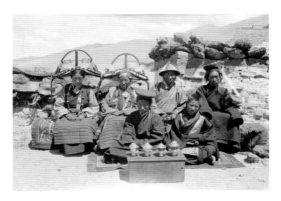

The dzongpen of Sar (C), a remote village in Tibet, seen here with his family.

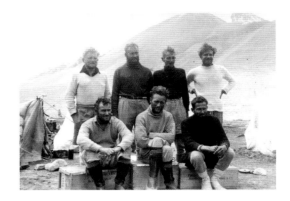

The '35ers, L–R: (back row) Bryant, Wigram, Warren, Spender; (front row) Tilman, Shipton, Kempson.

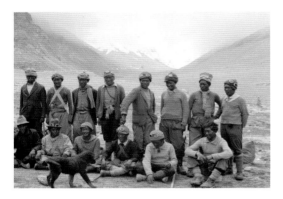

A group photograph of the porters on the 1935 expedition, who became known as the Sherpa Tigers.

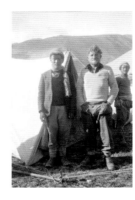

Sherpa Ang Tensing and New Zealander Leslie 'Dan' Bryant, a superb ice climber.

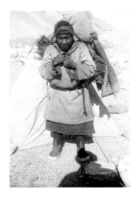

Sometimes it seemed as if there was no limit to the loads the porters could carry.

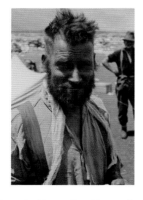

Bill Tilman struggled to acclimatise on the 1935 expedition, but went on to lead in 1938.

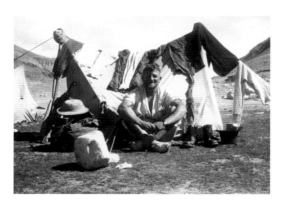

A self-portrait of Dan Bryant, taken on laundry day. He was known for his good humour.

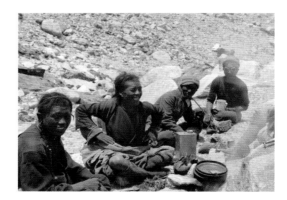

Whenever they stopped, the Sherpas' first desire was for a refreshing and warming mug of tea.

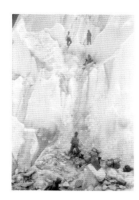

Members of the 1935 expedition crossing the main body of the Rongbuk Glacier.

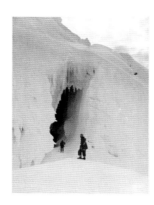

Expedition members cautiously investigate the mouth of an ice cave.

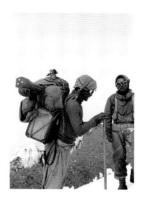

This porter carries his considerable load with the aid of a traditional head strap.

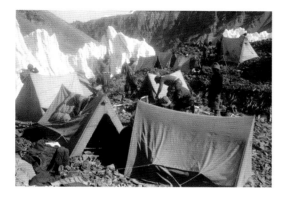

The flimsy tents of Camp II were pitched on scree and surrounded by ice pinnacles.

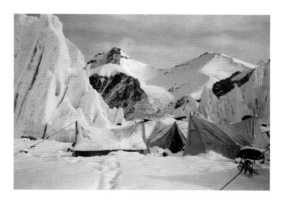

A subsequent heavy fall of snow dramatically transformed the terrain of Camp II.

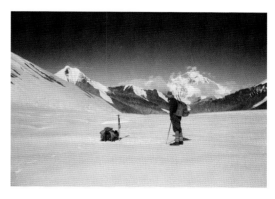

The expedition at 22,580 feet (6,882 metres), with Gyachung Kang (26,089 feet/7,952 metres) beyond.

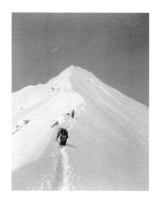

Climbers knee-deep in snow on a high ridge.

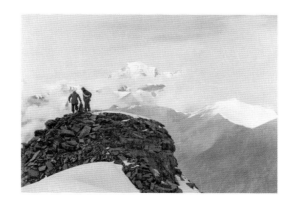

Team members on Horseshoe Peak at 20,800 feet (6,340 metres), with Gyachung Kang in the distance.

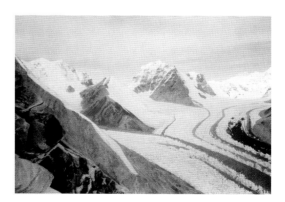

The West Rongbuk Glacier looks fairly flat and undemanding terrain, but appearances are deceptive.

1936 Expedition

Despite Eric Shipton's enthusiasm for small expeditions, a strong 12-man team was sent to tackle Mount Everest in 1936, led by Hugh Ruttledge. All but three had been to Everest before. As they trekked across Tibet, they could see bad weather in the region of the mountain; it was a portent of what was to come.

When they reached Everest at the end of April, however, the weather was fine and the mountain appeared to be in climbable condition. At first they made rapid progress, establishing a camp on the North Col on 14th May. Heavy snow began falling, though, and unusually there was no wind to blow the snow from the upper faces of the mountain. As conditions worsened and the porters became unnerved, Ruttledge called a retreat to the lower slopes.

Then came the news that the monsoon had arrived early off the coast of Ceylon. Aware that its arrival in the Everest region would scotch any further chance of attaining the Summit, the team set off again for the North Col camp, believing they might just have enough time for a Summit bid, but the monsoon reached them within days rather than the expected couple of weeks and bad weather stopped them in their tracks.

Reluctant to abandon their quest, Shipton and Percy Wyn-Harris convinced Ruttledge to allow them one final attempt at reaching the North Col. The experienced climbers were negotiating the slope leading to the crest of the col when they were caught in an avalanche and narrowly avoided being swept over a 400-foot (122-metre) drop. It was quite clear that no further attempt could be made that year; Everest had beaten them yet again.

John Morris crosses a small crevasse in the East Rongbuk Glacier, using his ice axe for balance. Despite the ice and snow, the fierce sun could make climbing unbearably hot; snow goggles were essential to protect climbers' eyes against the glare.

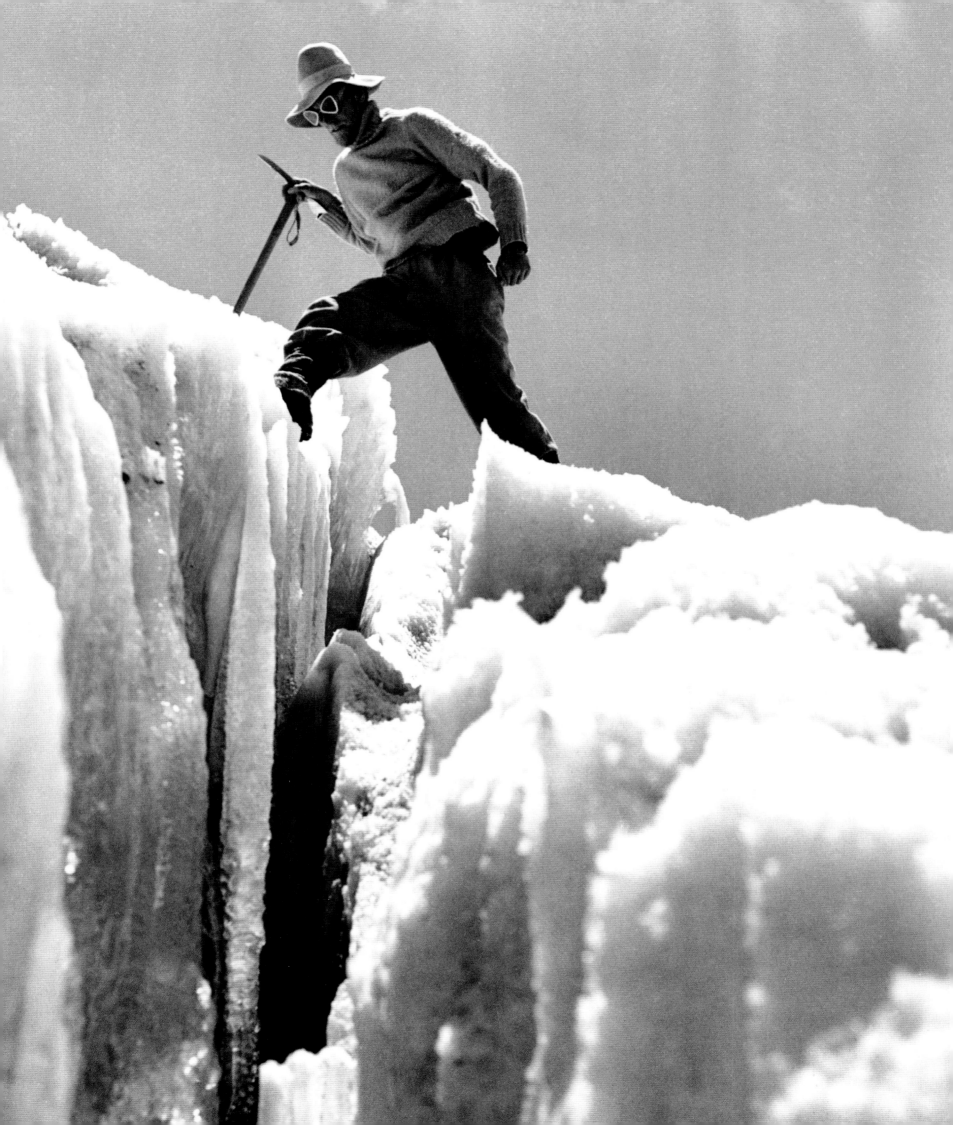

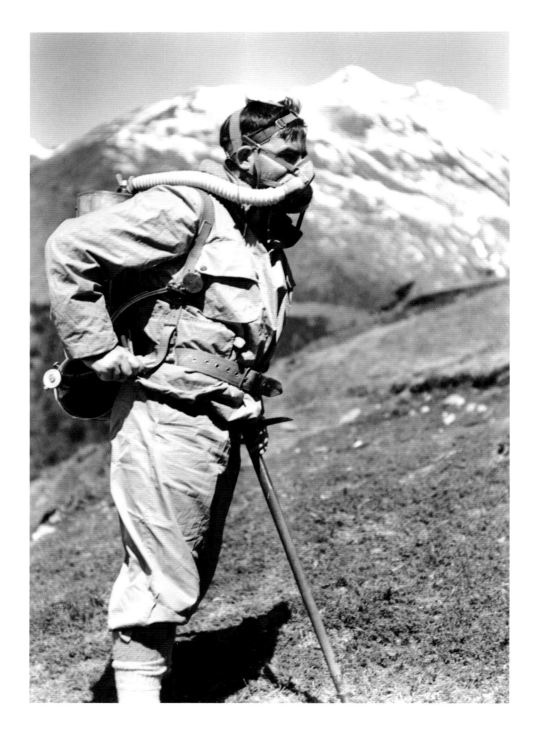

Percy Wyn-Harris tests oxygen equipment at Tangu on the march to Everest. Opinions differed among climbers as to whether it should be used: some felt it would be essential for the last 1,000 feet (304 metres) or so of the climb; others thought that to use it would be unethical in some way. The bulky apparatus weighed 35 pounds (15 kilograms), a very heavy load when climbing. In the event, the expedition was abandoned before it could be tested at altitude.

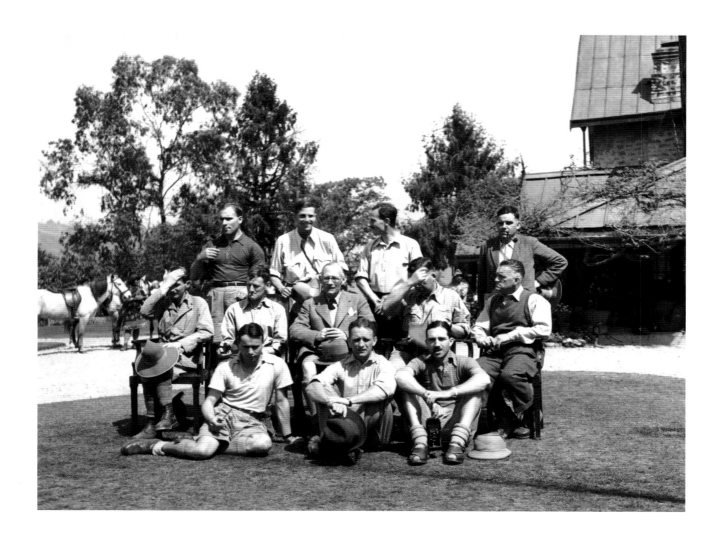

Members of the 1936 Mount Everest expedition, L–R: (back row) Edmund Wigram, Edwin Kempson, Charles Warren, Percy Wyn-Harris; (middle row) Peter Oliver, Frank Smythe, Hugh Ruttledge, John Morris, Noel Humphreys; (front row) Jim Gavin, Eric Shipton, William Smyth-Windham.

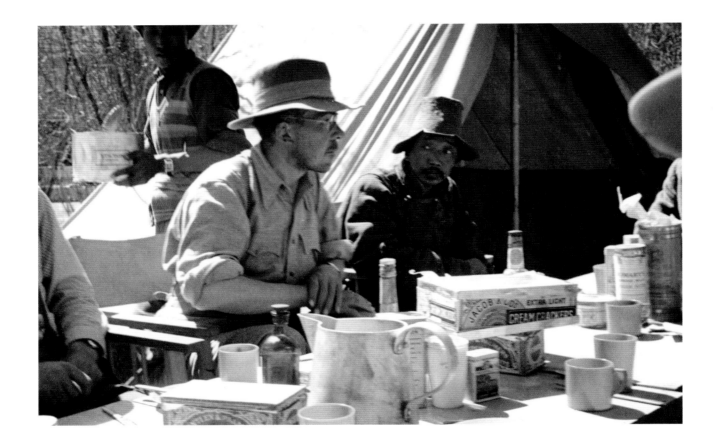

The importance of good food to the success of an expedition was realised. Here, John Morris (L) is seen at the Base Camp dining table, surrounded by familiar British brands, including Huntley & Palmer gingernut biscuits, Heinz tomato ketchup and sardines from J. Sainsbury.

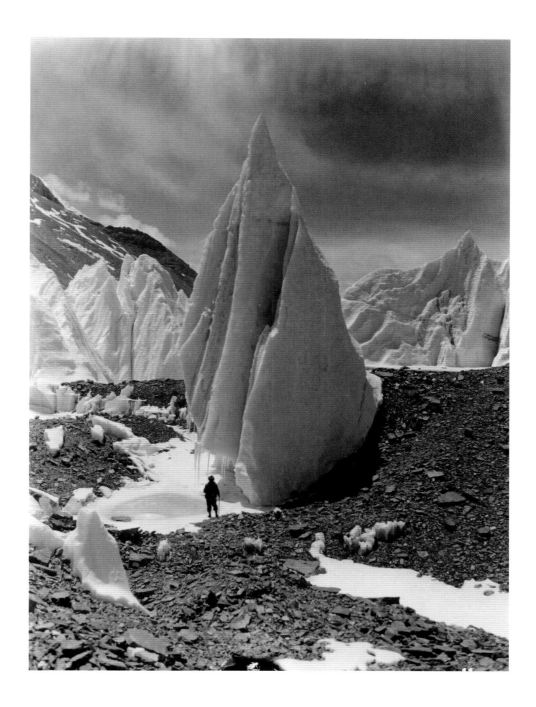

A member of the expedition is dwarfed by one of the glistening ice pinnacles of the East Rongbuk Glacier.

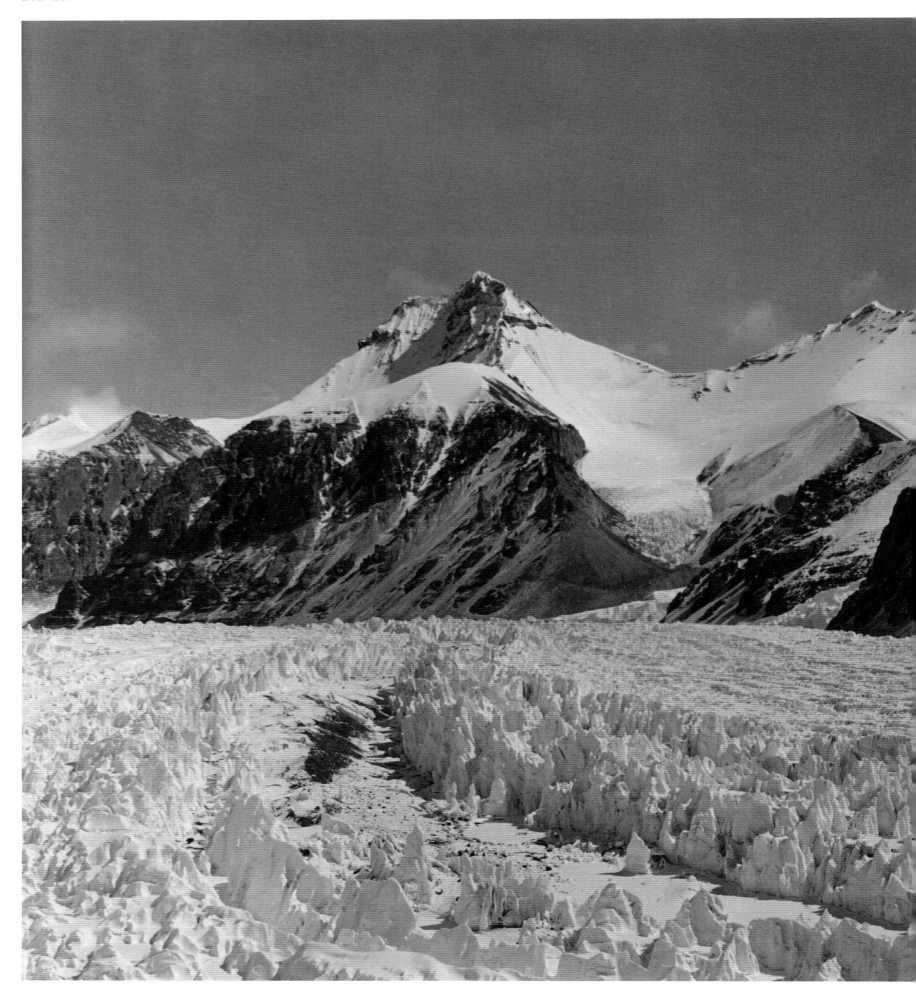

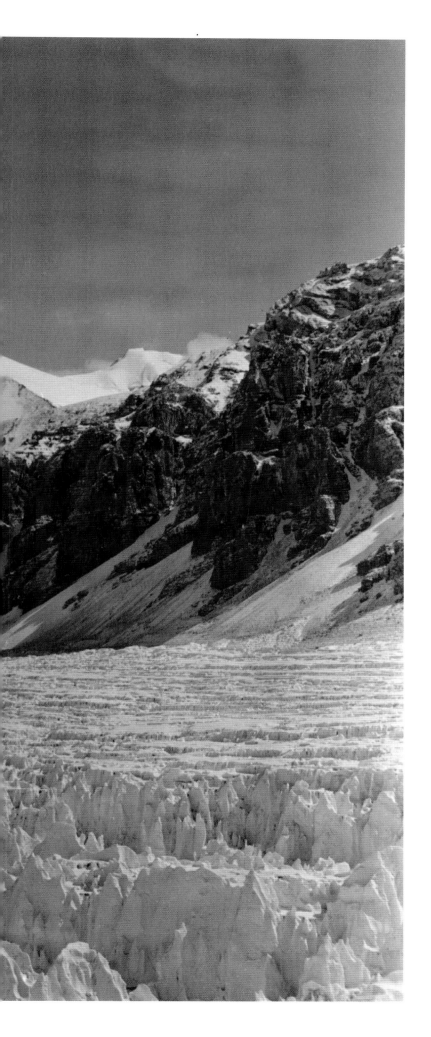

A view from the point where the open upper glacier is reached, looking down the trough in the direction of Camp II.

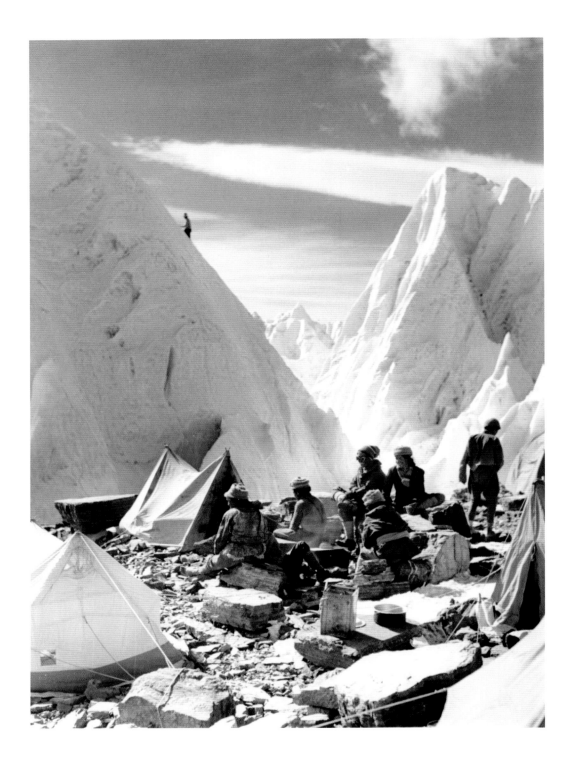

Sherpas enjoy the late afternoon sunshine at Camp II on the East Rongbuk Glacier, while in the background the tiny figure of Peter Oliver practises his step cutting techniques on one of the glacier's spectacular ice pinnacles.

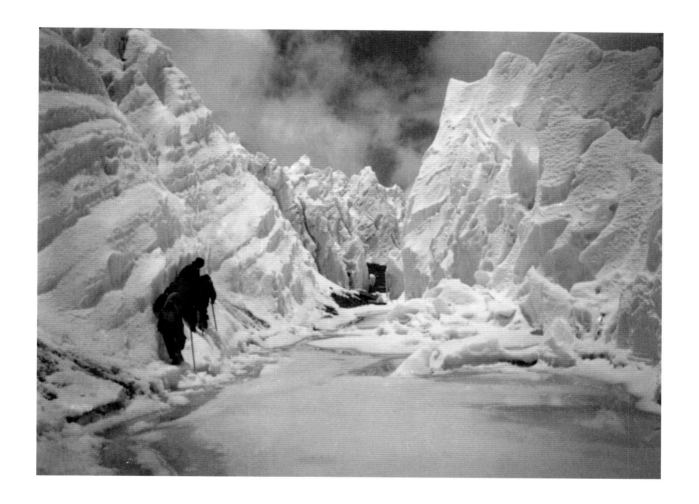

Slowly manoeuvring between the ice pinnacles of the East Rongbuk Glacier beneath the North Peak of Everest.

One of the expedition members picks his way between the peaks surrounding
the main Rongbuk Glacier and western slopes of the North Col.

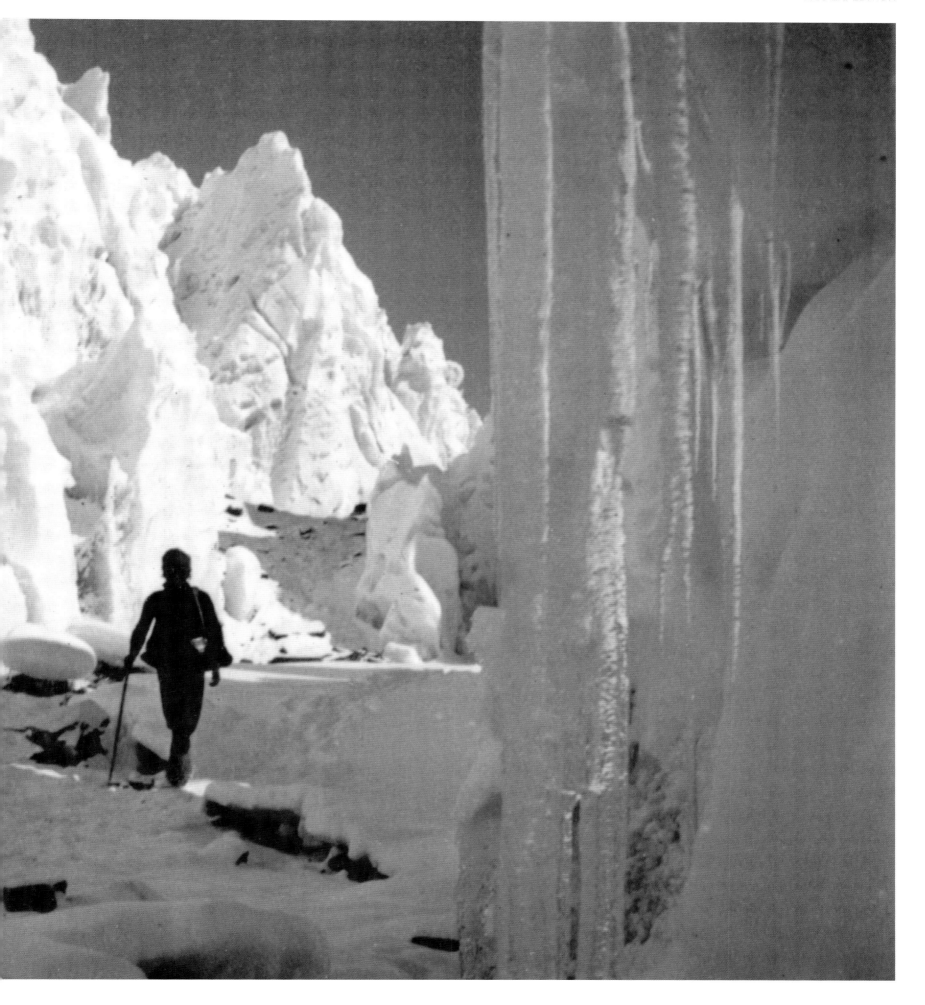

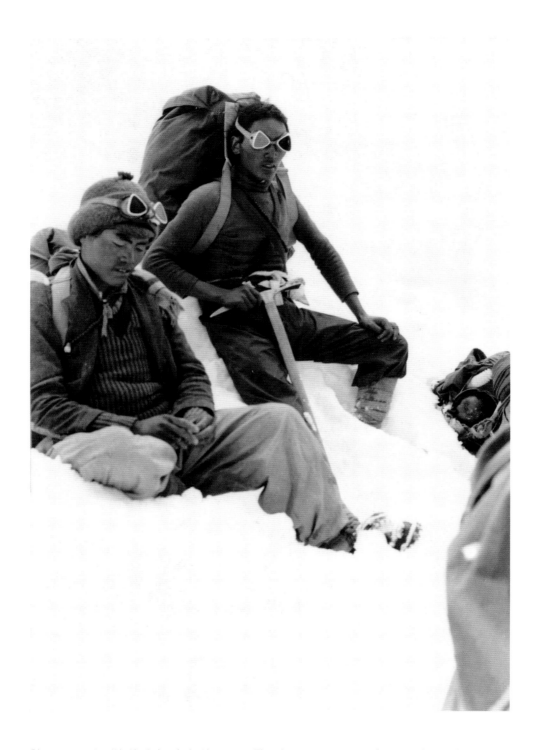

Sherpas rest with their loads in the snow. The deteriorating weather conditions had made some of them anxious, and expedition leader Hugh Ruttledge had become concerned for their safety.

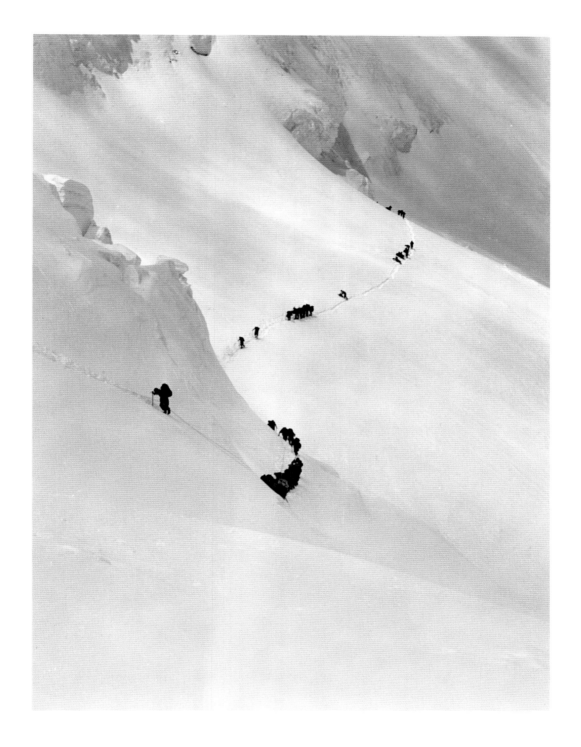

A long column of Sherpas traverses a snow-clad slope on the North Col. In 1936, the monsoon arrived early, depositing large amounts of snow on the mountain and making climbing conditions extremely difficult, such that the expedition had to be abandoned. It was on this slope that Eric Shipton and Percy Wyn-Harris nearly lost their lives in an avalanche.

At a club in Darjeeling, members of the expedition prepare to interview prospective porters.

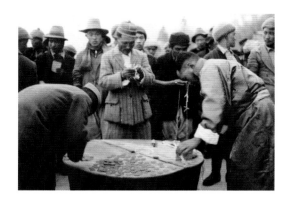

As soon as recruited, each porter was issued with an identity disc in case of subsequent mishap.

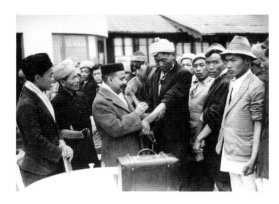

Darjeeling doctor B. Suraj Ram inoculates the porters before they set out for Mount Everest.

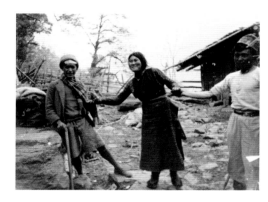

The expedition encountered these Tibetan villagers as they made their way through Sikkim.

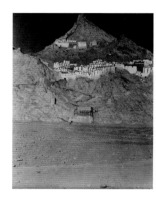

Shekar Dzong (Xêgar) Monastery viewed from the expedition's camp on the plain outside the town.

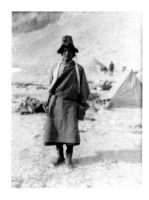

The Tibetan official who ensured smooth progress of the expedition between Shekar Dzong and Base Camp.

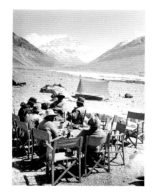

Climbers take lunch al fresco and survey the way ahead: the Rongbuk Glacier and Mount Everest.

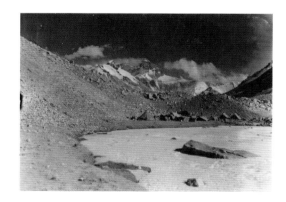

The terminal moraine (the mass of rocks and sediment carried down by a glacier) of the Rongbuk Glacier.

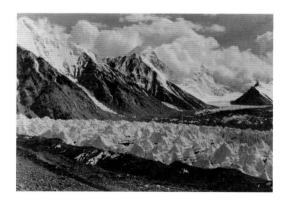

Another view of Mount Everest from the terminal moraine of the Rongbuk Glacier.

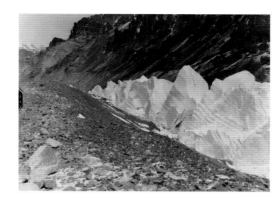

The climbers preferred to eat in the open air whenever possible, but wrapped up warmly at higher altitudes.

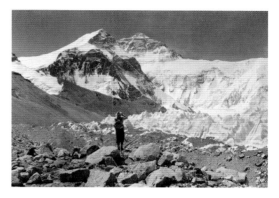

The dramatic and beautiful ice pinnacles of the East Rongbuk Glacier.

A member of the 1936 expedition looks up at the North Col of Mount Everest.

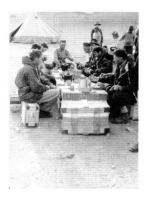

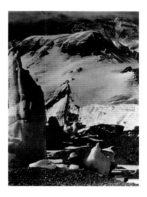

A group of Sherpas near the ice pinnacles of the East Rongbuk Glacier.

This afternoon build-up of cloud is an indication of the imminent monsoon season.

The darkening slopes of Mount Everest seen from the central trough of the East Rongbuk Glacier.

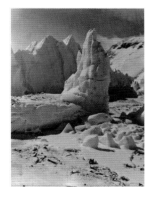

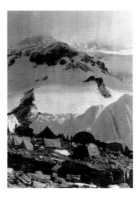

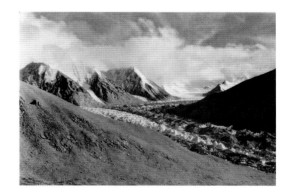

The Rongbuk Glacier is dotted with and flanked by long lines of ice pinnacles like these.

The 1936 expedition's Camp I at around 20,000 feet (6,096 metres). Mount Everest hides in cloud above.

This view of the main Rongbuk Glacier was taken from above the 1936 expedition's Camp I.

1938 Expedition

Bill Tilman was chosen to lead the 1938 Everest Expedition and, like Eric Shipton, he was a believer in small-scale, low-cost efforts. Consequently, his team comprised only six other climbers: Peter Lloyd, Noel Odell, Peter Oliver, Shipton, Frank Smythe and Charles Warren. All but Lloyd were veterans of previous Everest expeditions.

Mindful of the 1936 expedition's experience with the early arrival of the monsoon, the team planned an early assault on the mountain, arriving at Rongbuk on 6th April. The expected lull between the ferocious winter winds and the onset of the monsoon never occurred, however, and from the start they had to contend with bad weather conditions, as well as colds and flu. They retreated to the Kharta Valley to recuperate.

When the wind eventually dropped on 5th May, it began to snow. By the time the team returned to the mountain in mid-May, it was cloaked in snow, making climbing conditions very difficult. Nevertheless, they were on the North Col by the 24th and eventually began working their way up the North Ridge through knee-deep snow. Over the following days, they established two more camps, the highest at 27,200 feet (8,290 metres). From there, it was obvious that the conditions at the Summit were too bad, although attempts were made to reach the Northeast Ridge. Each was driven back by the snow and wind.

With one porter at the North Col camp having contracted pneumonia and another having suffered a stroke, they had no option but to abandon any further attempt that year. It would be 15 years before another expedition was sent to scale the world's highest peak, and the outcome would be very different.

While his companions wait at a respectable distance, a climber on the 1938 expedition carefully probes a snow bridge over a crevasse.

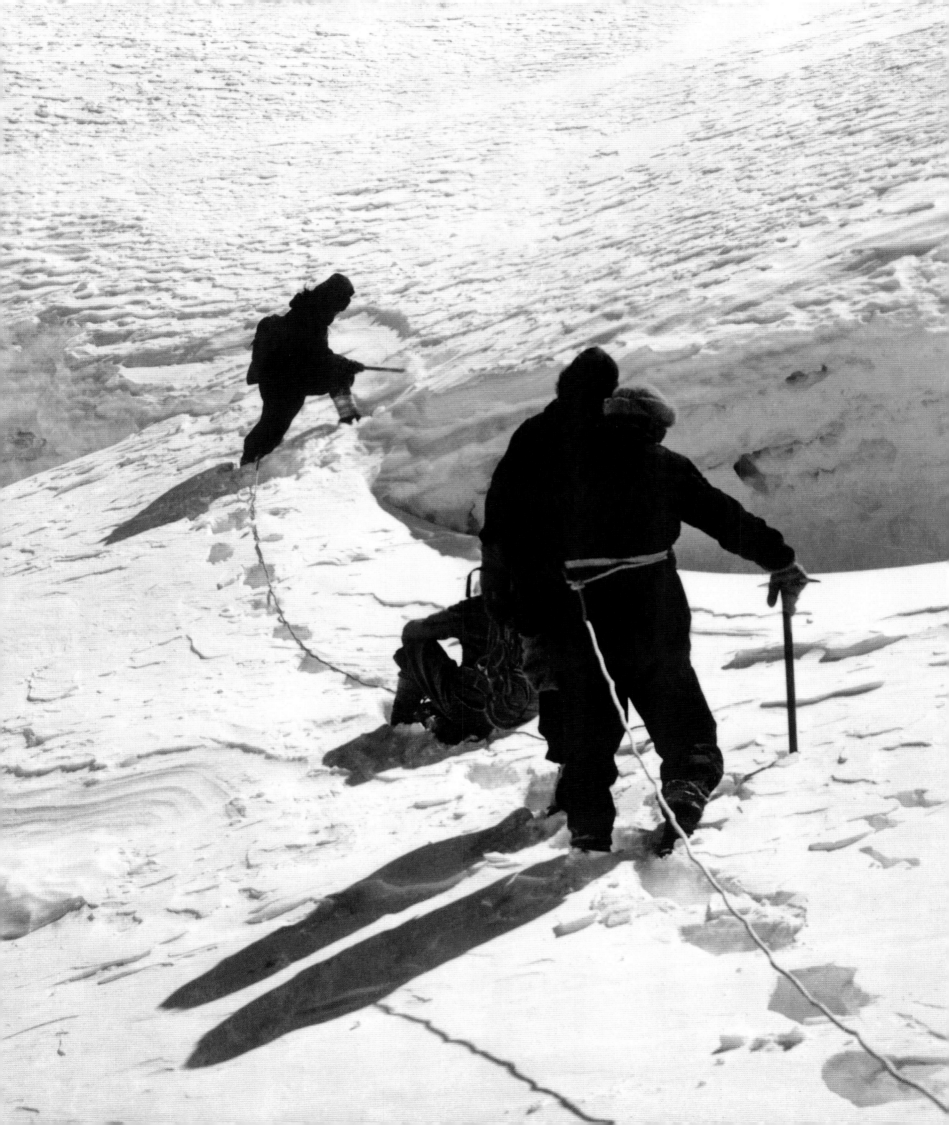

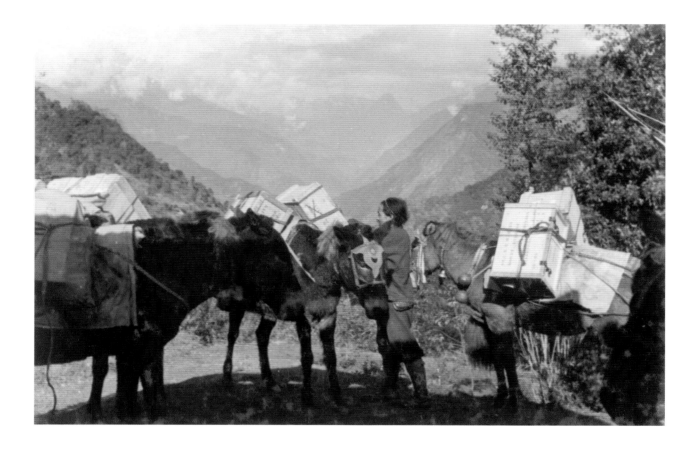

Mules are loaded with supplies in Sikkim before setting off for Mount Everest. The most common pack animals for rougher terrain, however, were yaks.

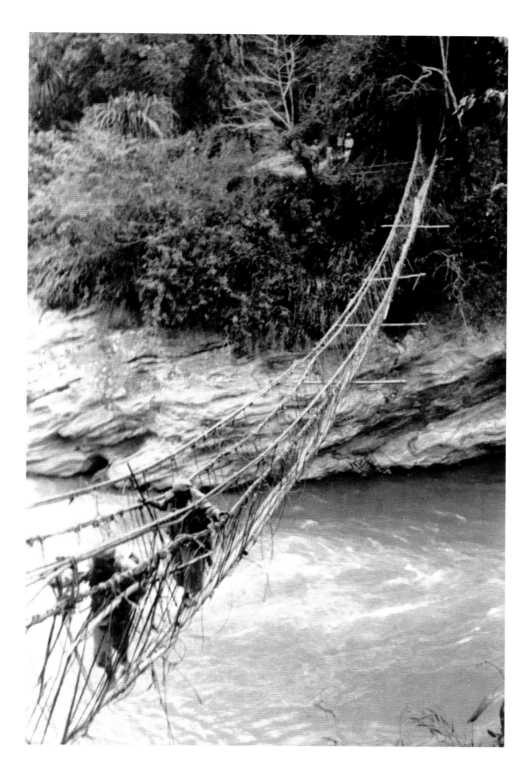

During the trek to the mountain, the expedition encountered this cane bridge in Sikkim.
Transporting the necessary stores and equipment to support the early attempts on
Everest was a difficult task in itself.

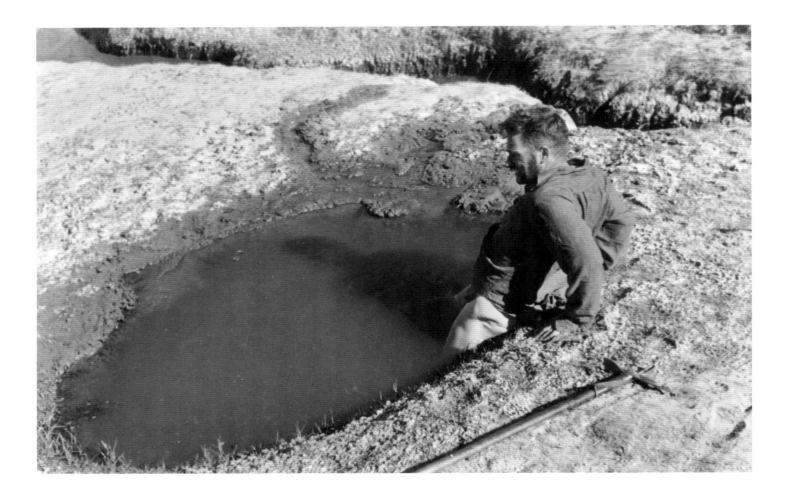

On the trek to the mountain, a member of the expedition enjoys the delights of bathing in a local hot spring.

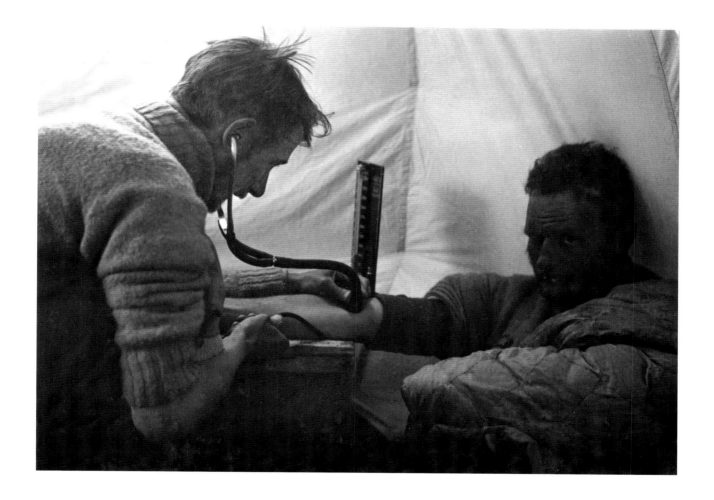

Charles Warren, a qualified doctor as well as experienced alpine climber, takes Eric Shipton's blood pressure during a medical check. Colds and flu dogged the early stages of the expedition, such that some members had to retreat to lower altitudes to recover.

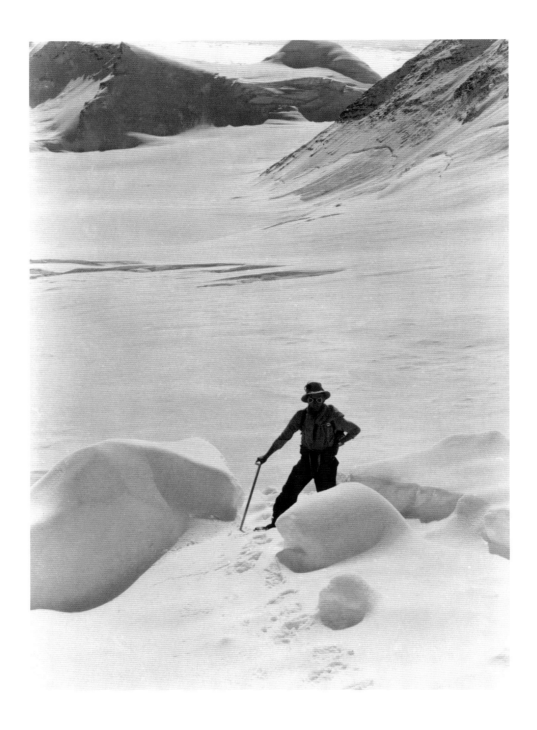

A member of the expedition stands in the snow among the remains of an avalanche. The loose, powdery nature of the snow, which fell in large quantities during the expedition, made such disasters extremely likely and the Summit attempt far too dangerous.

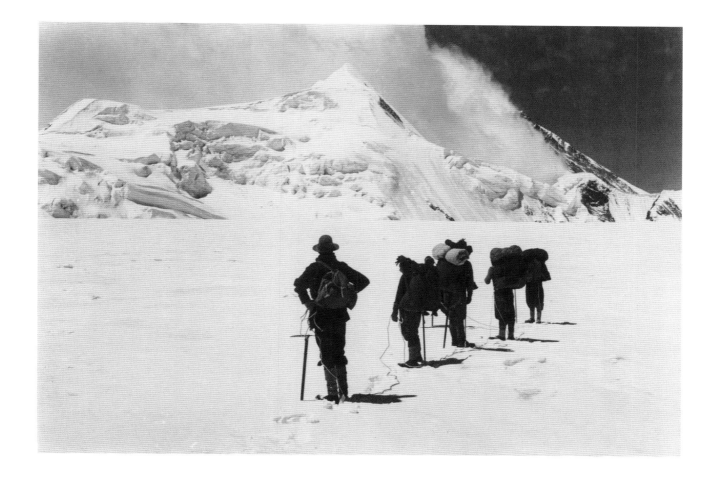

Peter Oliver leads a group of Sherpas down the eastern descent via the Lhakpa La Pass, with Everest shrouded in cloud behind. Several members of the expedition followed this route down to the Kharta Valley, where they were able to throw off the colds, sore throats and other flu-like symptoms that had dogged them during the early stages of the expedition.

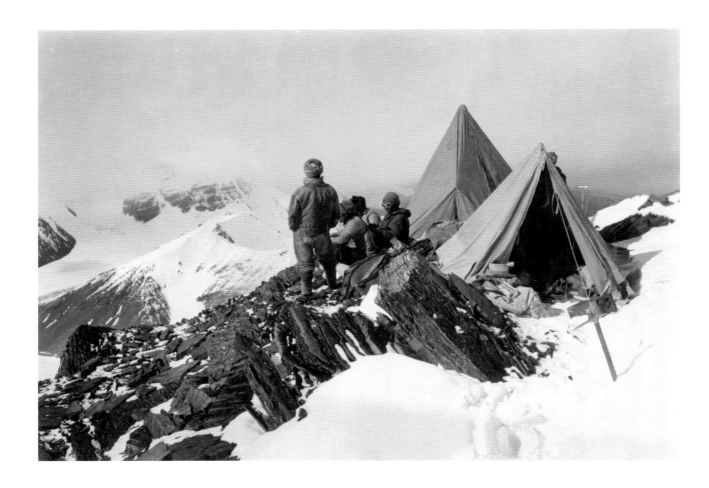

Sherpas contemplate the mountains in the distance from one of the camps established for the ascent. The expedition used pyramid tents at higher altitudes. Although heavy, they were very stable in the strong winds that were encountered on the mountain.

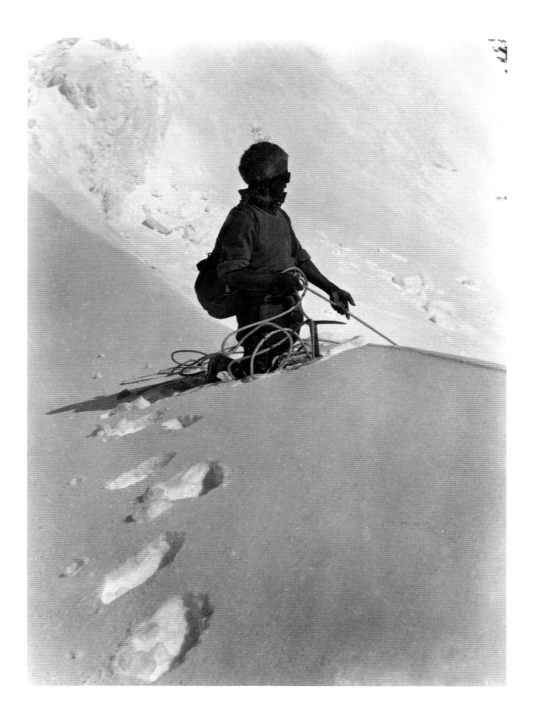

A Sherpa in deep snow controls the rope while an unseen partner below climbs. Widespread deep, unpacked snow on the mountain ultimately defeated the 1938 expedition and there were no more official British attempts for 13 years.

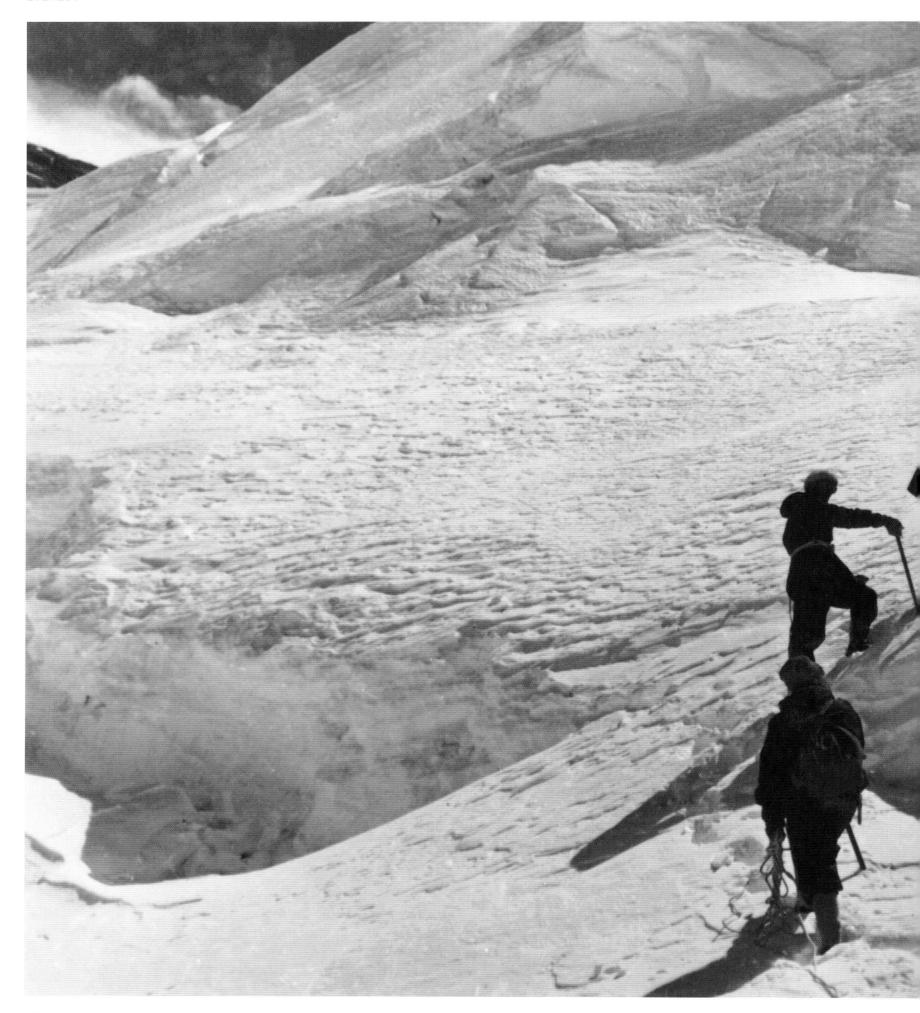

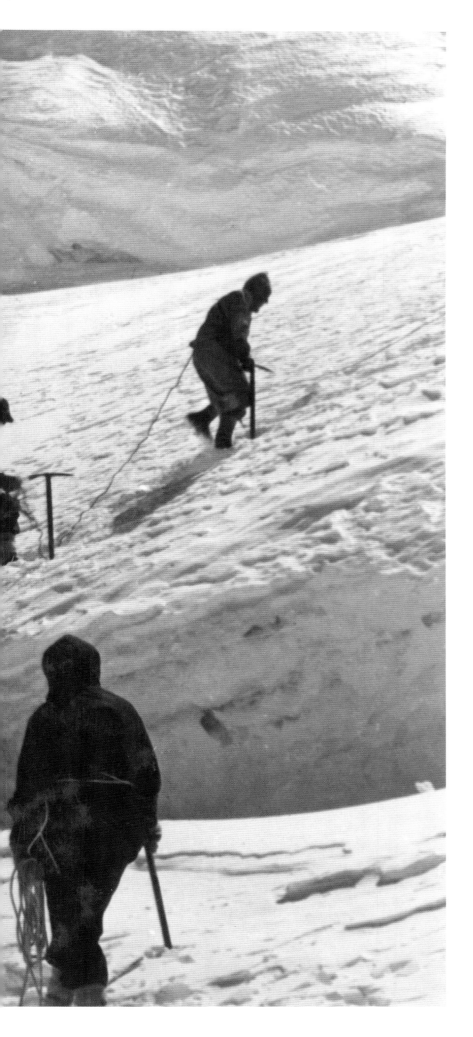

A party of Sherpas, roped together, carefully climbs up through a snowfield. Snow had come early to the mountain in 1938, as it had done in 1936. In some cases, the climbers had to wade through waist-deep powdery snow with the ever-present danger of avalanche.

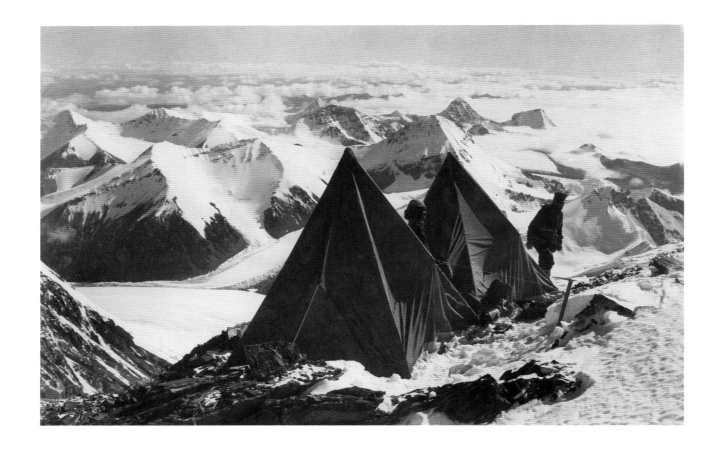

Camp V at 25,800 feet (7,863 metres). The double-skinned pyramid tents were of a style used by Arctic and Antarctic expeditions, and were easy to erect in the wind. In very strong winds, however, Harold Tilman, the expedition leader, reported that they flapped so much that it was impossible to sleep at night.

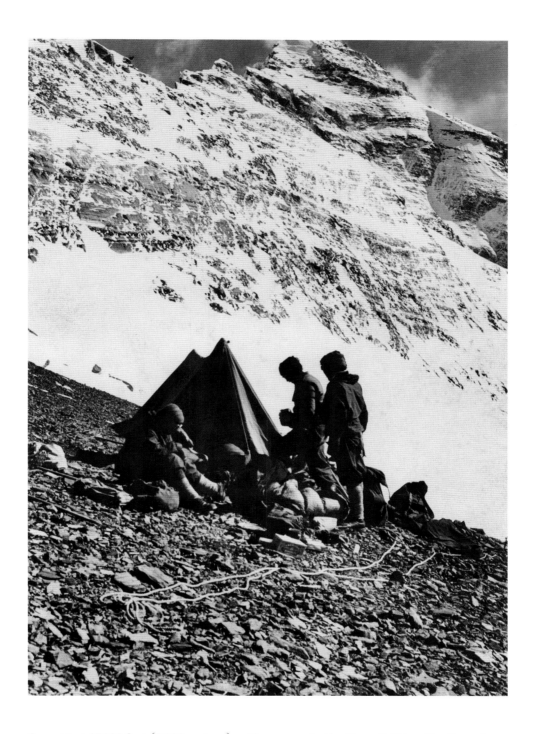

Camp VI at 27,200 feet (8,290 metres) on the way up to the Summit Ridge, the Summit of Mount Everest making a towering backdrop. Although Tilman and Lloyd attempted to make further progress and reach the Summit Ridge, the terrain and low temperatures proved impossible to overcome.

Lepchas (also known as Rongs), a small ethnic group in Sikkim, and also in Nepal and Bhutan.

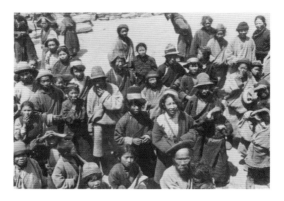

The Tibetans were as fascinated by the mountaineers as the mountaineers were by them.

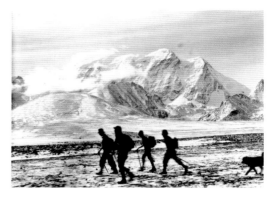

With canine escort, members of the 1938 expedition advance through Sikkim en route to Tibet.

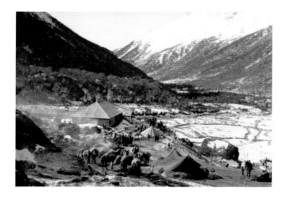

The expedition makes camp in Sikkim during the trek to Everest.

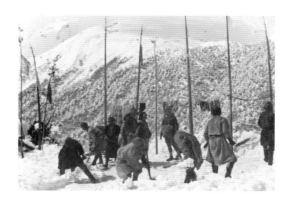

Shovelling recently fallen snow in the relatively low hills of Sikkim.

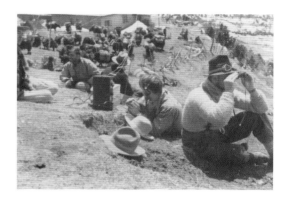

Members of the expedition test their wireless equipment, a vital link with the world below.

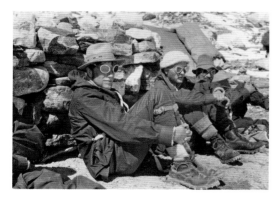

Expedition members in snow goggles take the weight off their feet during the trek to the mountain.

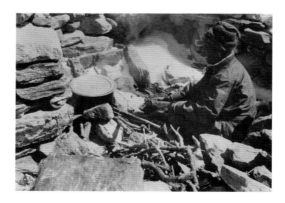

Haute cuisine: a Sherpa cooks a meal on an open fire at altitude in the Himalayas.

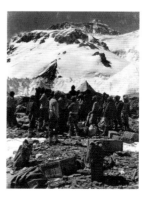

Climbers and Sherpas gather at Base Camp prior to getting to work.

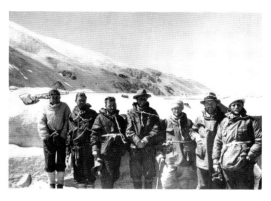

The climbers of 1938: (L–R) Warren, Lloyd, Tilman, Oliver, Smythe, Odell, and Shipton.

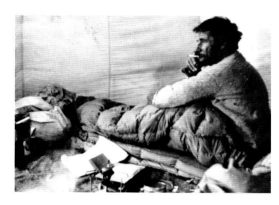

Bill Tilman smokes a cigarette while warming his lower body in a sleeping bag.

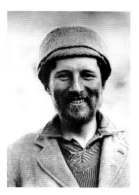

Geologist Noel Odell was a veteran of the ill-fated 1924 expedition, when Mallory and Irvine disappeared.

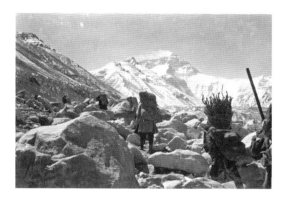

Trudging through and around glacial rock deposits on the route between Base Camp and Camp I.

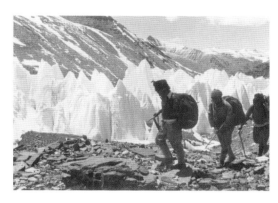

Sherpas with the 1938 expedition advance alongside the ice pinnacles of the East Rongbuk Glacier.

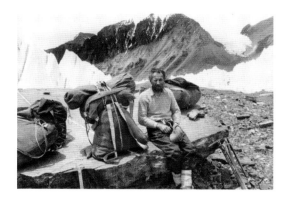

Another quick break on a relatively flat stretch of the glacier, but there's hard going ahead.

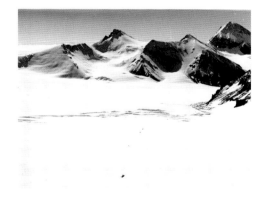

Leaving Camp III behind, the expedition attacks the slope leading to the North Col.

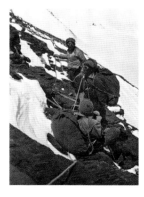

A group of heavily-laden Sherpas climbs the North Ridge of Mount Everest.

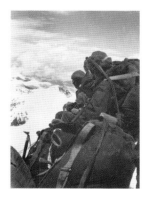

Sherpas take in the view as they rest for a while on the North Ridge of Mount Everest.

1953 Expedition

By 1951, Tibet had been occupied by Communist China and no longer welcomed Westerners, but at last Nepal had opened its frontiers, providing access to the south side of Everest. That year, a reconnaissance expedition was sent to the region, led by Eric Shipton, to seek a potential route to the Summit. Among its members was an experienced climber from New Zealand called Edmund Hillary. This was followed by a training expedition to the area, also under Shipton, while awaiting the outcome of two Swiss attempts to reach the Summit in 1952, both of which failed. Accompanying the Swiss climbers was a Sherpa by the name of Tenzing Norgay.

Thus, in 1953, the way was clear for the British to have another crack at Everest. A strong team was assembled under the leadership of experienced mountaineer and professional soldier John Hunt. Hillary was among the climbing party, as was Tenzing, who was also employed as sirdar of the Sherpas.

Profiting from the Swiss experience the previous year, Hunt's men worked their way up the Khumbu Glacier, through its fearsome Icefall and across the Western Cwm to the foot of the Lhotse Face. They scaled the face, traversed the steep ice slope above and finally reached the wind-blasted South Col. From a camp here, two attempts were made on the Summit. The second, by Hillary and Tenzing, put them on top of the world at 11.30am on 29th May, 1953. Mighty Everest had been tamed at last.

This Indian Air Force photograph of the south-west face of Everest shows the route of the successful ascent of the mountain. In the foreground is the Khumbu Glacier, into which runs the icefall from the snow-covered Western Cwm.

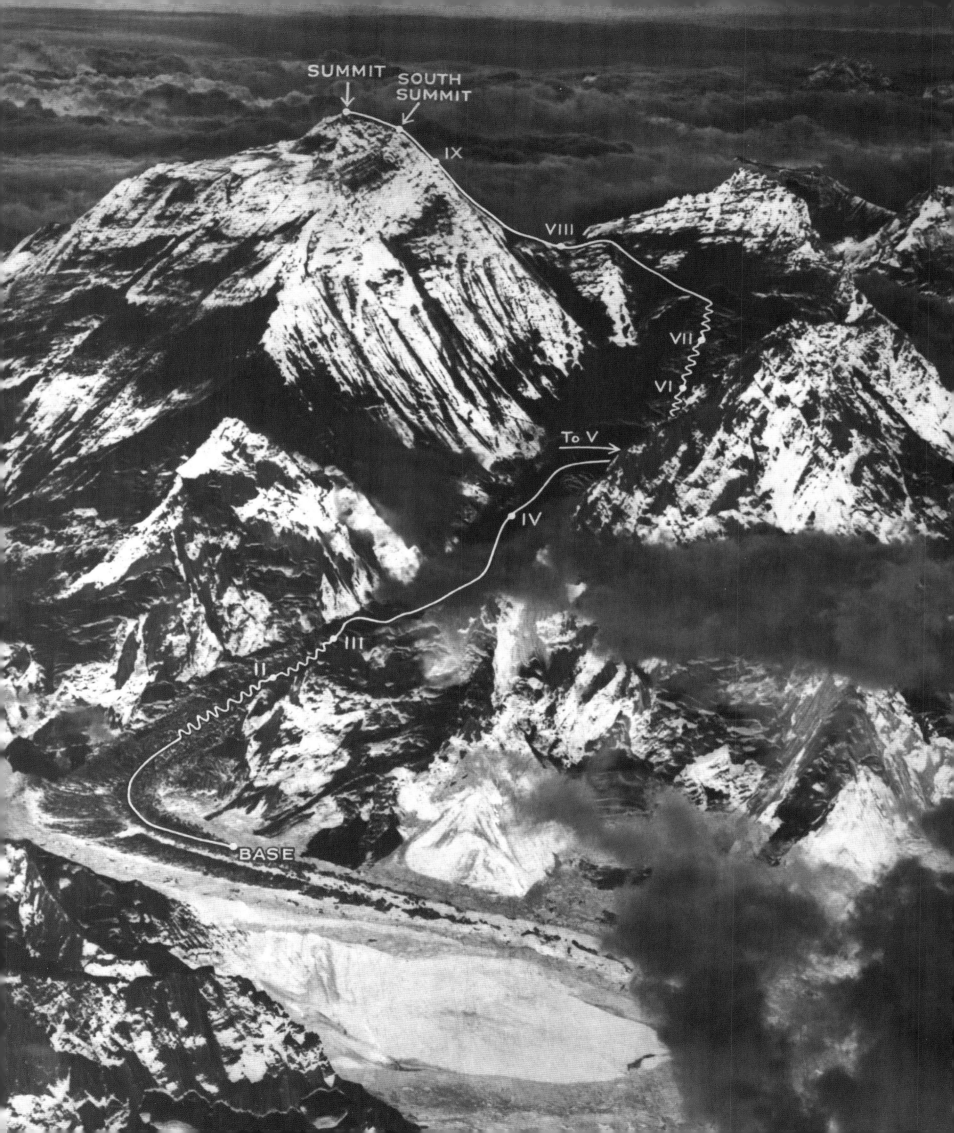

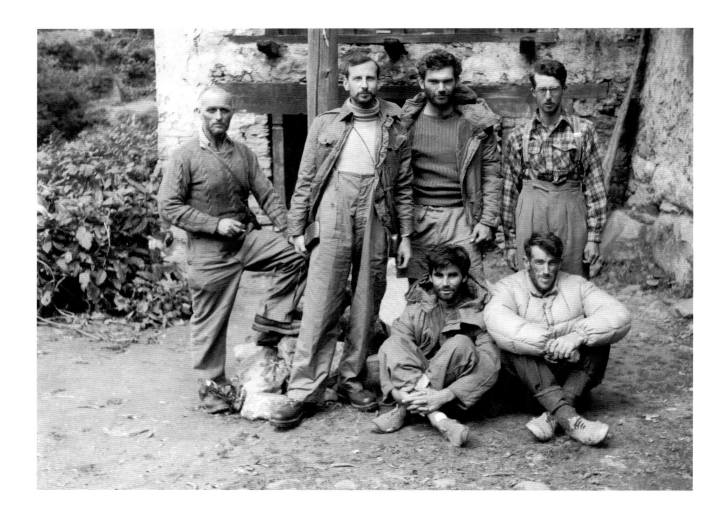

In 1951, the RGS sent a small expedition to Everest to reconnoitre new routes to the Summit from the Nepalese side of the mountain: (standing, L–R) Eric Shipton, Bill Murray, Tom Bourdillon, Earle Riddiford; (sitting, L–R) Mike Ward, Edmund Hillary.

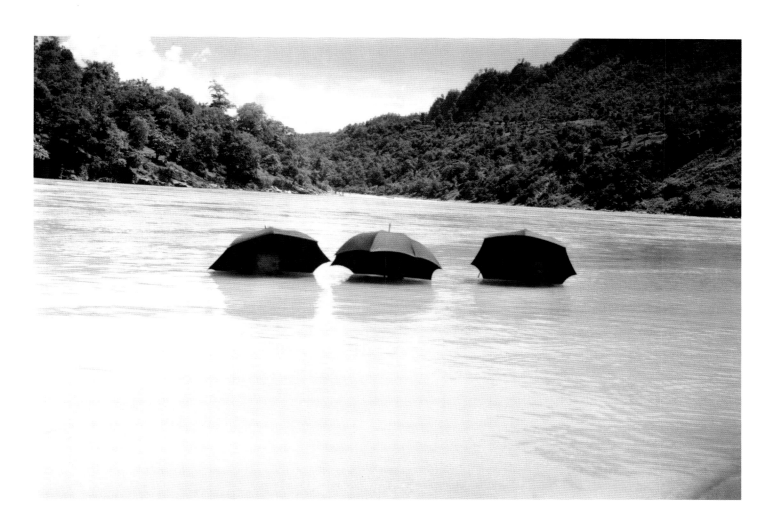

The heat of the valleys in Nepal came as a surprise to the 1951 expedition. One of the ways in which they sought refuge was to bathe in the Arun River under umbrellas. L–R: Eric Shipton, Michael Ward, Bill Murray.

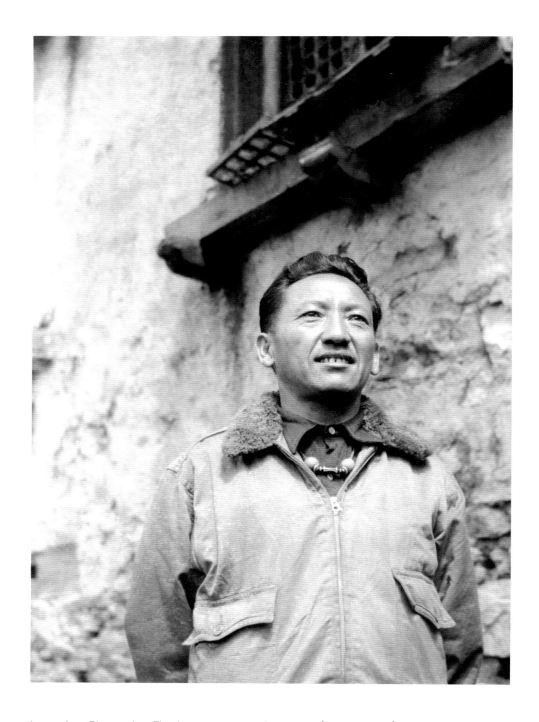

Legendary Sherpa Ang Tharkay was engaged as sirdar (head Sherpa) by the 1951 reconnaissance expedition. He was a veteran of several major expeditions in the 1930s.

Nestled on a small plateau among the mountains, the village of Thyangboche and its monastery was a jumping-off point for the expedition's trek to Base Camp.

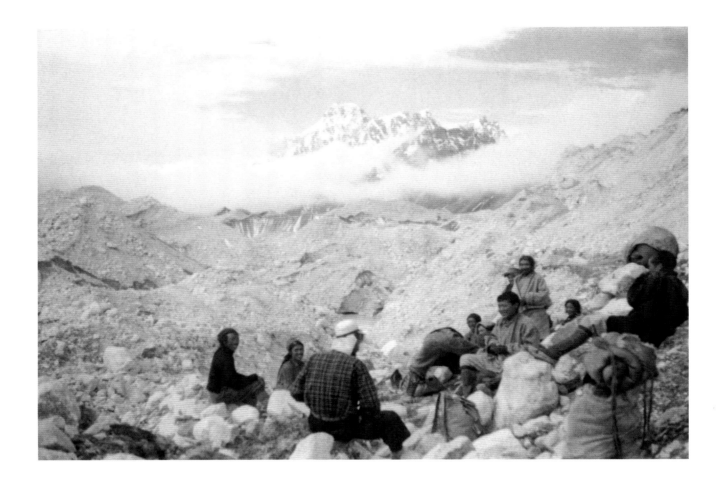

The climbers and Sherpas take a break among the broken rocks of a moraine on their way to Base Camp. Shipton was a great believer in small, lightly-equipped expeditions, but they still needed the Sherpas to help ferry their equipment.

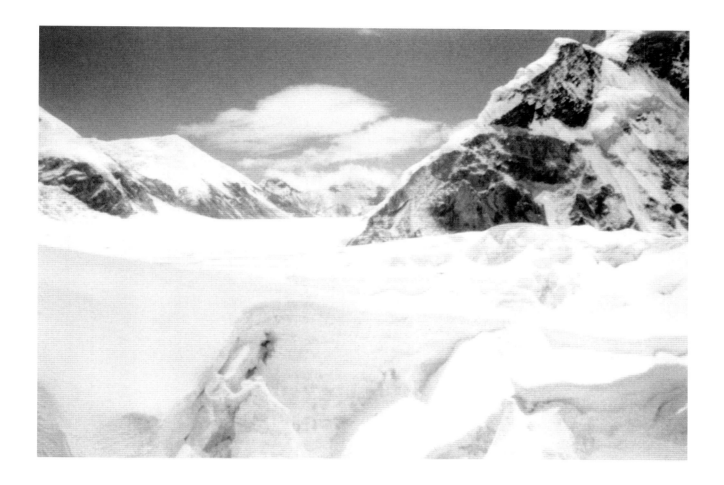

The Khumbu Icefall. Finding a route through this jumble of ice and rock was the first major task for the expedition. In the early days of exploration around the mountain, it had been considered impassable.

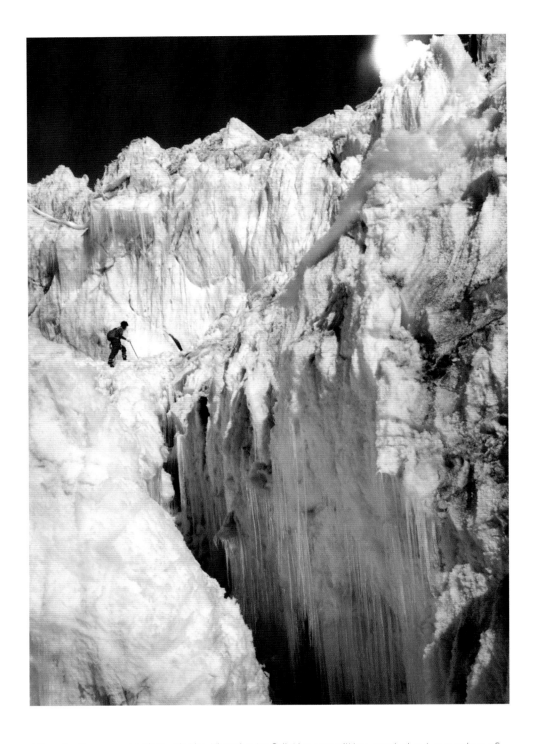

After finding a route through the Khumbu Icefall, the expedition carried out a number of explorations of the surrounding mountains, encountering this icefall on the route to the Nup La Pass on the border with Tibet.

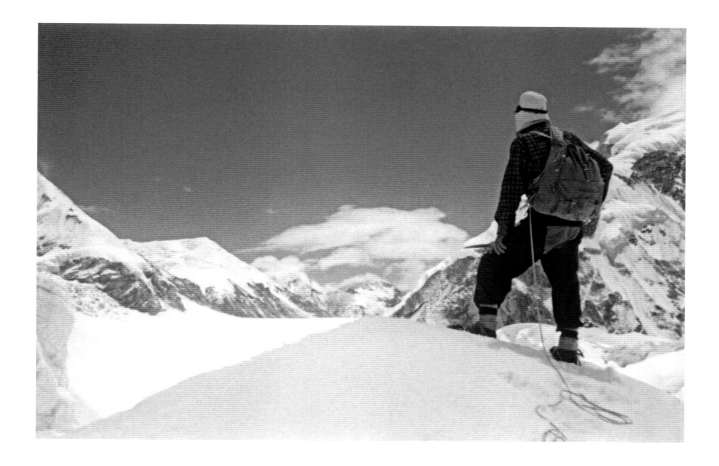

Edmund Hillary surveys the snow-clad peaks in the Everest region during the 1951 reconnaissance expedition. He and
Earle Riddiford, both members of the New Zealand Alpine Club, had been invited to join the expedition at the last minute.

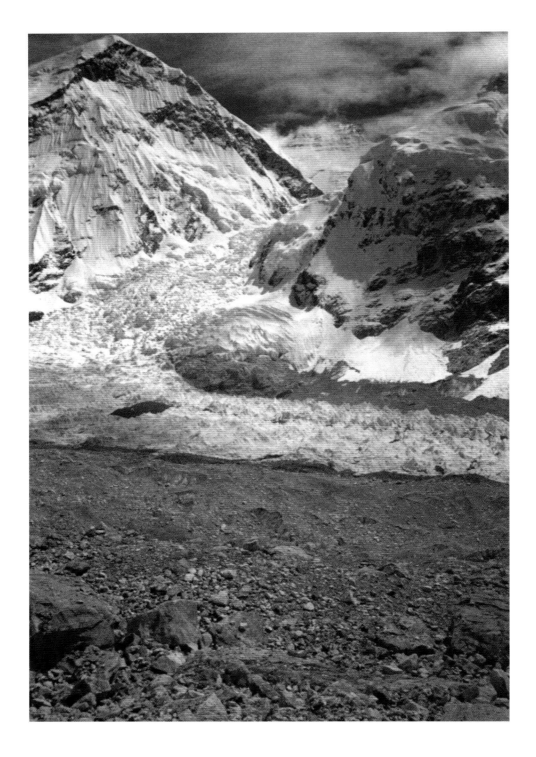

Everest (L) and Lhotse (C), showing the Khumbu Glacier, which flows like a river of ice from the 'hidden' valley of the Western Cwm. The way to the Summit began with finding a route through this frightening and confused jumble of ice, snow and rocks.

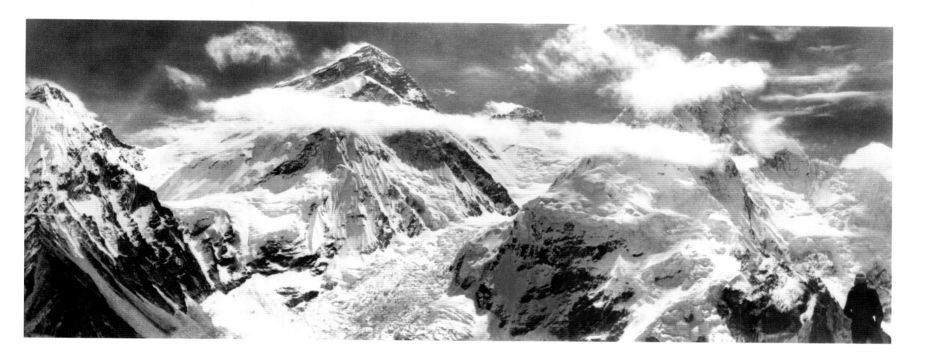

Seen from the peak of Pumori, Everest (C), wreathed in cloud, towers above the Khumbu Icefall. To the right of Everest, in the background, is the daunting Lhotse Face, which would have to be scaled by any expedition seeking the Summit by this route.

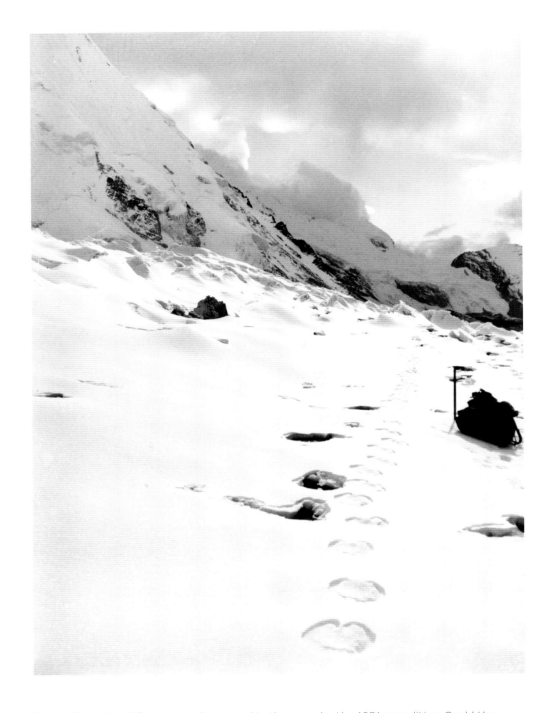

A mystifying line of footprints discovered in the snow by the 1951 expedition. Could they have been made by the mythical 'Yeti' or, as seems more likely, a Himalayan brown bear?

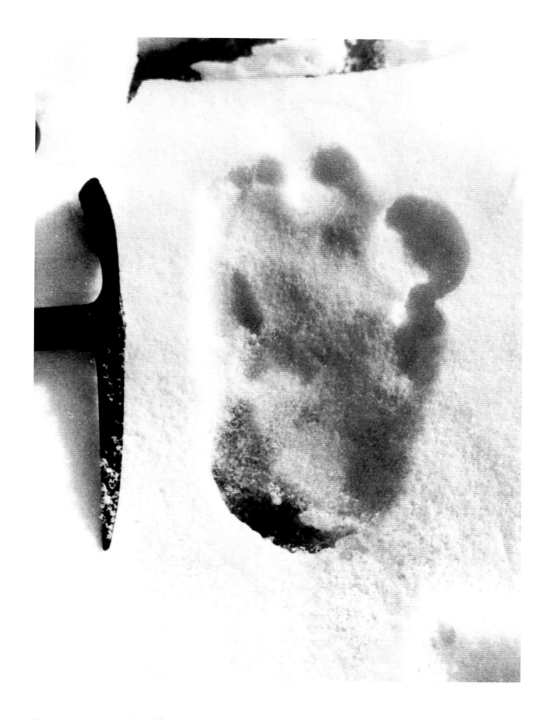

Hoax or a genuine 'Yeti' footprint? Eric Shipton, leader of the 1951 Everest reconnaissance expedition, took this photograph of a strange print in the snow while exploring Melung Chu, east of Everest. It has been suggested that he faked it as a joke to convince newspapermen of the existence of the 'Abominable Snowman'.

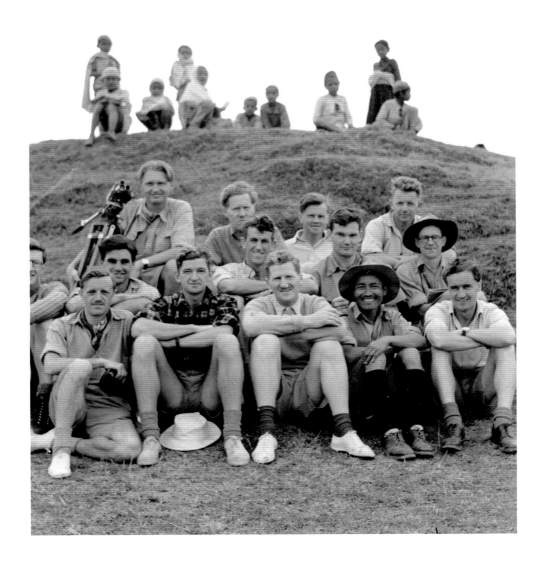

The climbing members of the 1953 expedition photographed at Bhadgaon (Bhaktapur) in the Kathmandu valley, during the trek to the mountain. Back row, L–R: Tom Stobart, Lewis Pugh, Wilfrid Noyce, Charles Evans. Middle row, L–R: George Band, Michael Ward, Edmund Hillary, Tom Bourdillon, Michael Westmacott. Front row, L–R: Alfred Gregory, George Lowe, John Hunt, Tenzing Norgay, Charles Wylie.

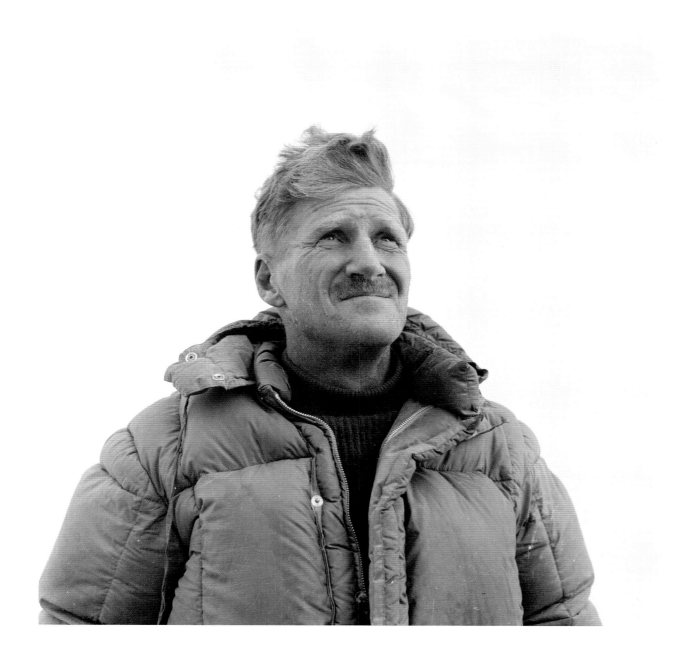

John Hunt, leader of the 1953 Everest expedition. A professional soldier, Hunt had applied for a position on the 1936 expedition, but had been turned down on medical grounds – the doctors told him to be careful climbing the stairs! He brought military methodology to the organisation of the expedition.

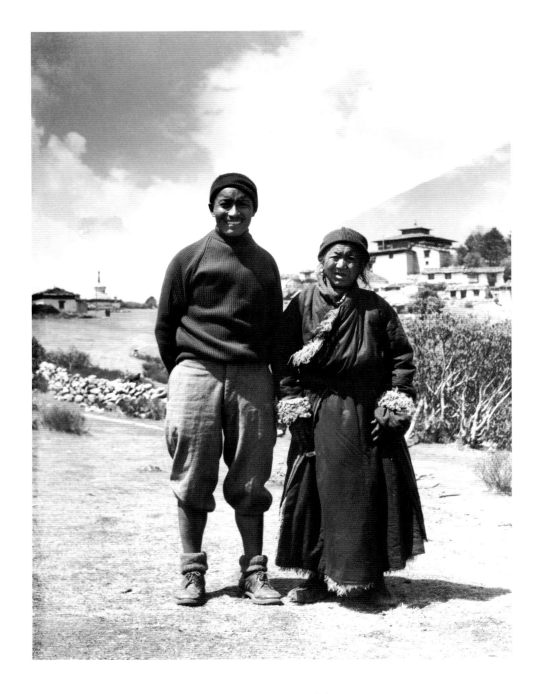

Before setting out on the expedition, Tenzing Norgay (L) sought the blessing of his mother, Kinzom, at Thyangboche Monastery. She wanted to be sure that he was fit and well enough to go; having satisfied herself, she returned to her home.

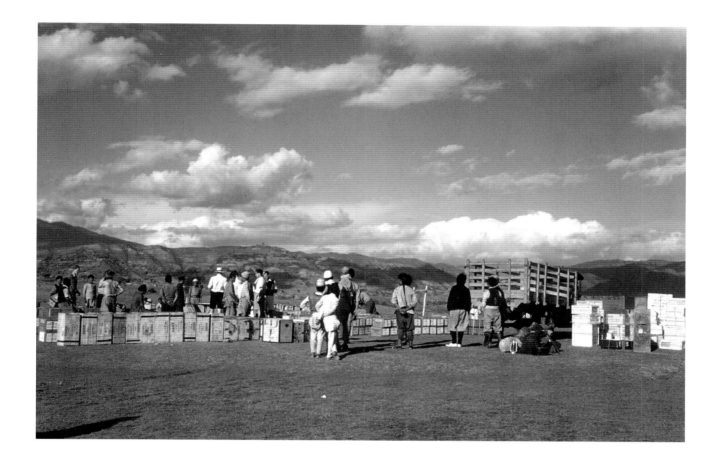

Members of the expedition check and sort through their stores and equipment at the town of Bhadgaon. Around 13 tons of baggage accompanied the expedition. Hundreds of porters were needed to transport it all to Base Camp.

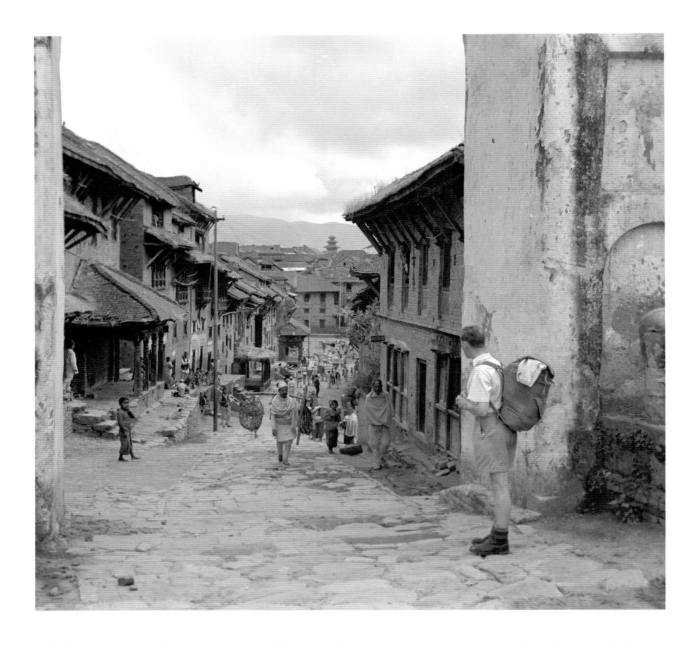

Wilfrid Noyce explores the narrow streets of Bhadgaon. The ancient town was once the capital of Nepal and is the third largest city in the Kathmandu valley.

Tenzing Norgay at Bhadgaon, where the expedition was preparing to set off on the trek to Base Camp. At the time, he was one of the most experienced Sherpas alive and was put in charge of the high-altitude porters. He was also included in the climbing group.

Near Jumbesi, Nepal, George Lowe looks out across the Himalayas; in the foreground, the rock has been inscribed with a Buddhist prayer, a mani, as an offering to local spirits.

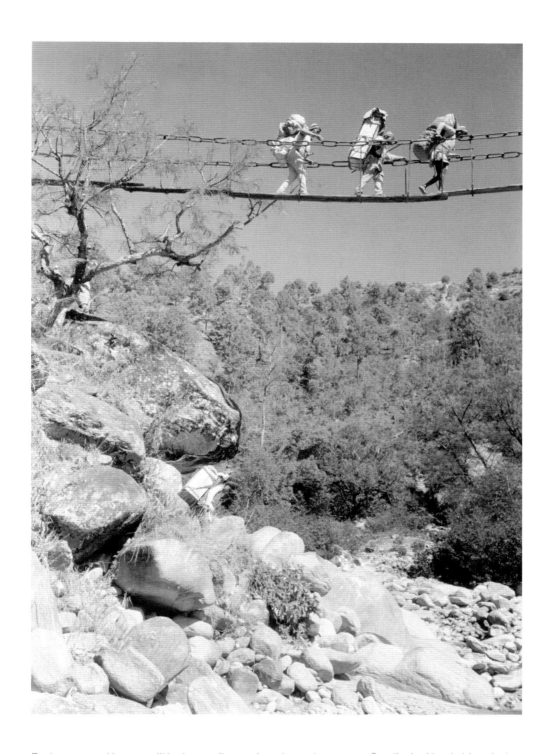

Porters carry the expedition's supplies and equipment across a fragile-looking bridge during the trek to the mountain.

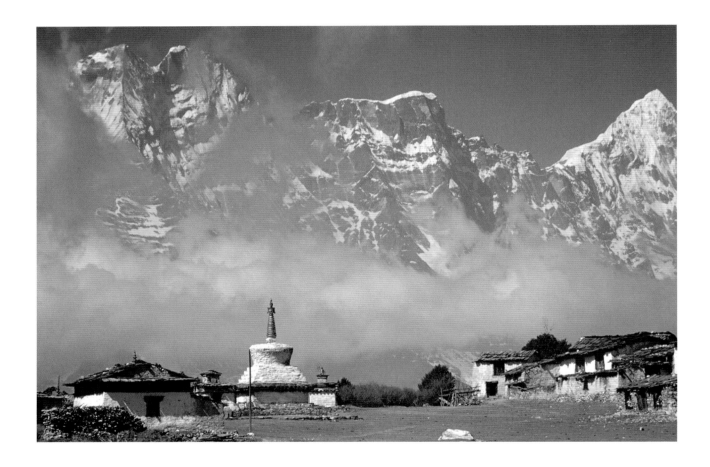

The stupa, or chorten, at Thyangboche Monastery seen against the towering backdrop of the Himalayas. The golden-topped structure contains Buddhist relics and is used as a place of meditation. It was at this monastery that Tenzing Norgay studied to become a monk before finding a topographically higher calling.

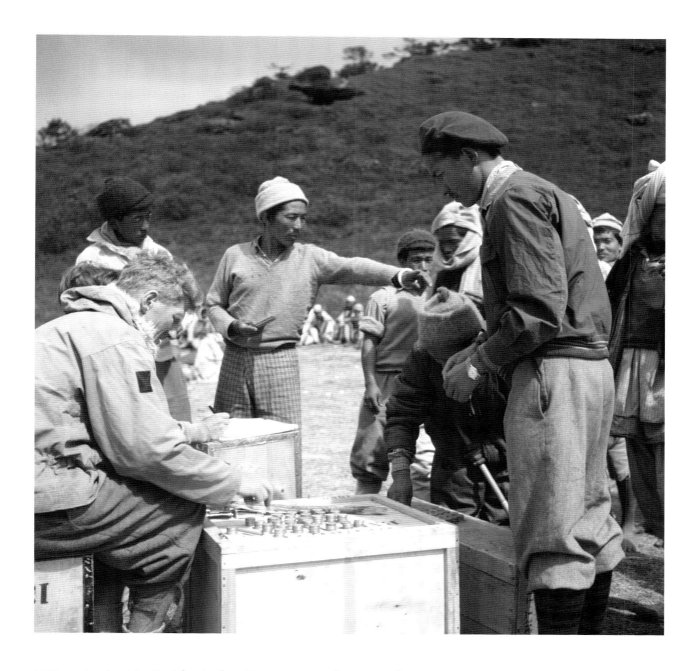

At Thyangboche, John Hunt (seated) and Tenzing Norgay (standing, R) hand out wages to the low-altitude porters. As George Mallory had remarked 30 years previously, "these Sherpas' power surpassed all expectations; they were worth every srang."

Inquisitive Nepalese children peer through the open doorway of a tent at the expedition's camp at Thyangboche. For years, the parties of Westerners bent on climbing in the Himalayas had mystified local people.

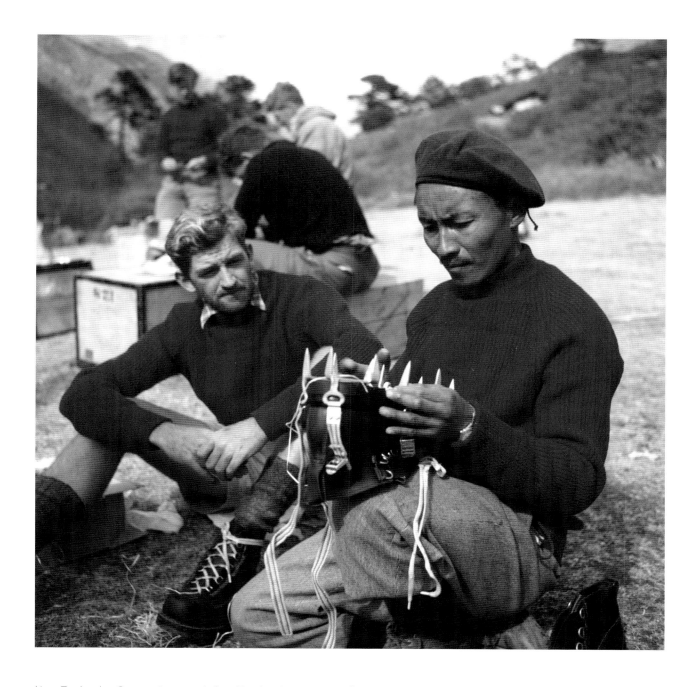

New Zealander George Lowe watches Tenzing Norgay test-fit crampons to his new climbing boots at the expedition's camp alongside the monastery at Thyangboche, where they stayed for three weeks to acclimatise to the mountains. The metal spikes provided good grip when climbing on ice and snow.

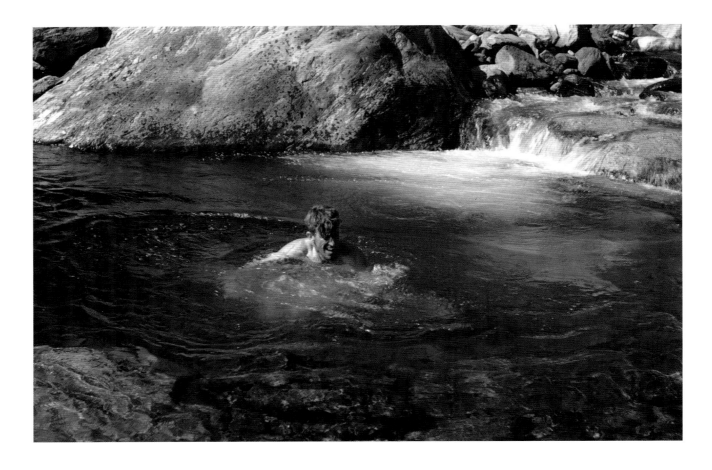

Any water that wasn't frozen was warm enough to bathe in. At least, that seems to have been the view of Edmund Hillary, seen here apparently enjoying a bracing dip in a mountain stream.

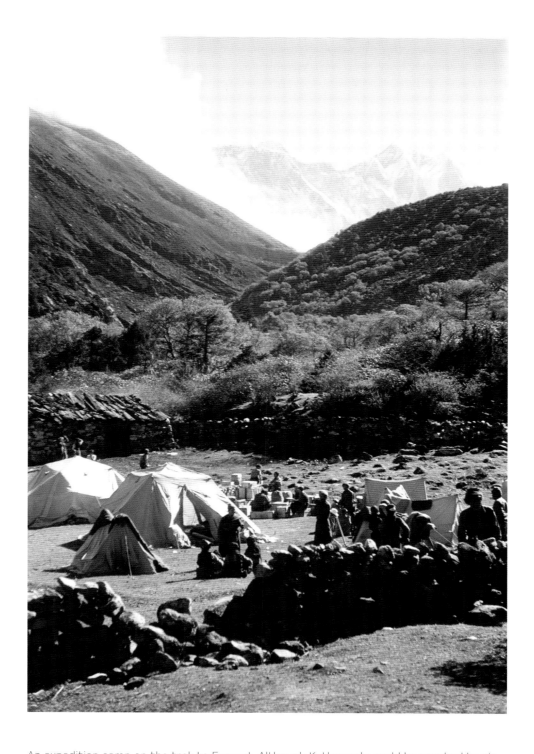

An expedition camp on the trek to Everest. Although Kathmandu could be reached by air
in 1953, unlike in the 1930s, there was still a considerable march to be made to reach Base
Camp at the foot of the Khumbu Glacier.

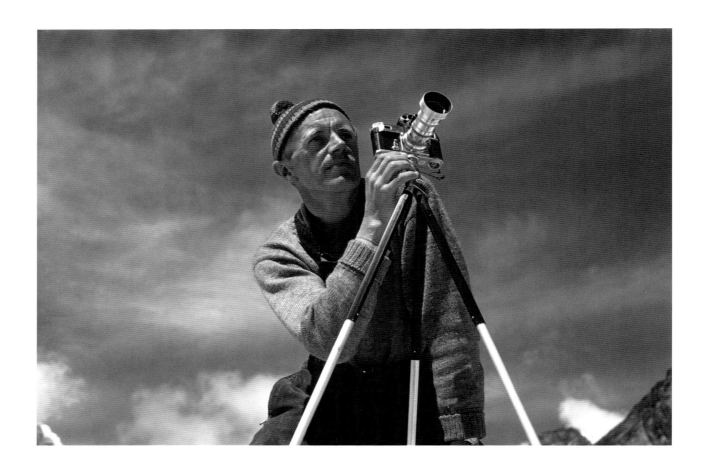

Photographer Alfred Gregory, who accompanied the expedition to 28,000 feet (8,500 metres). His book, 'The Picture of Everest', later became a bestseller.

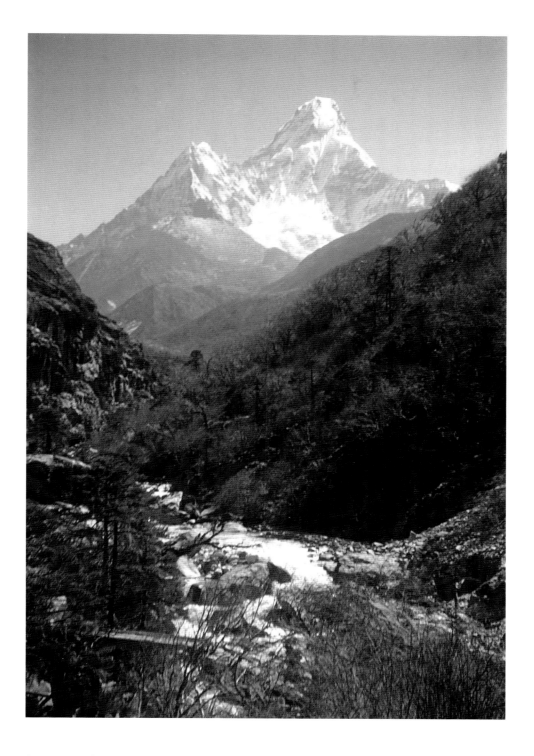

A scene on the approach to the expedition's Base Camp. The Imja River tumbles through a rocky valley while in the background the snow-covered peak of Ama Dablam soars into the blue sky.

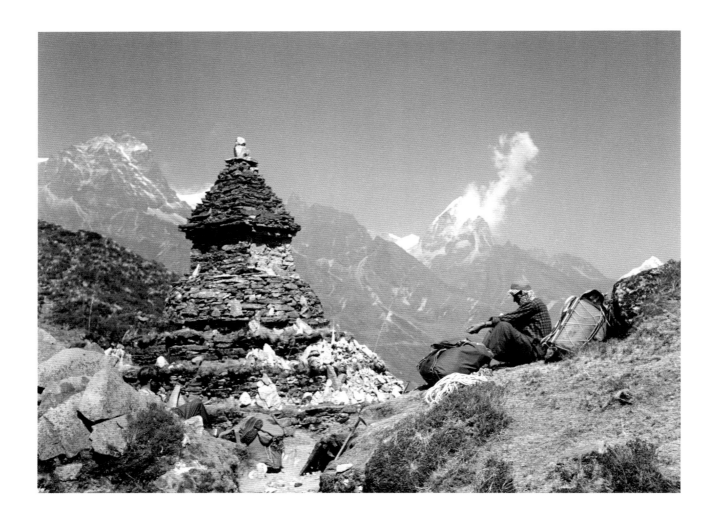

Edmund Hillary (R) and other expedition members break their march to the mountain at a Buddhist stupa, an apt place to relax and spend a little time in quiet contemplation.

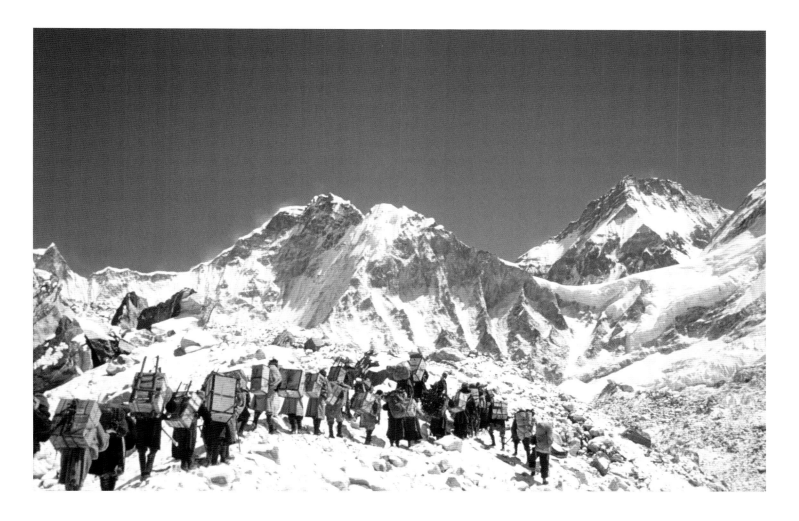

A long line of porters, laden with supplies, makes its way through the broken terrain towards the expedition's Base Camp. Around 10,000 pounds (4,536 kilograms) of equipment and stores were transported by 362 men and women.

Mike Westmacott, who had served with the Indian Army in Burma during the Second World War, was tasked with finding a route through the Khumbu Icefall and then maintaining it while the climbers pressed on up the mountain.

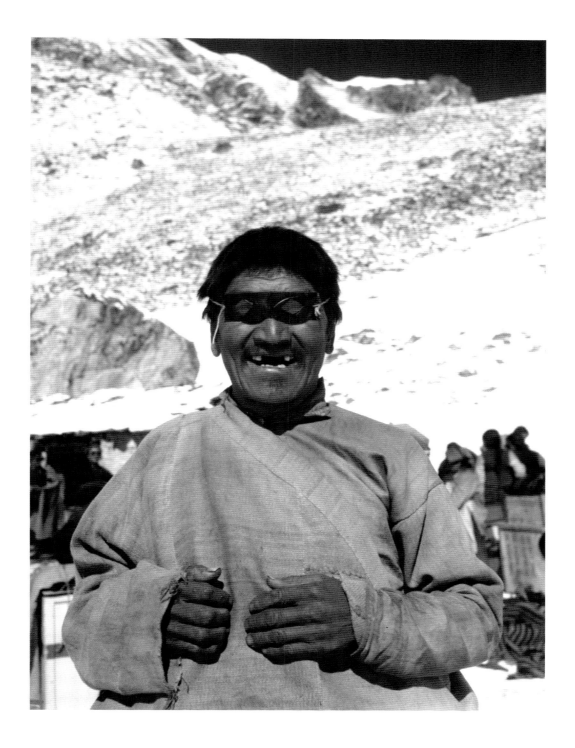

A porter displays his own version of snow goggles. The glare from the surrounding landscape made some sort of eye protection essential to avoid injury.

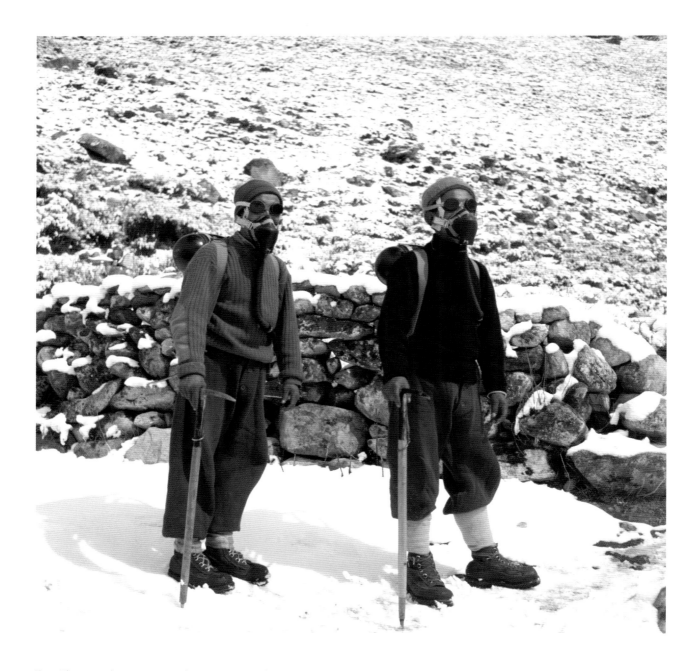

Two Sherpas demonstrate the equipment that was essential to the success of the 1953 ascent of Everest: breathing apparatus, ice axes, snow goggles, and boots that were warm and waterproof.

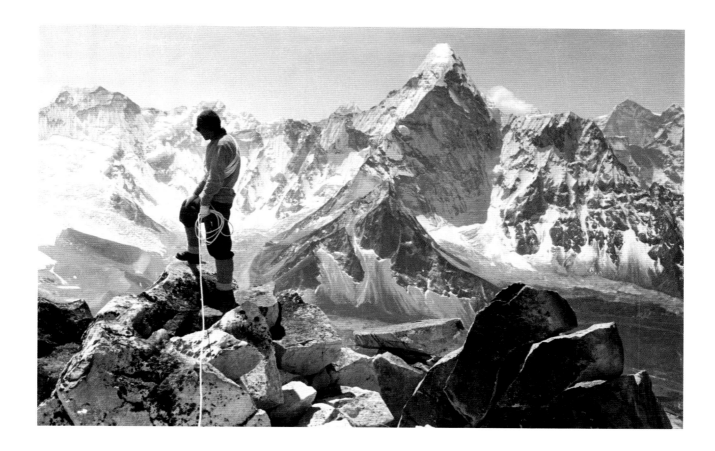

Prior to making their assault on Everest, the expedition scaled a number of mountains in the area, testing their equipment. Chukhung Peak was one of them, and Tenzing Norgay is shown standing on the Summit at 19,400 feet (5,913 metres). It was on Chukhung that John Hunt came to appreciate Tenzing's fitness and skill as a mountaineer.

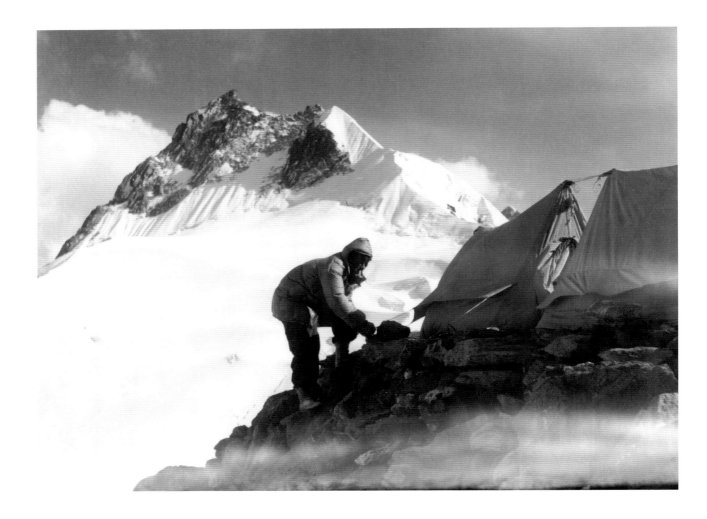

Edmund Hillary secures a tent on a col at the head of the Chola Khola valley during an acclimatisation climb. In the background is Pointed Peak (19,500 feet/5,944 metres).

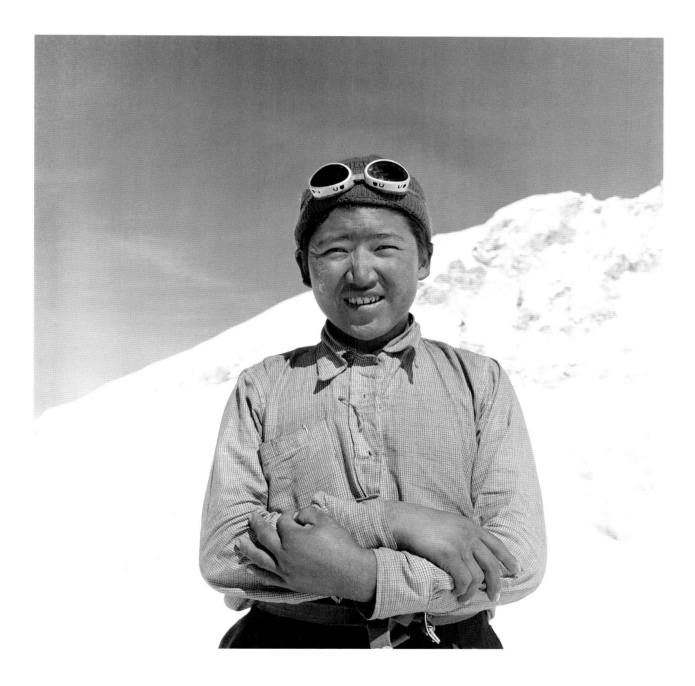

Nephew of Tenzing Norgay, Nawang Gombu was one of the youngest Sherpas on the expedition. He was among the group of high-altitude porters who twice carried loads up to the South Col without oxygen.

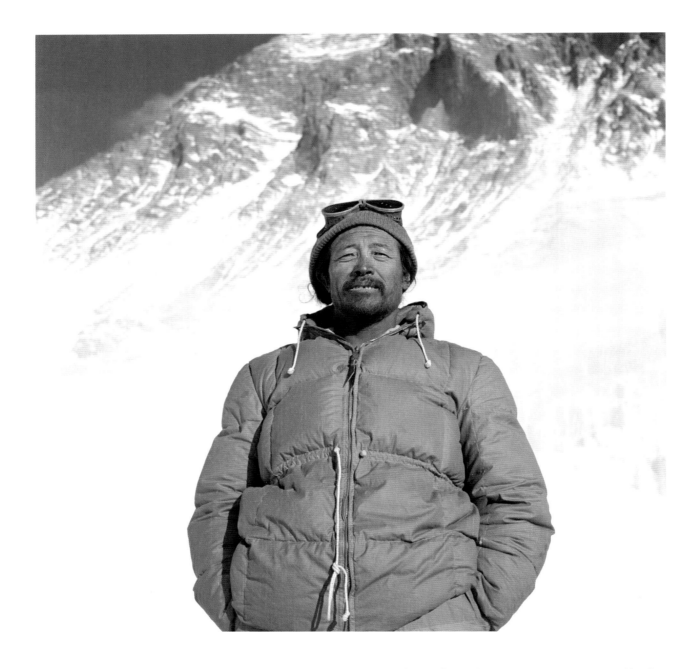

Legendary Sherpa Dawa Tenzing, who was involved with Everest expeditions from the 1920s to 1963. He carried loads up to the South Col in 1952 and 1953.

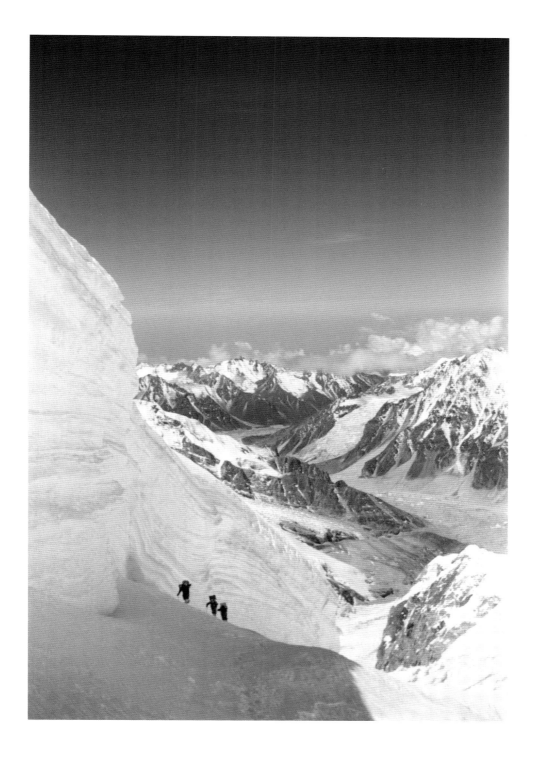

Ascending an ice slope during an acclimatisation climb of one of the peaks in the Everest region. The expedition made six first-time ascents of mountains exceeding 20,000 feet (6,096 metres) prior to tackling Everest itself.

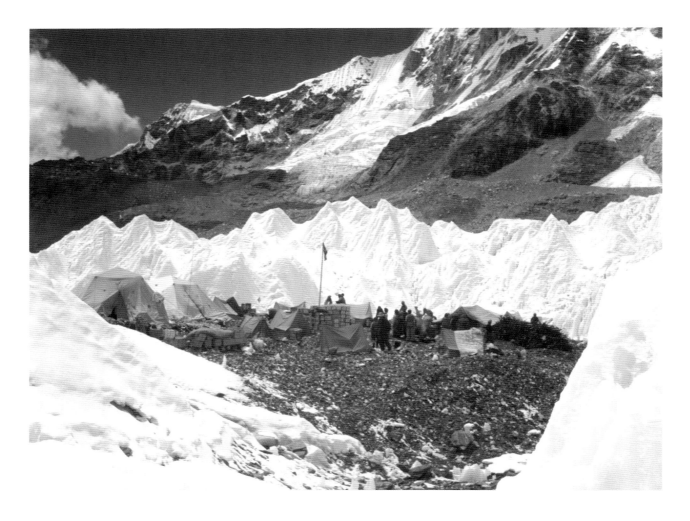

The expedition's Base Camp on the Khumbu Glacier, established in a rocky clearing surrounded by a miniature mountain range of ice pinnacles.

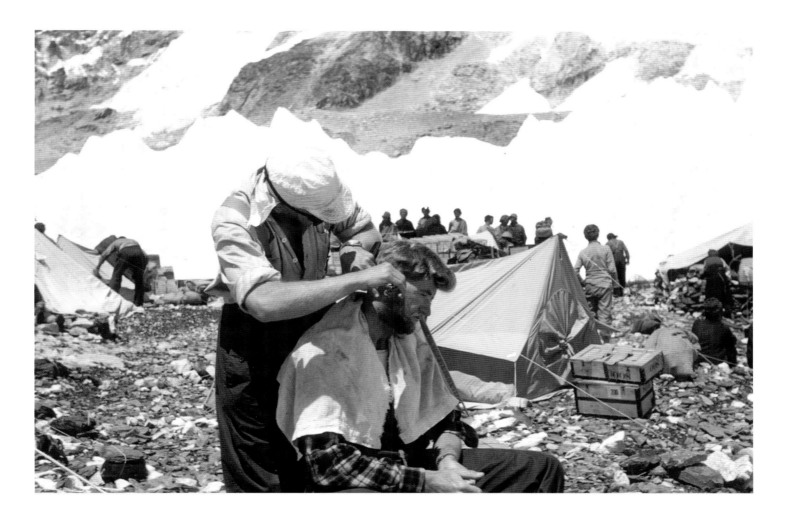

Charles Evans cuts George Lowe's hair at the expedition's Base Camp. Being away from civilisation for so long meant that they had no option but to take care of such needs themselves.

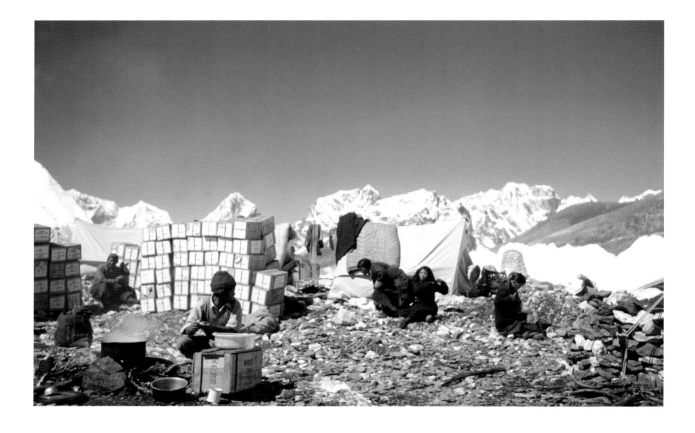

These great piles of boxes, stacked among the tents at Base Camp, are just some of the material carried up the lower slopes of Mount Everest by a team of only 34 Sherpas.

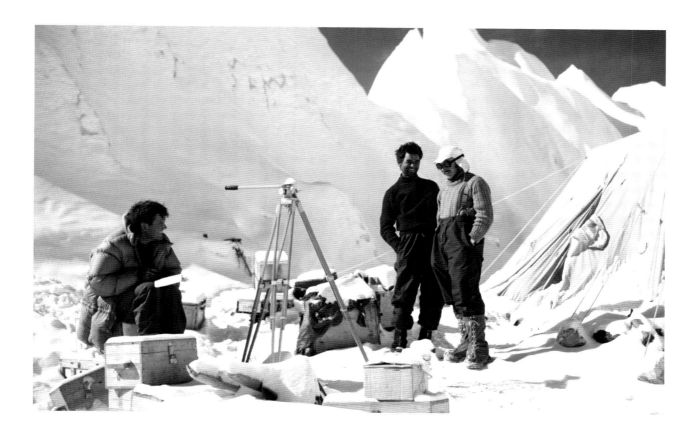

In the sunshine at Base Camp: (L–R) Michael Ward, the team's medical officer; Tom Bourdillon, who had special responsibility for the oxygen equipment; and Charles Evans, deputy expedition leader and quartermaster.

Mike Ward, whose research in the RGS archives had suggested a possible route to the Summit from the Nepalese side of Everest. His work led to the 1951 reconnaissance expedition, in which he took part. In 1953, he was the expedition's medical officer as well as a member of the climbing party.

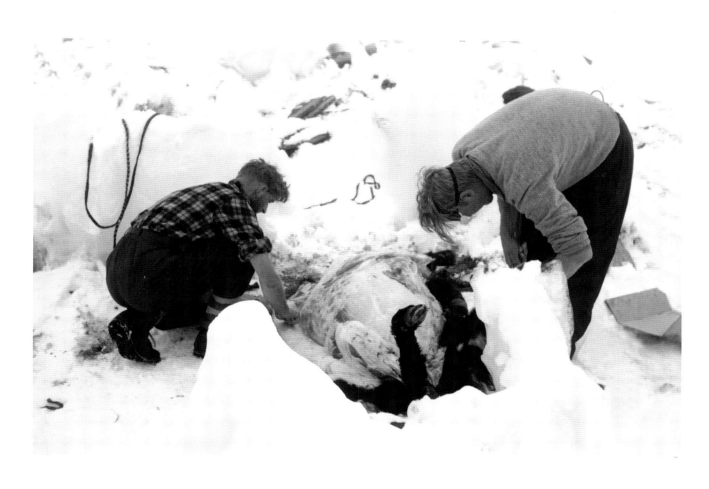

Good food, including fresh meat, was essential to the successful attempt to reach the Summit of Everest. Here, Tom Stobart and George Lowe skin a slaughtered yak at Base Camp.

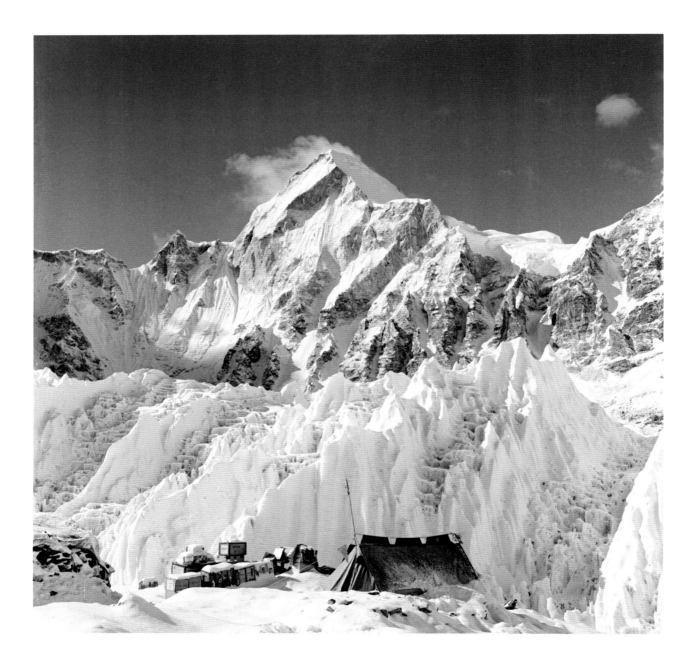

The expedition's Base Camp on the Khumbu Glacier with the peak of Lingtren rearing up behind. Recent snowfall has covered everything in a white mantle.

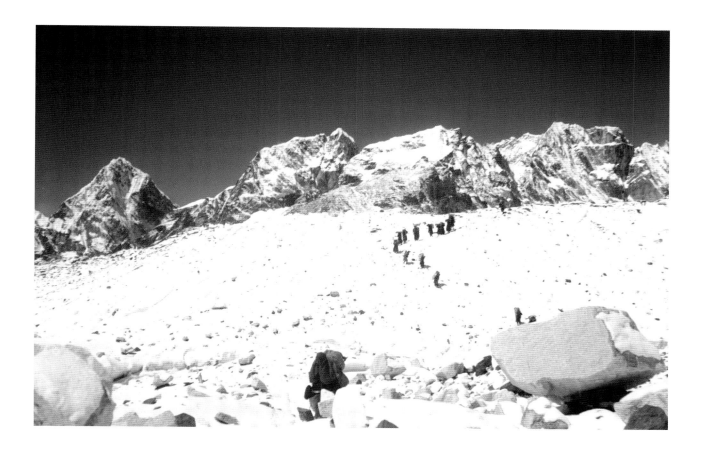

Carrying large, heavy loads, Sherpas push their way through the Khumbu Glacier. The massive blocks of stone and ice made the going very difficult.

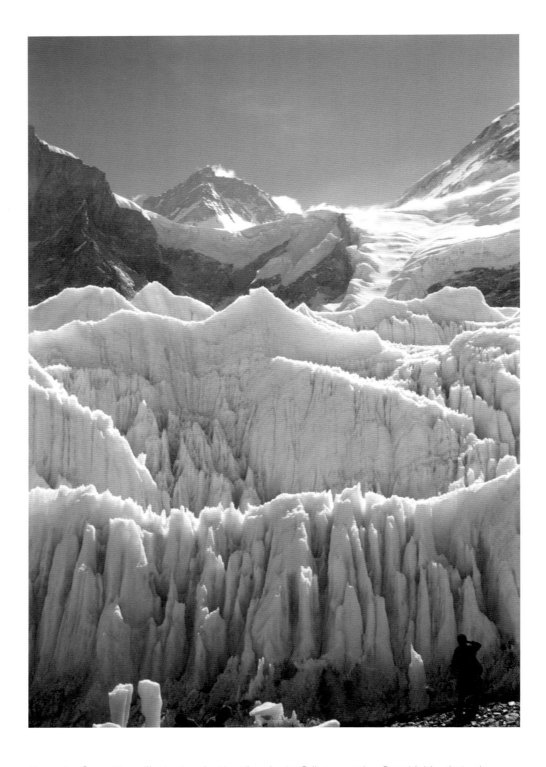

These ice formations illustrate why the Khumbu Icefall was such a formidable obstacle to the expedition's progress. Finding a safe, viable route through was a priority. In the background can be seen the goal: Everest itself.

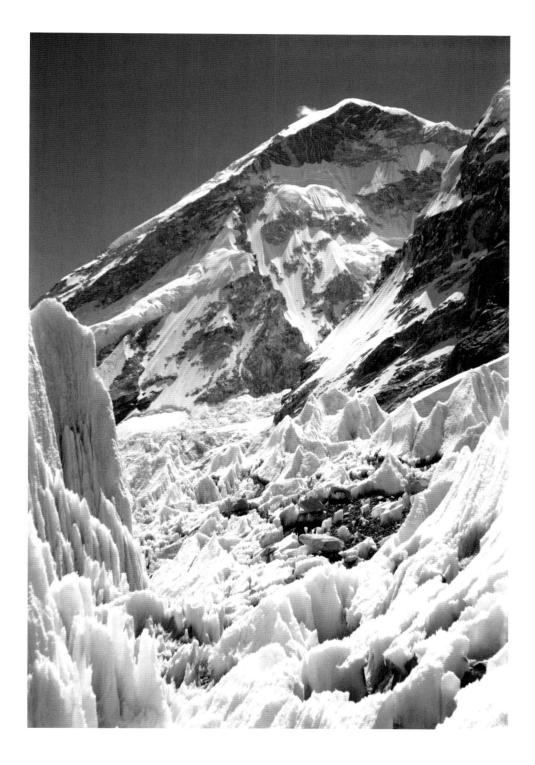

Some of the amazing ice pinnacles on the Khumbu Glacier. Tons of equipment had to be ferried by the Sherpas through this bizarre landscape.

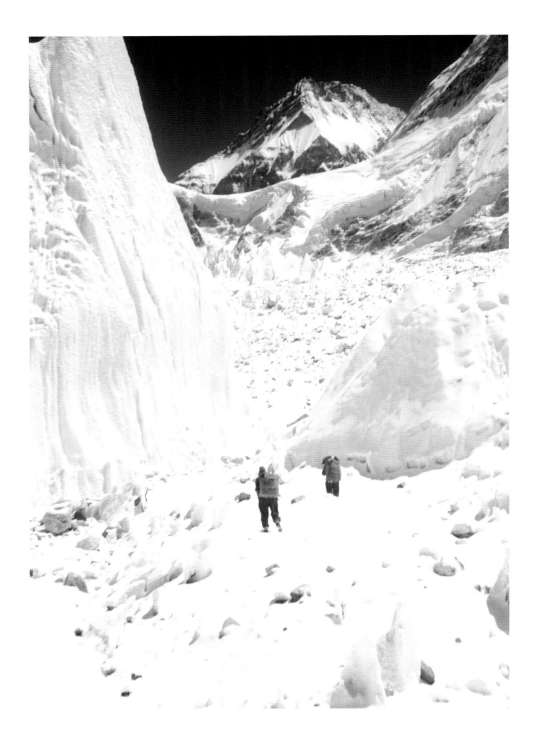

Members of the expedition work their way through the Khumbu Icefall. The constant movement of the giant ice blocks meant that the route was frequently amended. It was a very dangerous place to be.

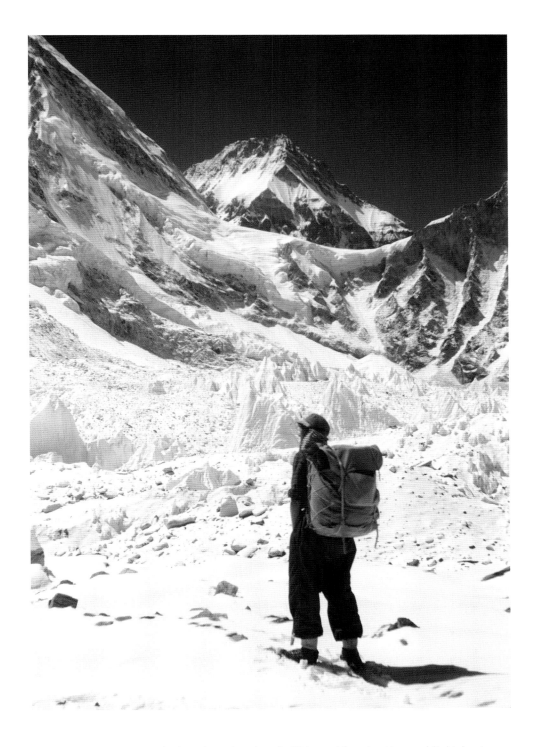

Edmund Hillary surveys the ice pinnacles ahead of him on Khumbu, the world's highest glacier, which starts at 24,900 feet (7,600 metres) and descends to 16,100 feet (4,900 metres) above sea level.

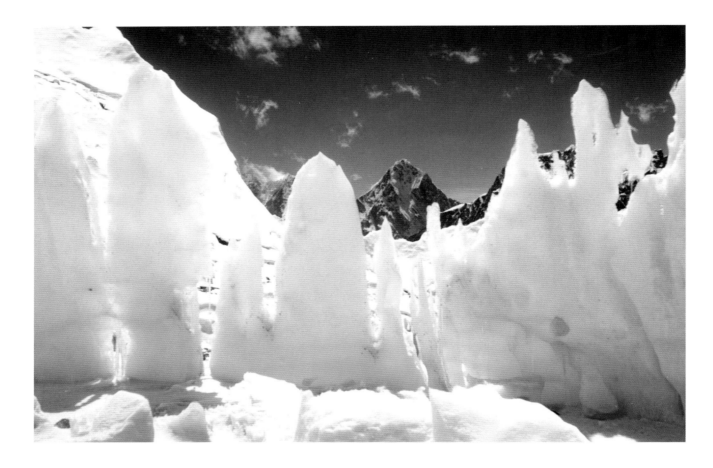

A great wall of ice 'blades' in the Khumbu Icefall. The shapes and colours of the ice were mesmerising.

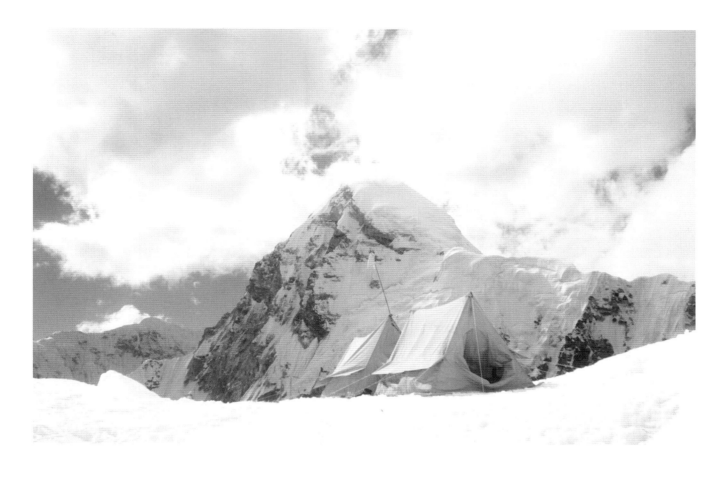

Camp II on Mount Everest. In the background is Pumori, 'Everest's Daughter', which stands 23,494 feet (7,161 metres) above sea level and which remained unconquered until 1962, when the peak was scaled by Gerhard Lenser on a German-Swiss expedition.

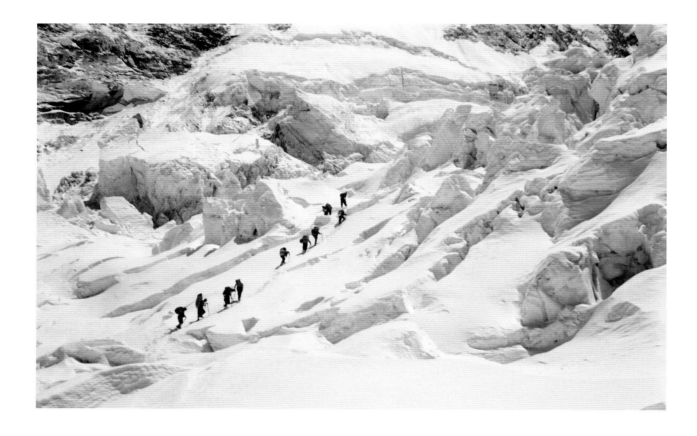

Seen from higher ground through the lens of George Lowe, members of the expedition pick their way in single file through the Khumbu Icefall.

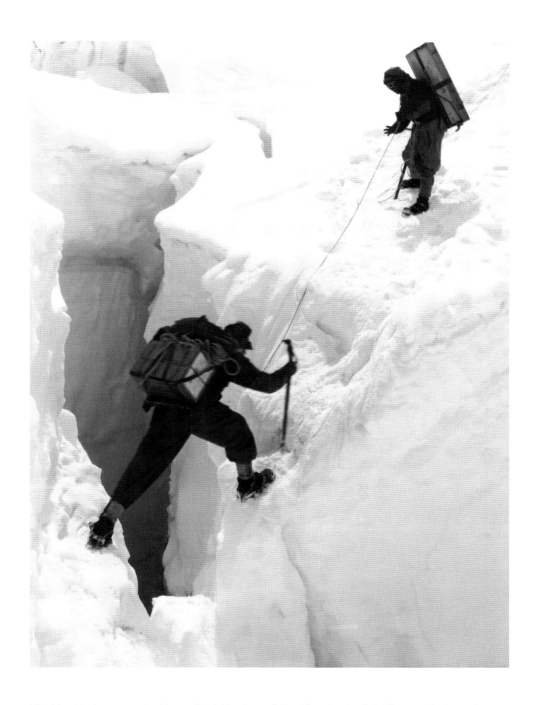

Working their way up to Camp III, at the top of the Khumbu Icefall, Sherpas help each other across a narrow crevasse, not a task for the faint-hearted.

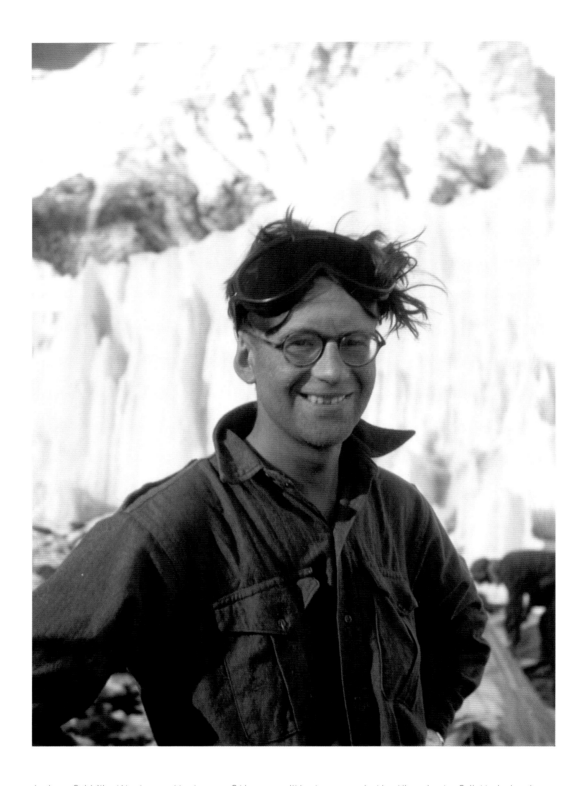

A cheerful Mike Westmacott at one of the expedition's camps in the Khumbu Icefall. He helped Times correspondent James Morris to descend the mountain to break the story of the successful ascent of Everest.

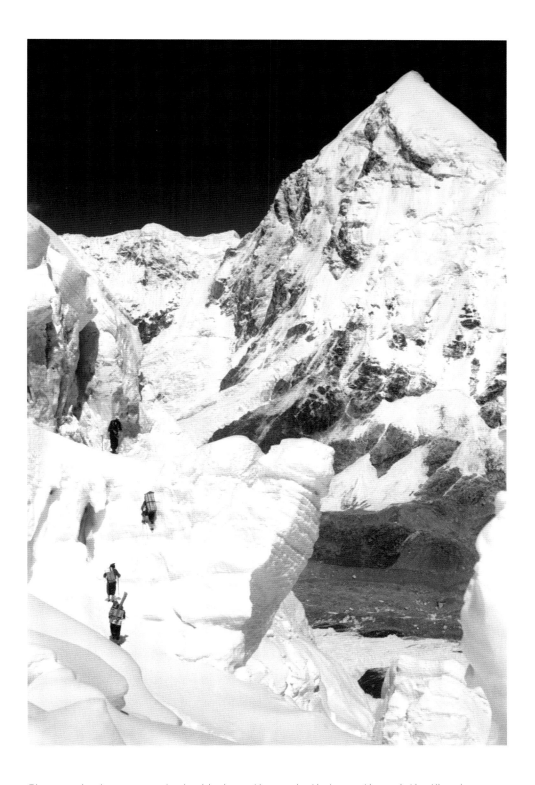

Sherpas clamber up massive ice blocks as they make their way through the Khumbu Icefall towards the Western Cwm and the expedition's Advance Base Camp (Camp IV). Behind rises Pumori, a mountain named in 1921 by George Mallory for his daughters. The name means 'unmarried daughter' in the Sherpa language.

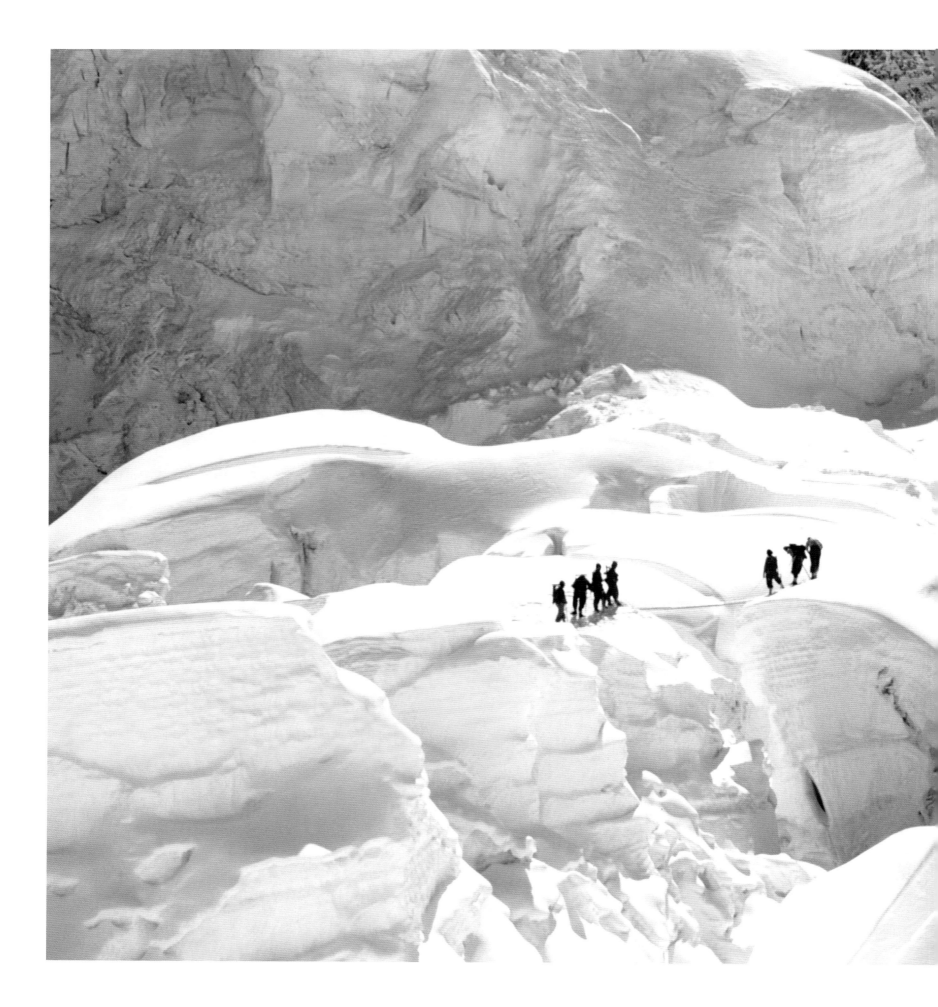

Members of the expedition cross a large crevasse in the Western Cwm between Camps III and IV. Without lightweight, portable ladders, traversing this region would have been impossible.

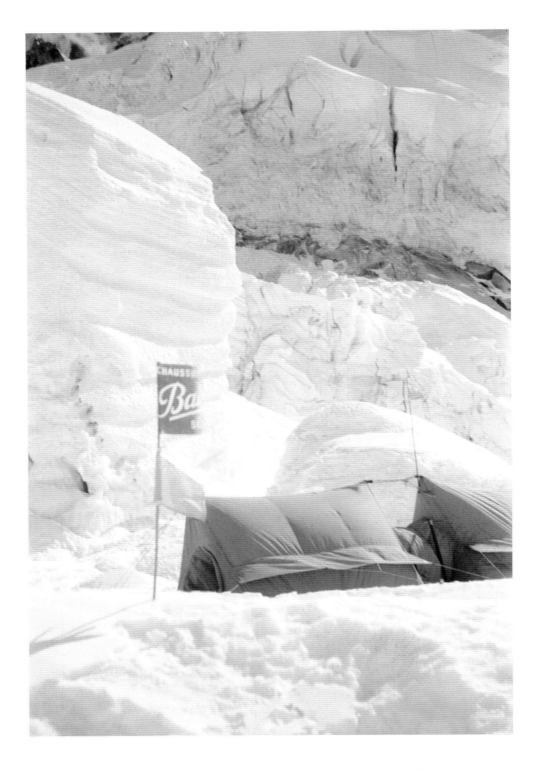

A stiff wind batters the tents of Camp II among the massive ice blocks of the Khumbu Icefall. It was not far from here that Edmund Hillary fell into a crevasse, being saved by the quick action of Tenzing Norgay.

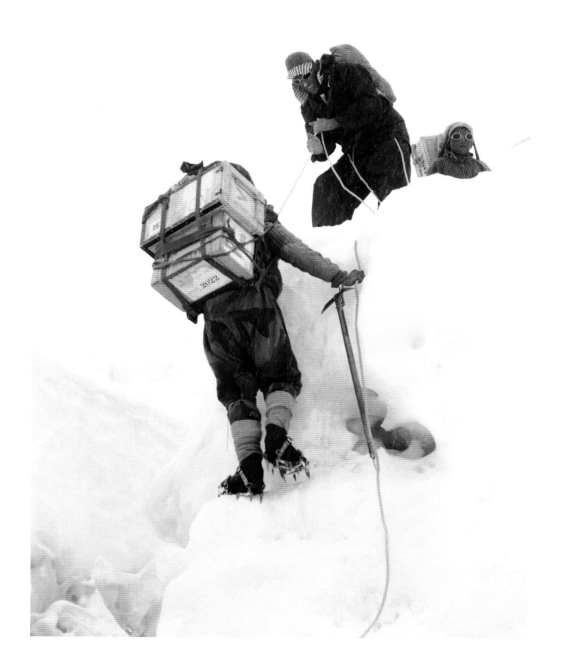

Edmund Hillary helps Sherpas through the Khumbu Icefall as they carry supplies up to the Western Cwm. A treacherous, ever-shifting, confused jumble of massive ice blocks and rocks, the Icefall proved a major hazard for the climbers.

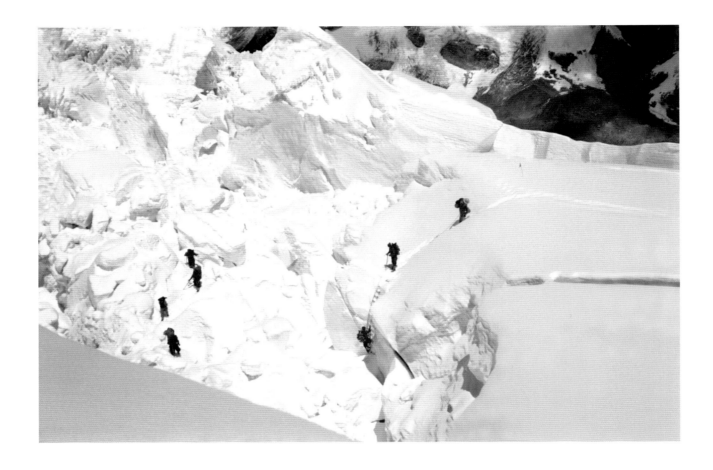

Sherpas, dwarfed by the broken landscape of ice and snow, carry heavy loads along a tortuous route through the Khumbu Icefall on their way to Camp II.

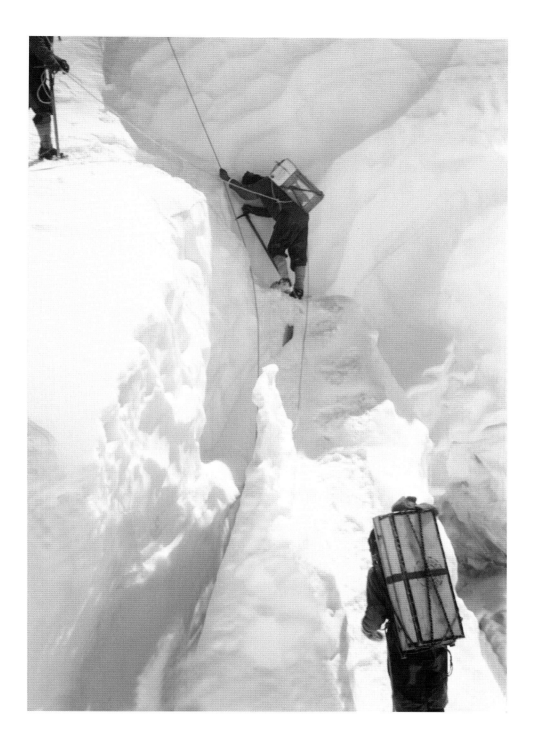

Sherpas in the Khumbu Icefall. One of the most dangerous stretches of the ascent of Everest, this is a region of séracs – columns of ice into which glaciers break as they descend steep inclines, creating treacherous and constantly moving crevasses.

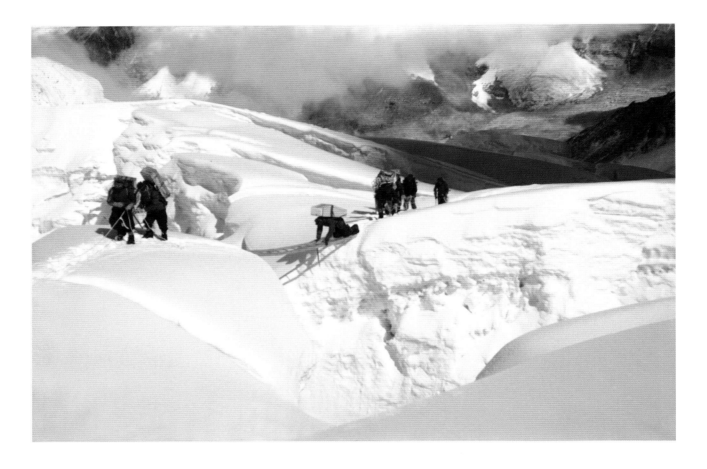

A Sherpa inches his way across a metal ladder over a crevasse. Keeping the path open through the Khumbu Icefall was the special responsibility of Mike Westmacott.

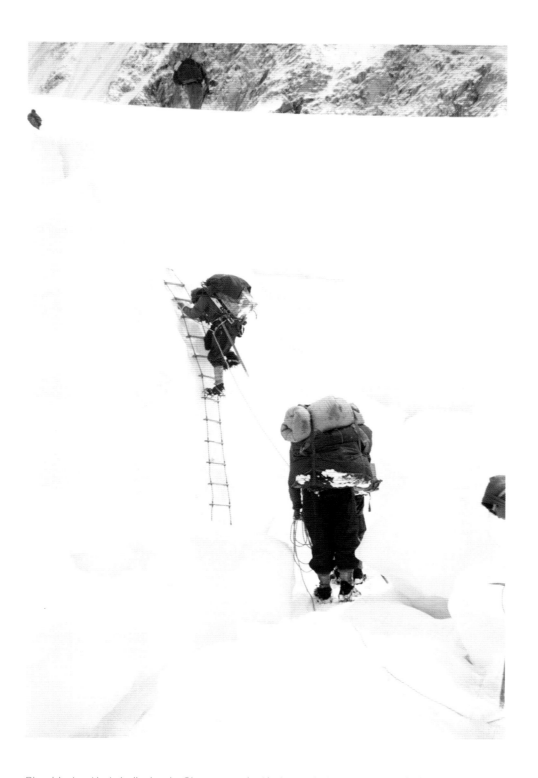

Shouldering their bulky loads, Sherpas make their way in turn up a rope ladder in the Khumbu Icefall. The broken nature of the terrain in the Icefall made passing through it a slow, difficult process.

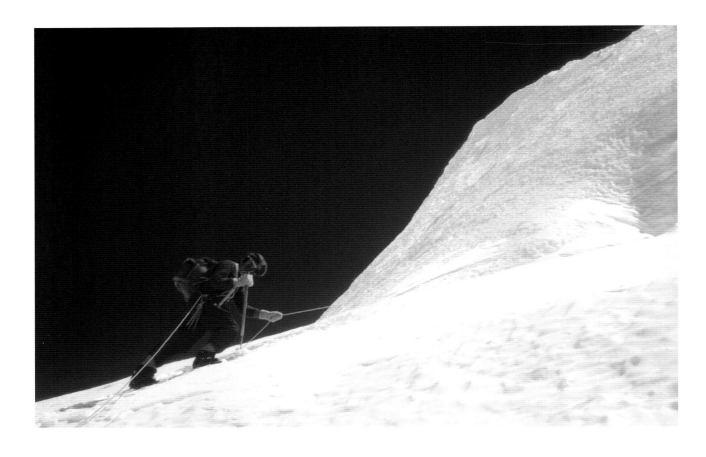

Wilfrid Noyce ascends an ice face on the Khumbu Glacier. A skilled climber, he was known for his speed and stamina.

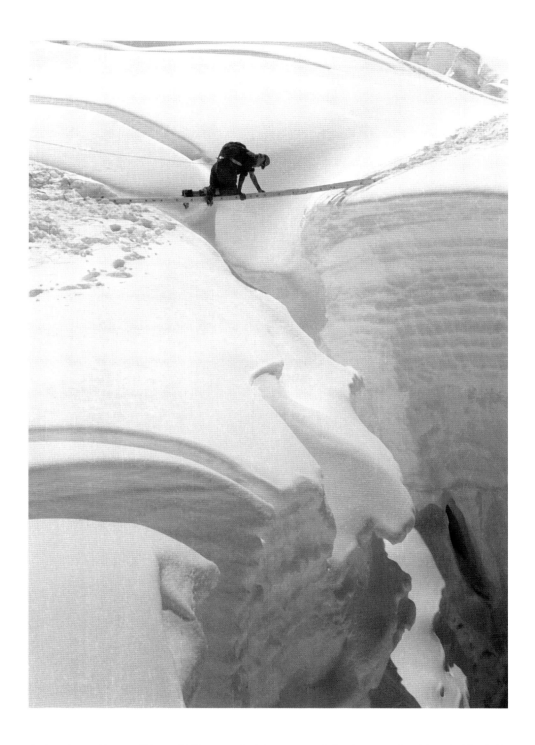

On hands and knees, Edmund Hillary works his way carefully along an aluminium ladder laid across a crevasse in the Khumbu Icefall.

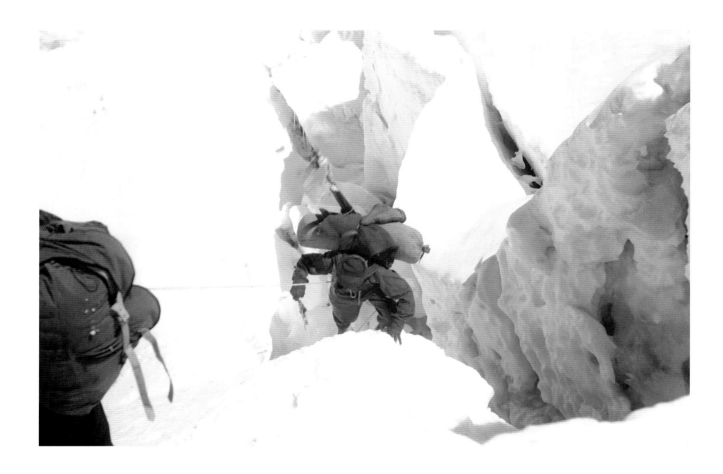

This striking image shows a Sherpa edging his way up an ice pinnacle on the Khumbu Glacier. Simply climbing such a feature is difficult enough, never mind carrying a heavy load as well.

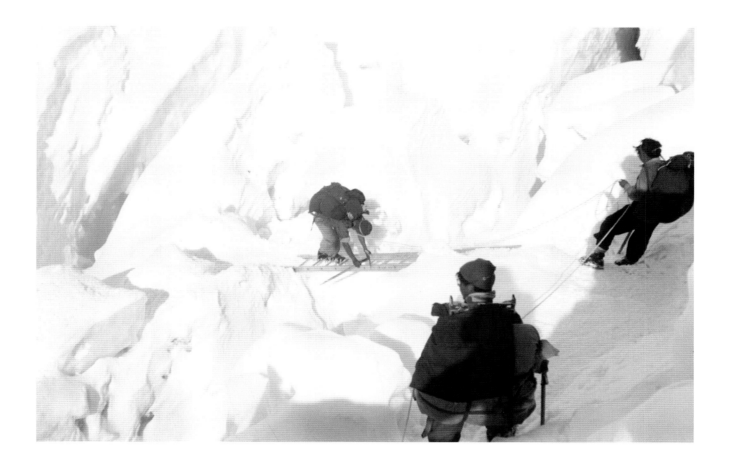

Sherpas use an aluminium ladder to make their way across the Icefall. The giant blocks of ice and snow made their job extremely difficult. Because the expedition only had two ladders, they had to be carried from one obstacle to the next.

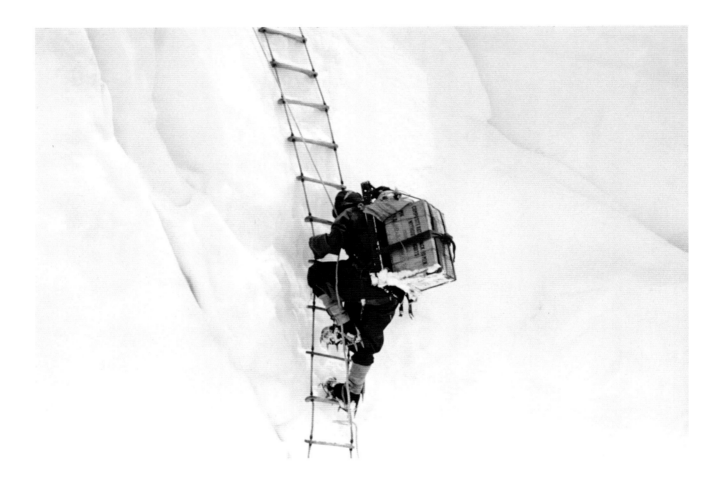

A Sherpa ferries a load up a rope ladder, the crampons strapped to his boots making his task even more difficult. The ladder had been donated to the expedition by the Yorkshire Ramblers' Association, who had used it for potholing.

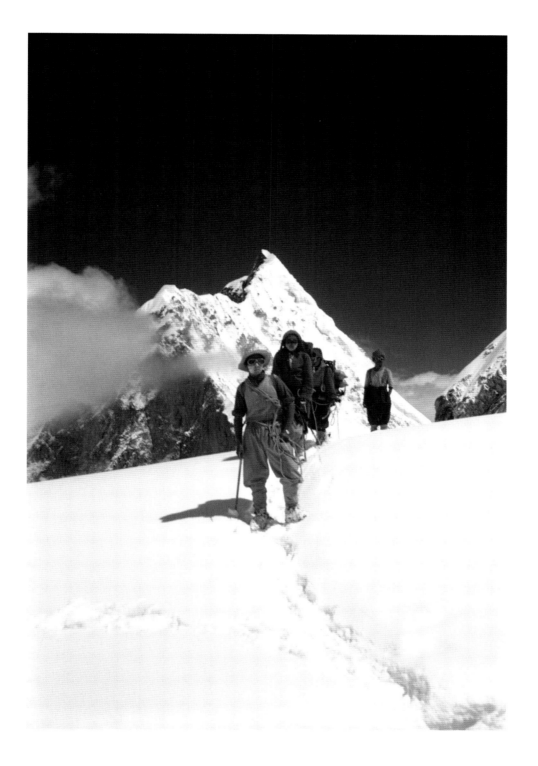

Sherpas pause during their trek through the Western Cwm. Despite the snow and ice, ferrying supplies in the blazing sun could be remarkably hot work. The expedition's success rested in no small part on the efforts of these willing high-altitude workers.

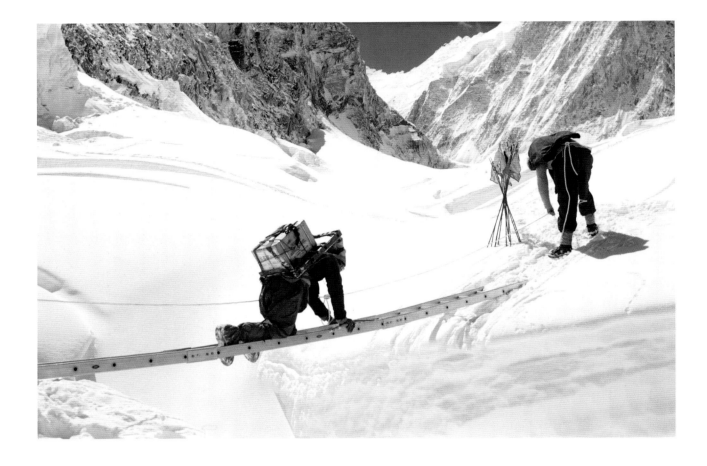

A Sherpa carrying a heavy load inches his way across a metal ladder spanning a crevasse. He is secured by rope to the waist of Wilfrid Noyce.

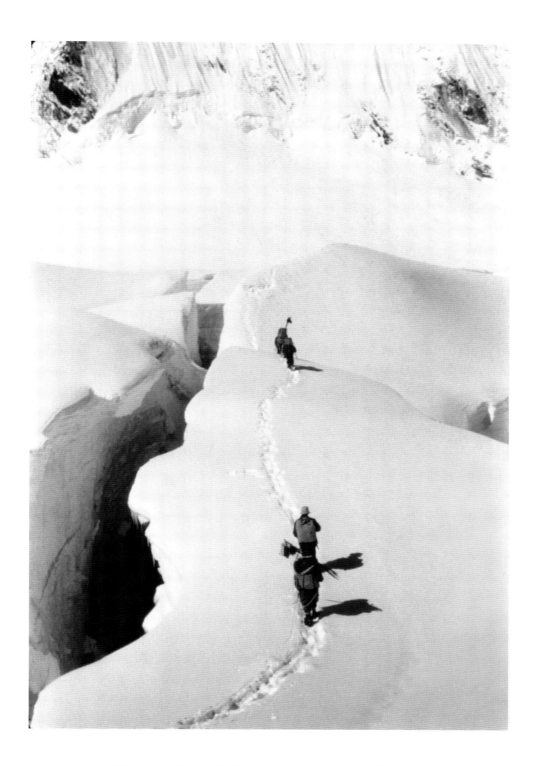

Four members of the expedition make their way along the edge of a deep crevasse, taking the utmost care not to dislodge any of the impacted snow underfoot. They are carrying flags to mark out a safe route.

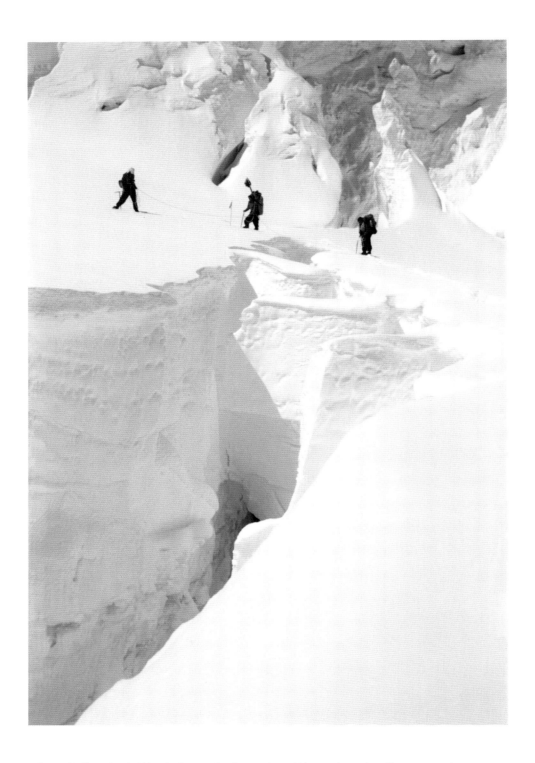

Edmund Hillary took this photograph of a party setting out marker flags around a crevasse on the Western Cwm. Having found a safe passage, it was essential to mark it for future use, since footprints were frequently filled in by fresh snowfall.

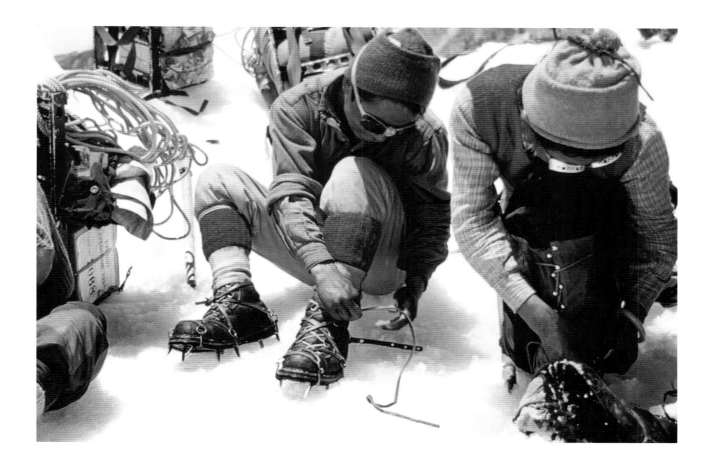

Sherpas attaching spiked crampons to their boots for maximum grip on the ice and snow. Although these devices had been available since 1908, this was the first Everest mission to employ them.

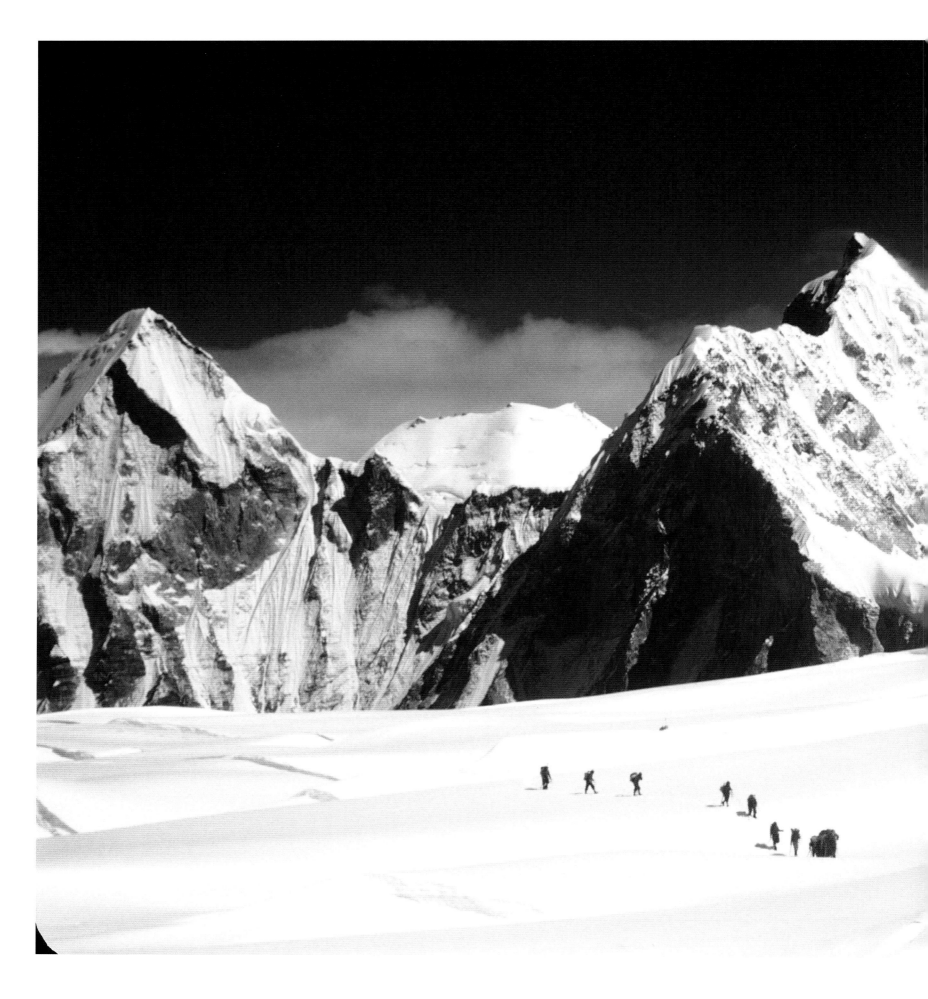

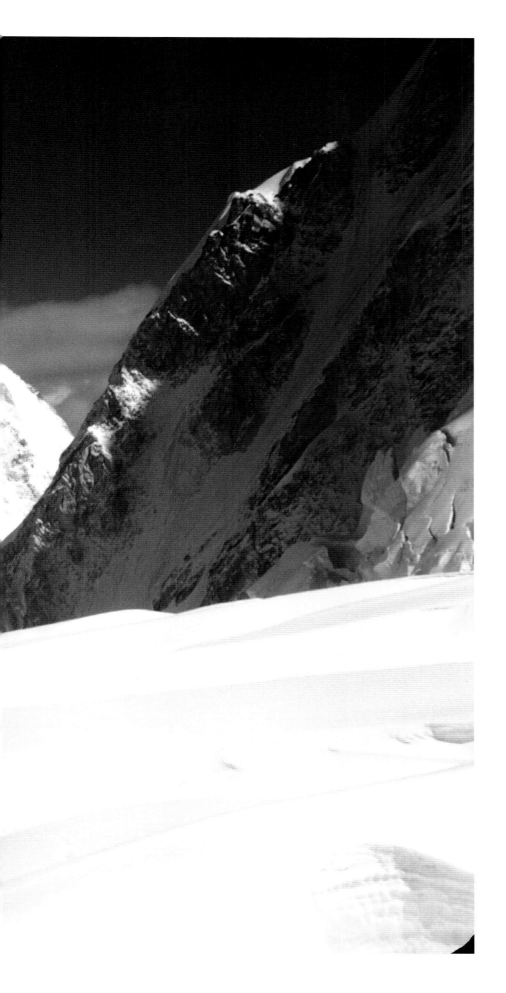

A party of Sherpas heads through the Western Cwm during the build-up to the ascent of Everest. In the background (L) is the 22,027-foot (6,714-metre) peak of Lingtren.

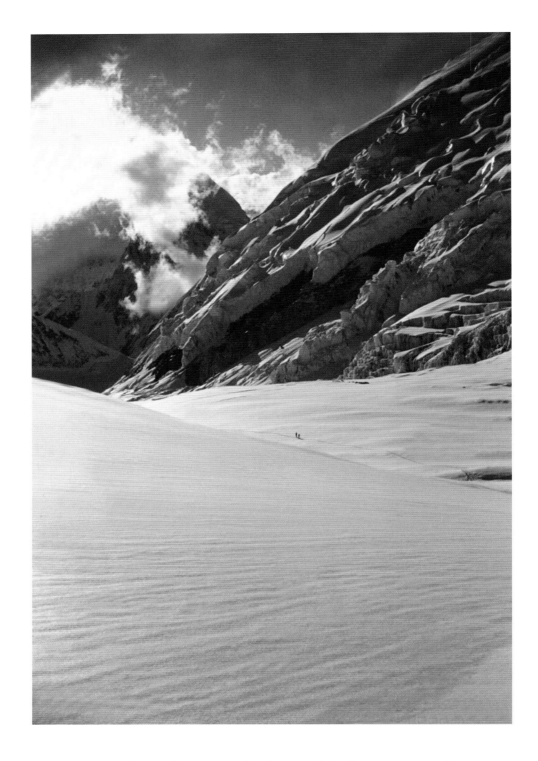

Two members of the expedition are rendered minuscule by the vast Western Cwm, a gently sloping glacial valley with huge lateral crevasses around which detours had to be made to reach the advanced base of Camp IV.

Wilfrid Noyce, the first of the expedition's climbers to reach the all-important South Col. He led a group of Sherpas there on two occasions, helping to establish Camp VIII.

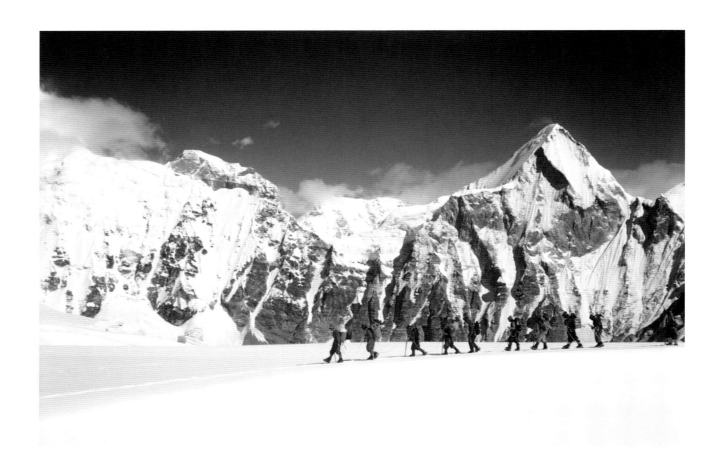

With a backdrop of craggy peaks, a line of Sherpas, laden with stores and equipment, heads across the snowfield of the Western Cwm. They are roped together for safety.

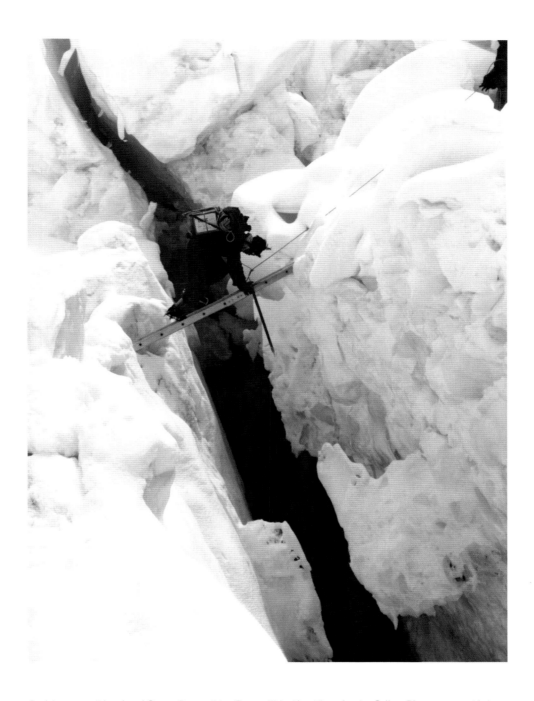

On his way with a load from Camp II to Camp III in the Khumbu Icefall, a Sherpa negotiates a ladder spanning a deep crevasse. A vast amount of stores and equipment was transported through the Icefall in this manner.

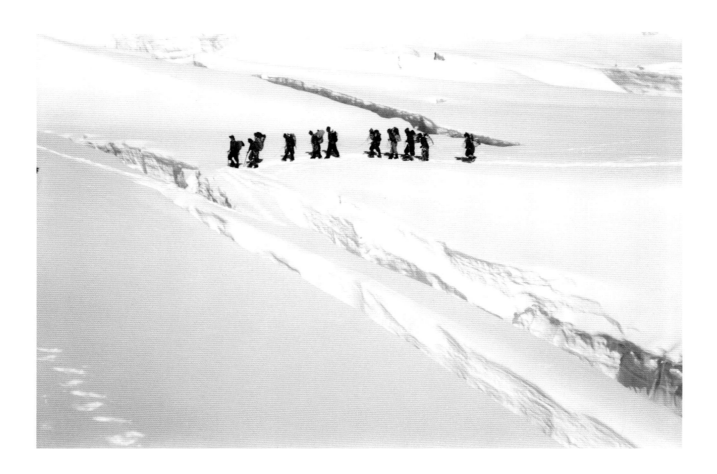

Sherpas are led across the Western Cwm, which was riven by deep crevasses, as can be seen. They appear to be on firm snow, but the problem with the terrain was always that appearances could be deceptive.

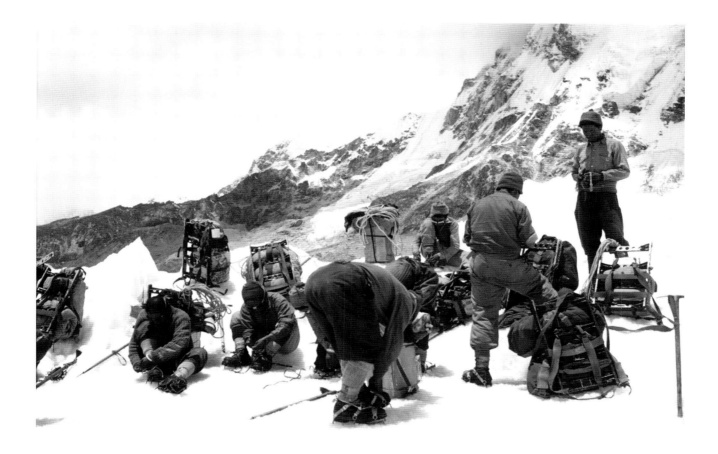

Sherpas prepare for the first load of the day by attaching crampons to their boots. The expedition had 34 high-altitude Sherpas to carry loads up the mountain in support of the climbers.

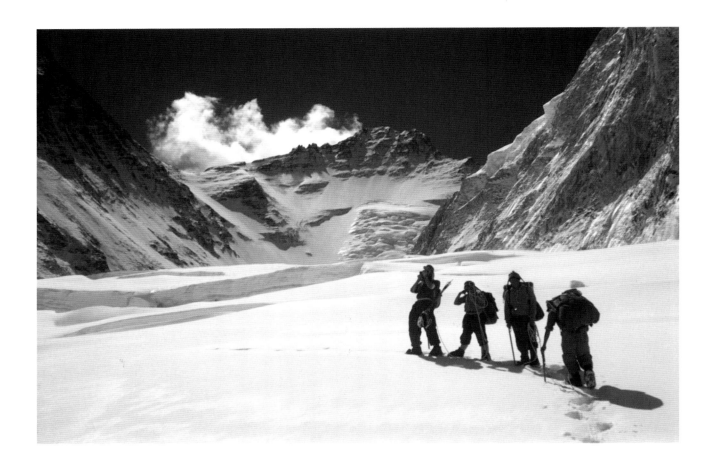

Edmund Hillary (L) leads a group of Sherpas into the Western Cwm, transporting supplies to the expedition's advance base, Camp IV. In the background stands the mountain of Lhotse. The expedition's route led up the rippled Lhotse Face (centre of photo), across the smoother ice slope above it and on to the South Col (dip in the skyline to the left of the photo), where Camp VIII was established.

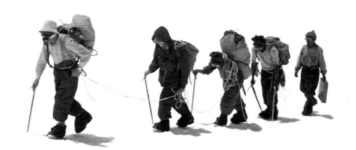

John Hunt leads a group across the dazzling snow in the Western Cwm. Curiously, the man at the back does not appear to be roped up, nor does he have an ice axe.

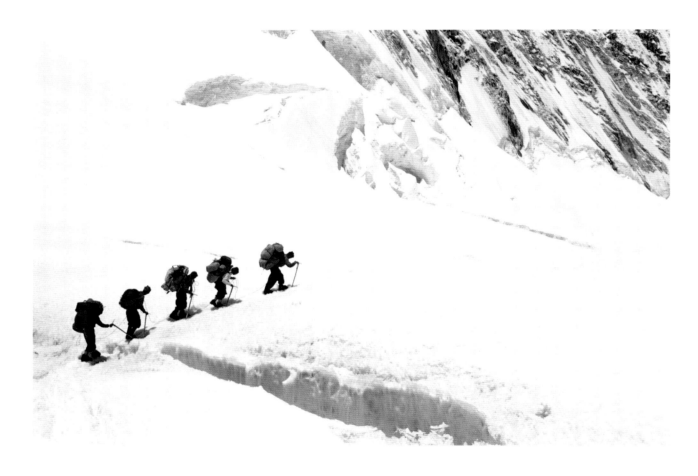

A group of Sherpas advances in line, taking particular care to tread lightly lest their footfall triggers an ice slippage that could pull them down into the threatening crevasse on their right.

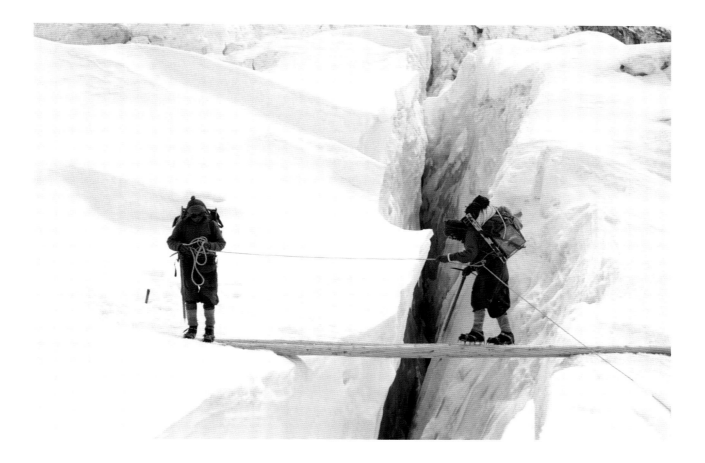

Sherpas ferrying supplies cross a log bridge over a crevasse in the Western Cwm. The crampons on their boots make the procedure doubly hazardous. The expedition had only two aluminium ladders and a few tree trunks to bridge crevasses, and they often had to be moved from one to another.

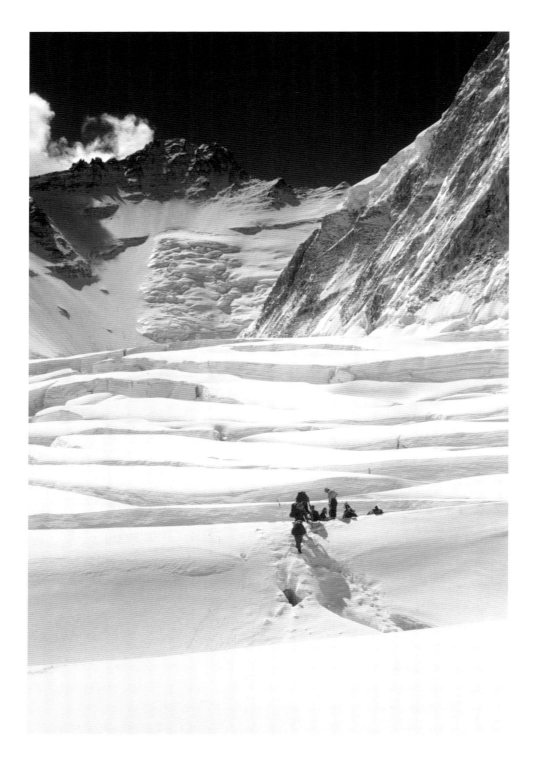

Sherpas crossing the undulating snowfield of the Western Cwm. In the distance ahead of them is Lhotse, at 27,940 feet (8,516 metres) above sea level the fourth highest mountain in the world. The route to Everest's Summit lay up the daunting Lhotse Face.

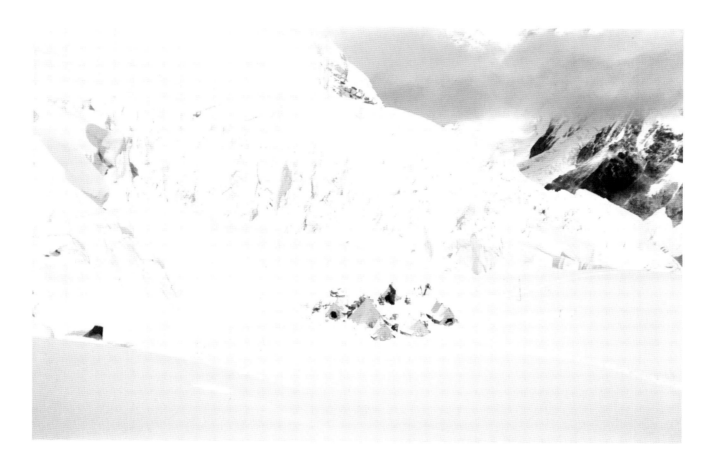

Advance base, Camp IV, at the foot of the Lhotse Face at 21,300 feet (6,500 metres) above sea level. From here, loads had to be carried up the steep and hazardous face, and then across it to reach the windswept South Col of Everest.

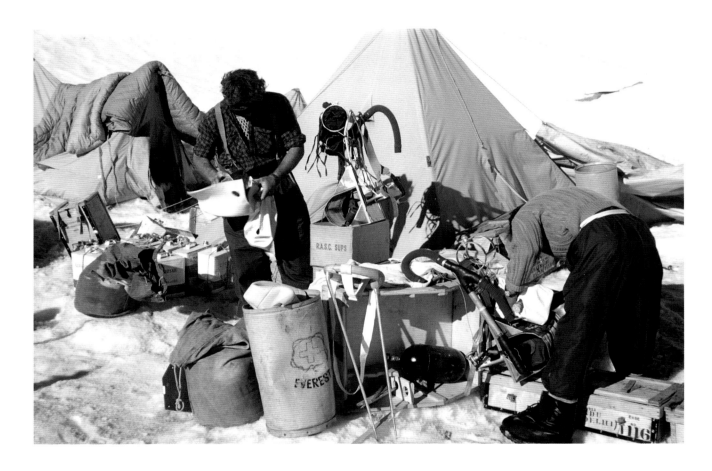

At Camp IV, Tom Bourdillon (L) checks the oxygen equipment that he had developed specially for the 1953 climb. With him is deputy expedition leader Charles Evans.

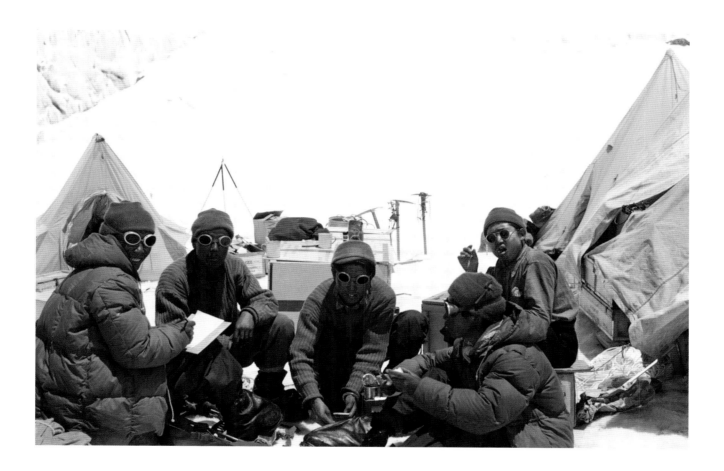

Sherpas enjoying a well-earned break at Camp IV in the Western Cwm. Snow goggles were essential to combat the glare from the surrounding landscape.

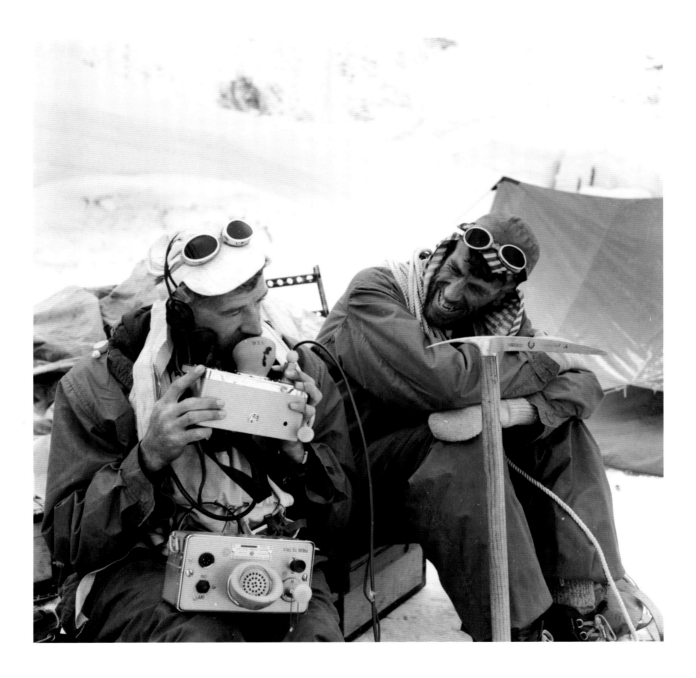

George Lowe tests the portable radio equipment used to communicate between camps on Everest while Edmund Hillary listens with amusement. Both New Zealanders, the pair were good friends and had taken part in a 1952 training expedition to the region.

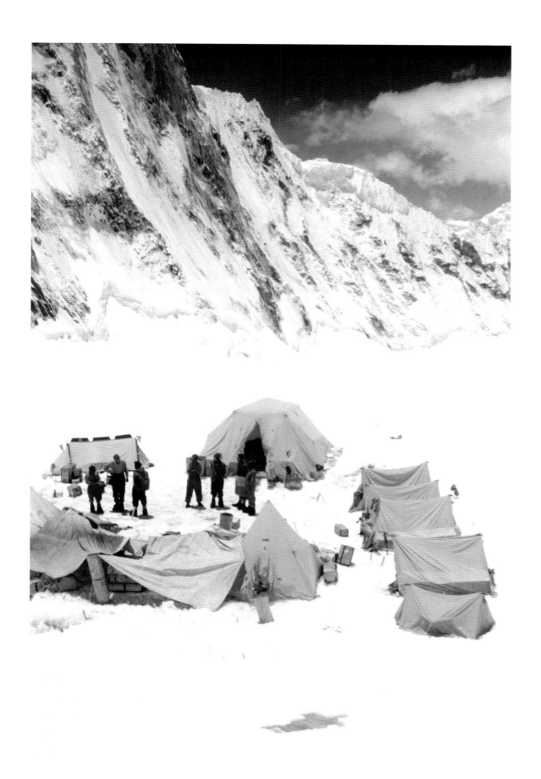

Camp IV in the Western Cwm, the expedition's Advance Base Camp. From here, climbers
set out to tackle the daunting Lhotse Face on their way up to Camp VIII on the South Col.

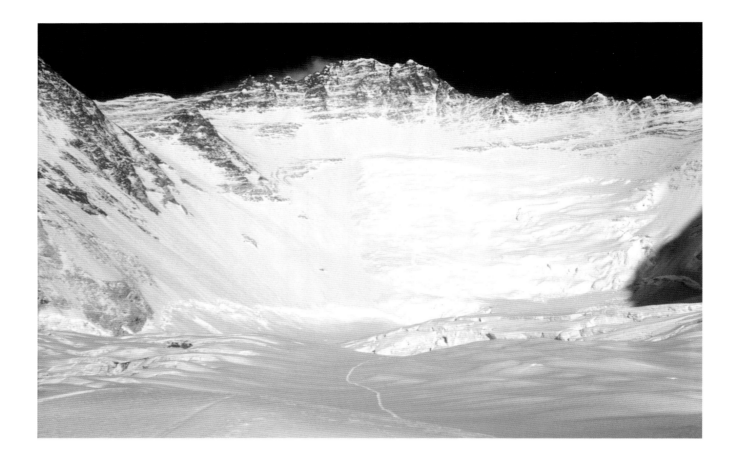

The Lhotse Face towers above the Western Cwm. In the centre foreground can be seen the track in the snow marking the route followed by the climbers.

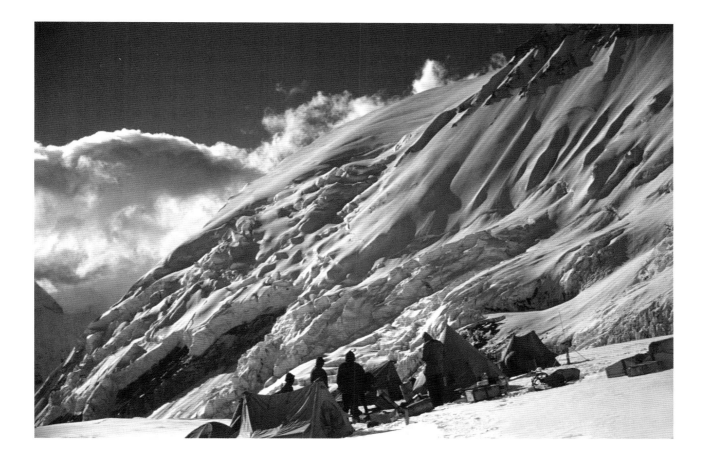

Camp V, at around 22,000 feet (6,705 metres) above sea level, was right at the very base of the Lhotse Face. The face provided the climbers with a major challenge on their route to the South Col, where Camp VIII would be established.

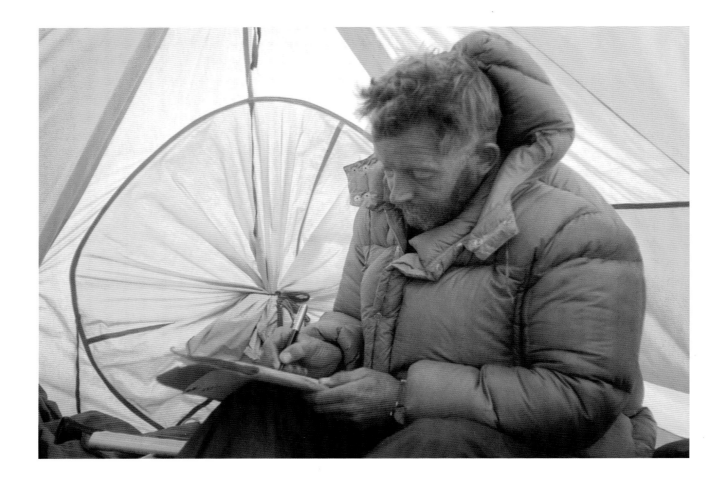

Bundled up in his down jacket, Charles Evans, the expedition's deputy leader, writes notes in his tent. He would make the first ever ascent of Everest's South Summit with Tom Bourdillon.

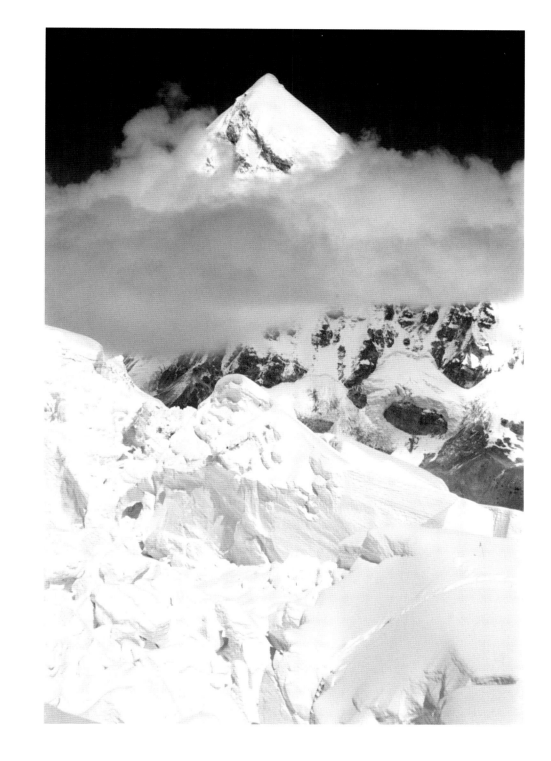

Seen from Lhotse, the peak of Pumori rises above a blanket of cloud. The mountain lies about five miles (eight kilometres) to the southwest of Everest.

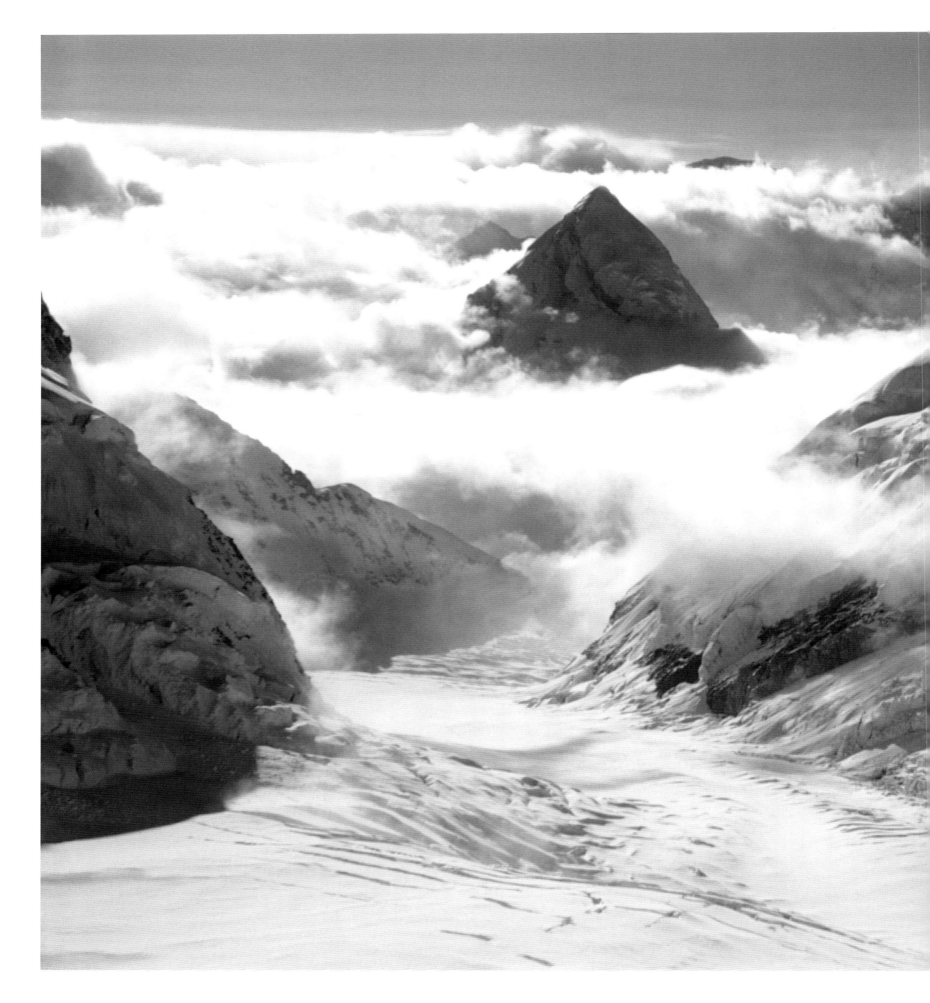

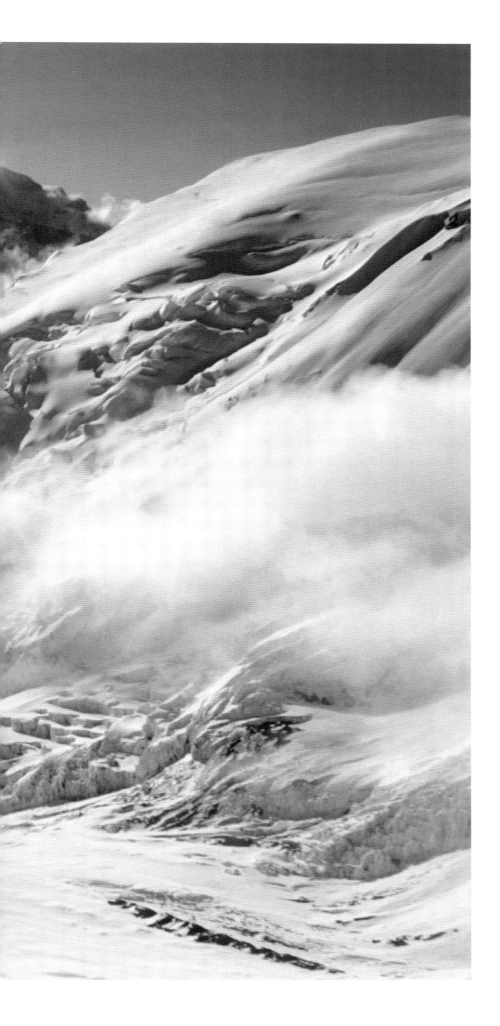

The view from the Lhotse Face looking down on to the ridge of Nuptse (L), which borders one side of the Western Cwm; the other side abuts the Southwest Ridge of Everest itself (R). In the distance is the conical peak of Pumori (C).

Camp VII is established with a lone tent on a ledge on the steep snow-clad Lhotse Face. Pushing upwards over this forbidding terrain tried the skills of the expedition's climbers.

The bleak outpost of Camp VII, perched on the Lhotse Face. This was a staging post on the route from the Western Cwm to the South Col.

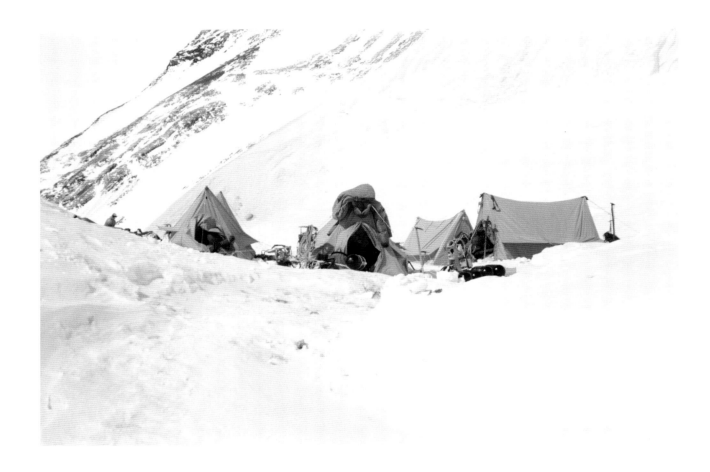

Camp VII on the Lhotse Face. The camp was established because the climb from the Western Cwm to Camp VIII on the South Col rose through 3,200 feet (975 metres) and was too exhausting for a single load carry.

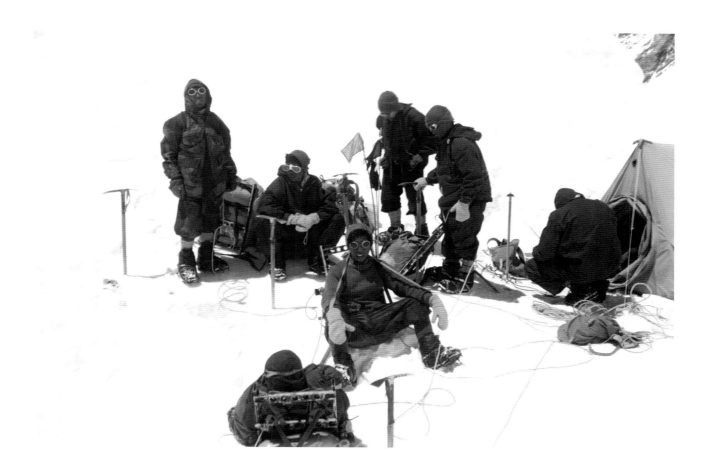

Sherpas take a break at Camp VII before continuing their climb up to Camp VIII on the South Col. The difficult conditions of the Lhotse Face almost brought the expedition to a halt.

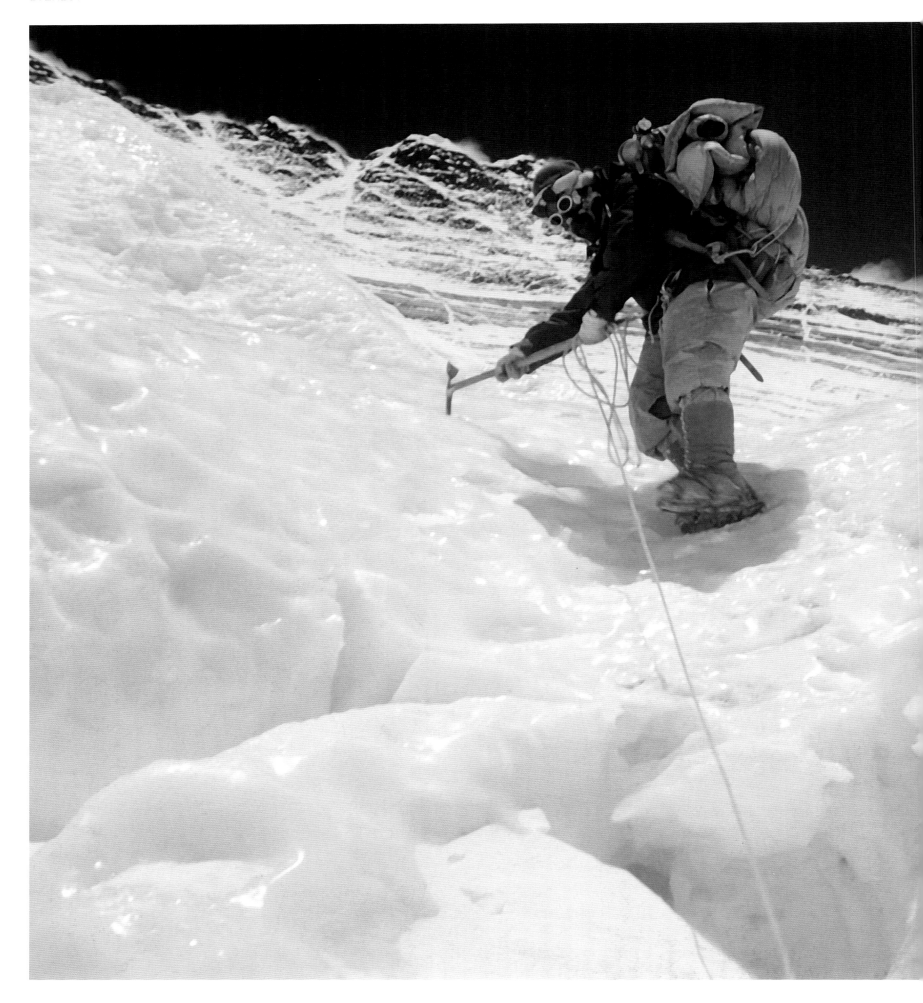

Tenzing Norgay steadies himself with his ice axe as he makes his way down the Lhotse Face. His climbing boots, made of reindeer skin with laced fabric covers, had been given to him during his time with the Swiss expedition of 1952, when he and Raymond Lambert had climbed to above 28,000 feet (8,534 metres) before being forced to turn back by inefficient oxygen equipment.

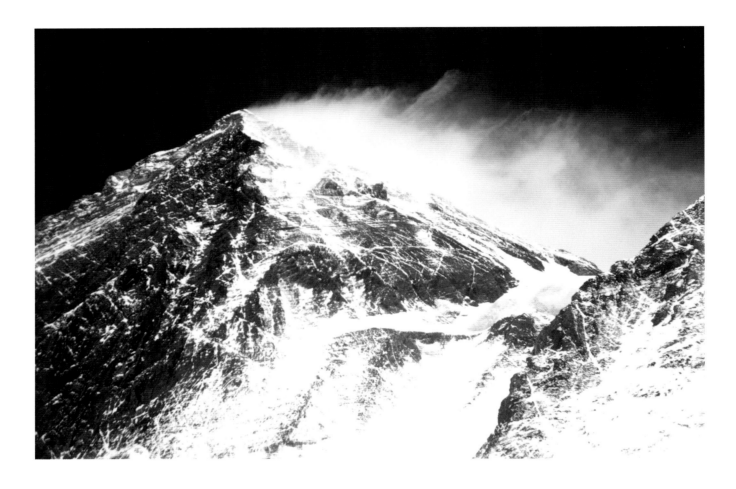

The South Summit of Everest, seen from Camp VII. Beyond lay the Summit Ridge, the route to the Summit itself.

Huddled on the bleak, windswept rocky plateau of Everest's South Col, Camp VIII was the final jumping-off point for the teams of Tom Bourdillon and Charles Evans, and Edmund Hillary and Tenzing Norgay who made attempts on the Summit.

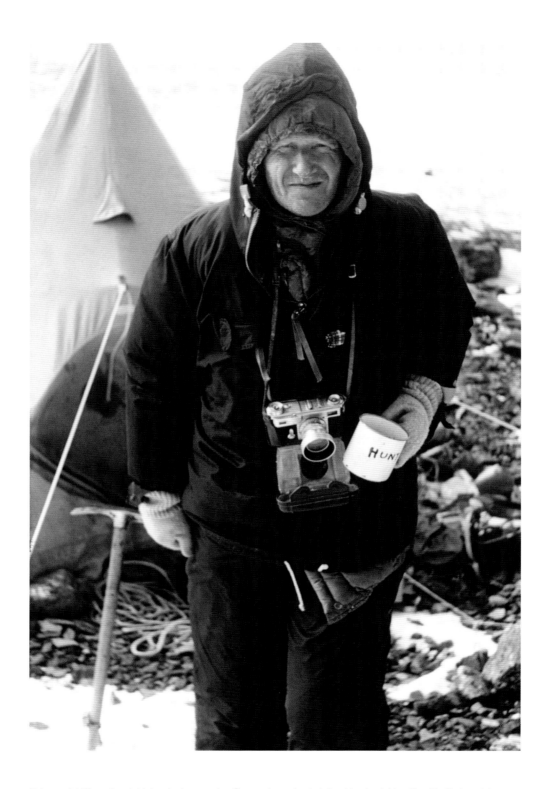

Edmund Hillary took this photograph of an exhausted John Hunt at the South Col on his return from the Southeast Ridge, where he had helped ferry supplies for the final Summit bid. The strain of carrying heavy loads at altitude shows clearly on his face.

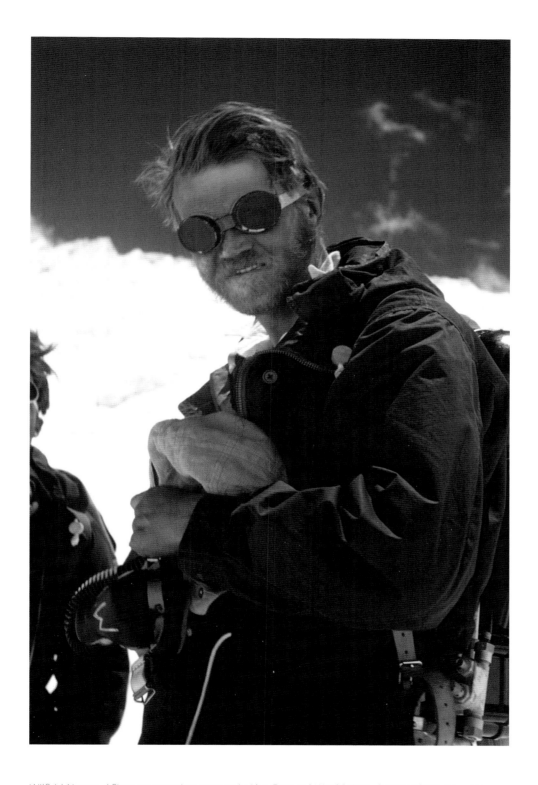

Wilfrid Noyce. After an amazing career in the Second World War, during which he went from conscientious objector to lieutenant in the King's Rifles, Noyce became what Hillary described as "the most competent British climber" he had met.

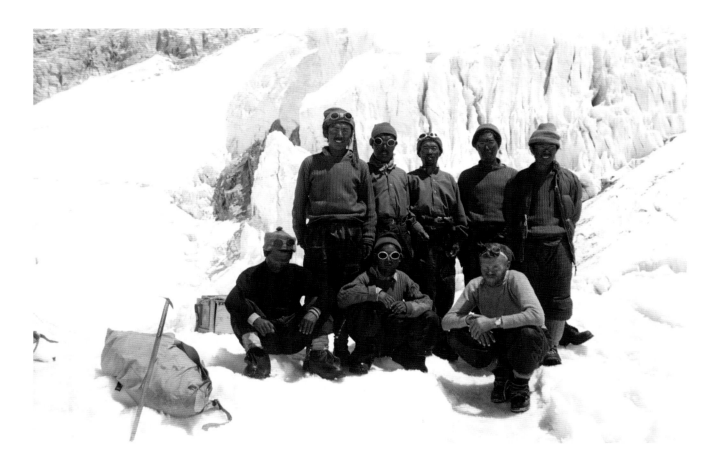

Overcoming the obstacle of the Lhotse Face so that the expedition could reach the South Col, jumping-off point for the attempt on the Summit, was a major problem and progress was slow. Eventually, Wilfrid Noyce and Sherpa Annullu completed the route. Here, Noyce is shown with the Sherpas who climbed up to the South Col to establish Camp VIII.

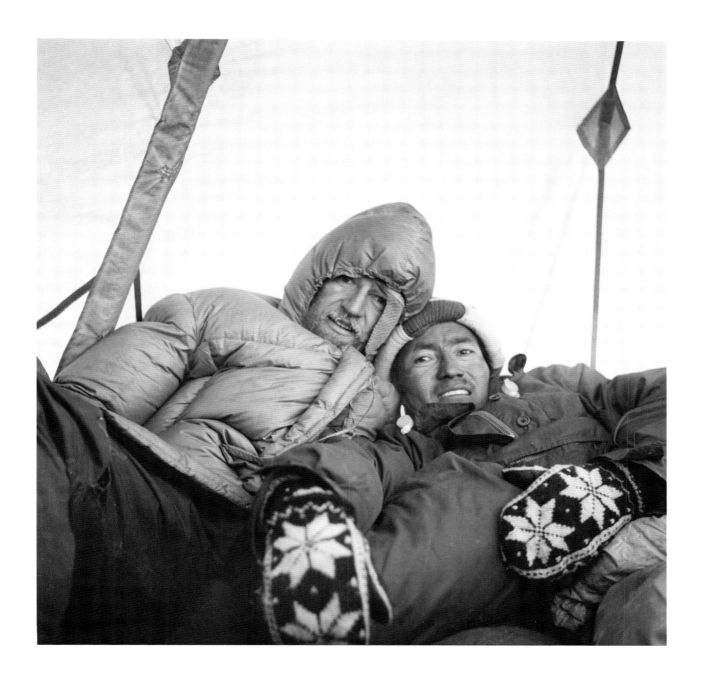

Dressed to combat the extreme temperatures, Tenzing Norgay and George Lowe share a tent at Camp VIII at 26,000 feet (7,925 metres) on the South Col.

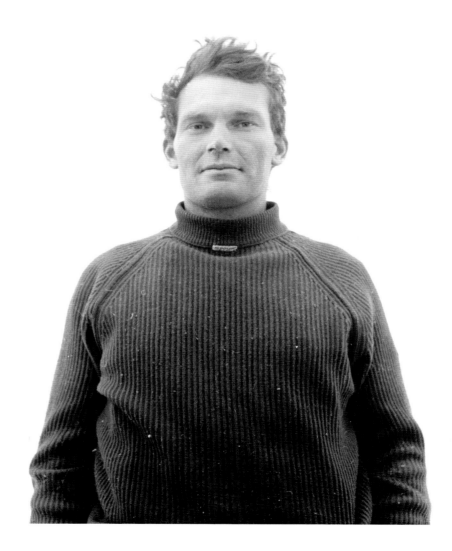

Tom Bourdillon, who was responsible for all of the oxygen equipment used by the expedition. He and Charles Evans were the first climbers to reach the South Summit of Everest, but failed to go further.

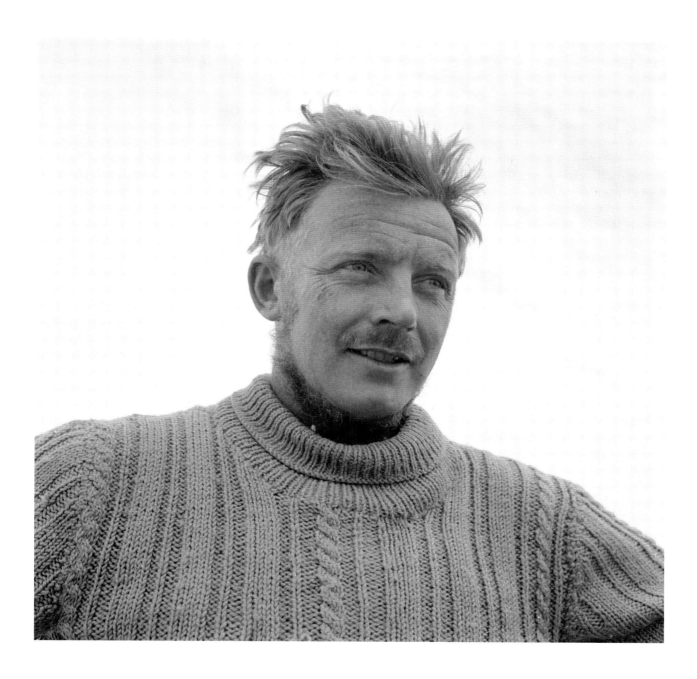

Charles Evans, deputy leader of the 1953 expedition, made the first ascent of Everest's South Summit with Tom Bourdillon. Although tantalisingly close to the actual Summit, they were forced to turn back by faulty oxygen equipment and a lack of time. Evans, a doctor, had served with distinction in Burma during the Second World War and later became a neurosurgeon.

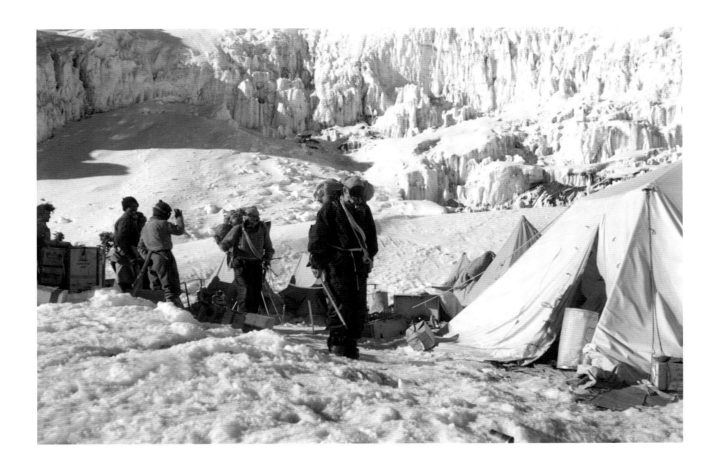

Hunt had chosen two teams to make the final assault on the Summit: Tom Bourdillon and Charles Evans, and Edmund Hillary and Tenzing Norgay. Here, Bourdillon (R) and Evans (second R) leave Camp IV for the first attempt at the Summit. They would be forced back after attaining the South Summit at 28,703 feet (8,749 metres), higher than any human being had been before.

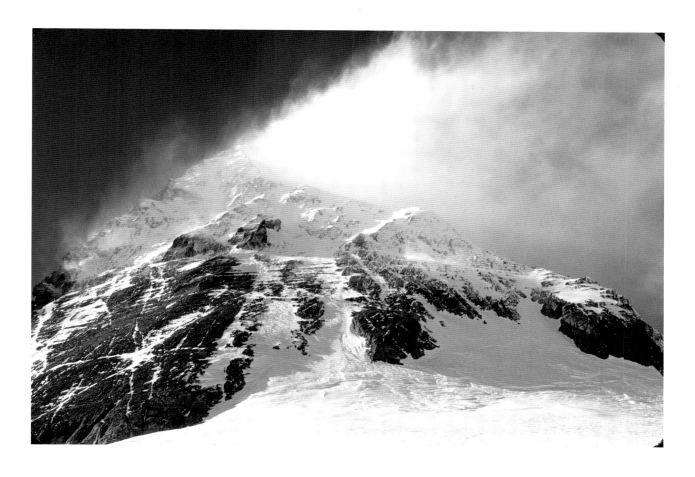

The South Summit of Everest and Southeast Ridge seen from Camp VIII on the South Col. There lay the route to the Summit itself.

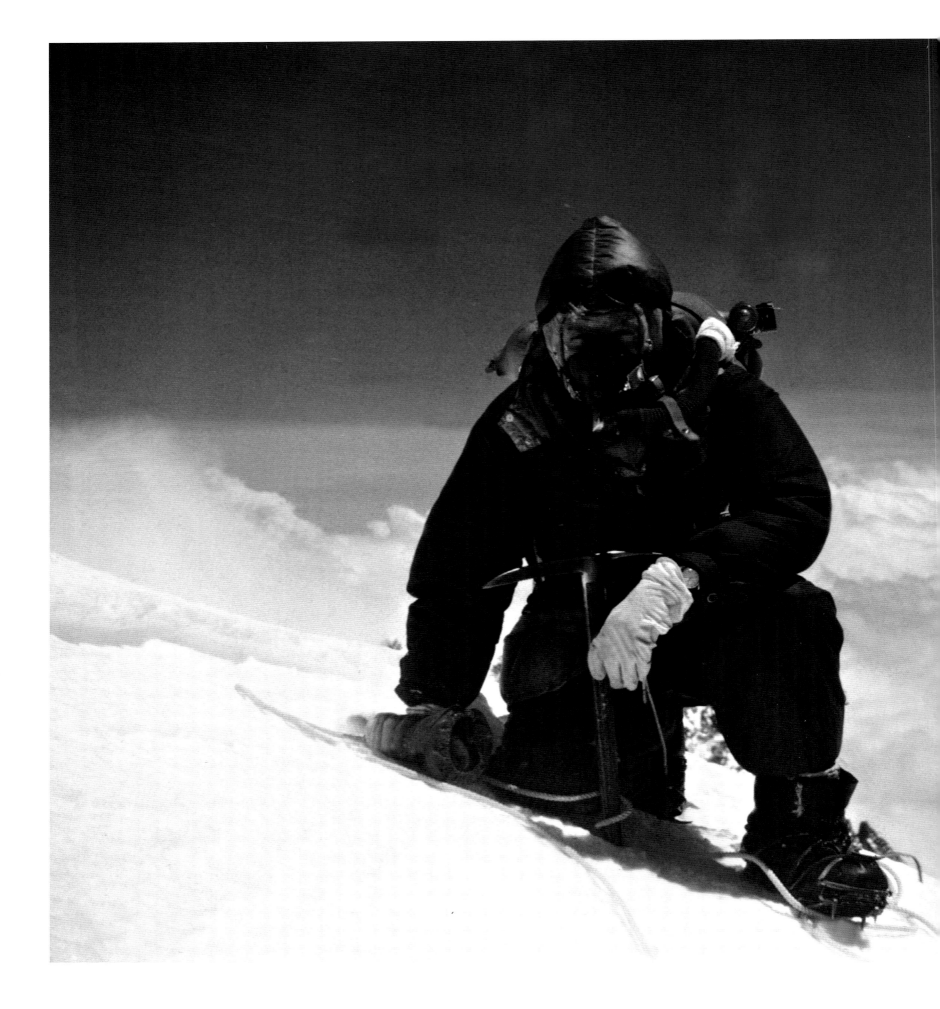

Tom Bourdillon at the South Summit of Everest, which he reached with Charles Evans on 26th May, 1953.

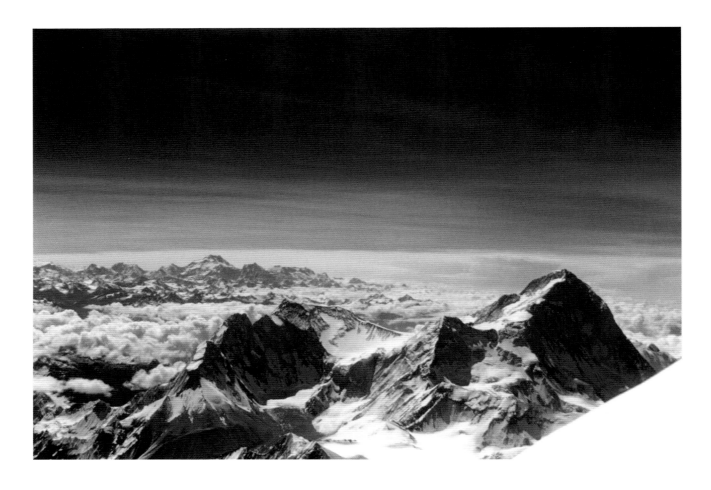

The view from the South Summit of Everest, showing Makalu (R), the fifth highest peak in the world at 27,825 feet (8,481 metres), and off in the distance the third highest, Kanchenjunga at 28,169 feet (8,586 metres).

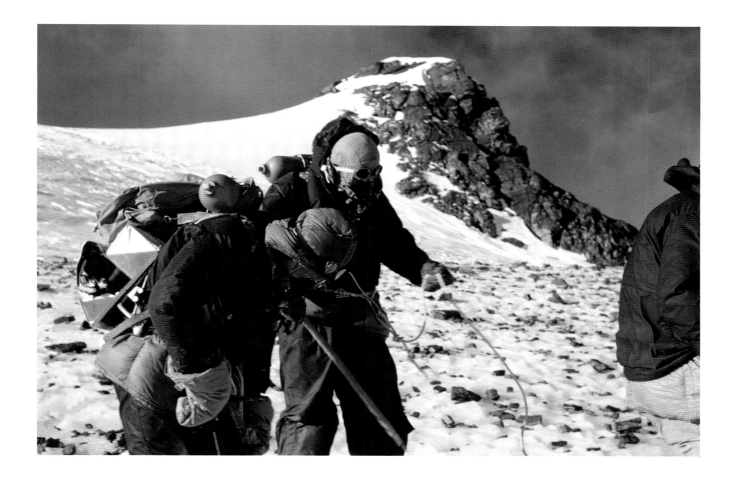

Charles Evans (L) and Tom Bourdillon return disappointed to Camp VIII on the South Col after failing in their attempt to reach the Summit. Three days later, Edmund Hillary and Tenzing Norgay finally made it.

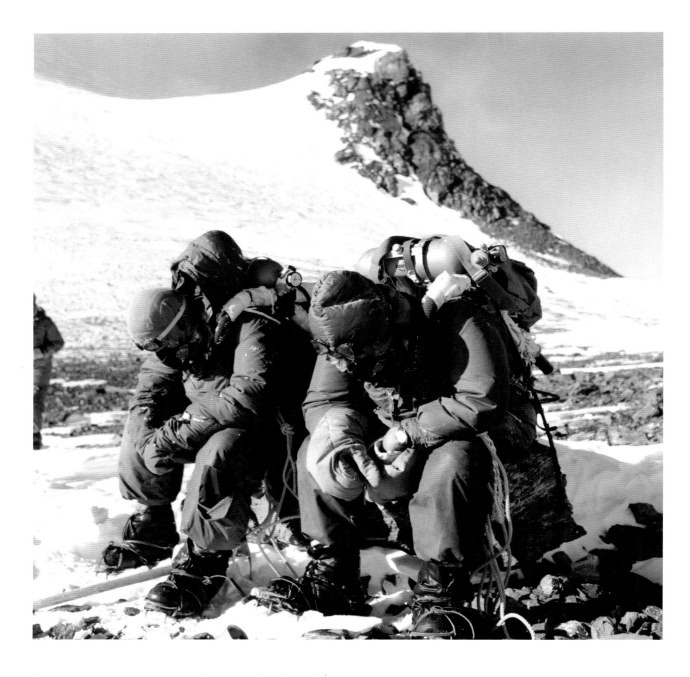

Completely exhausted, Charles Evans and Tom Bourdillon try to gather their strength upon their return to Camp VIII from the South Summit. Problems with Evans's oxygen equipment and a lack of time had prevented them from making an attempt on the Summit itself. During their descent from the Southeast Ridge, Evans had slipped, dragging Bourdillon with him and they had been lucky to arrest their fall.

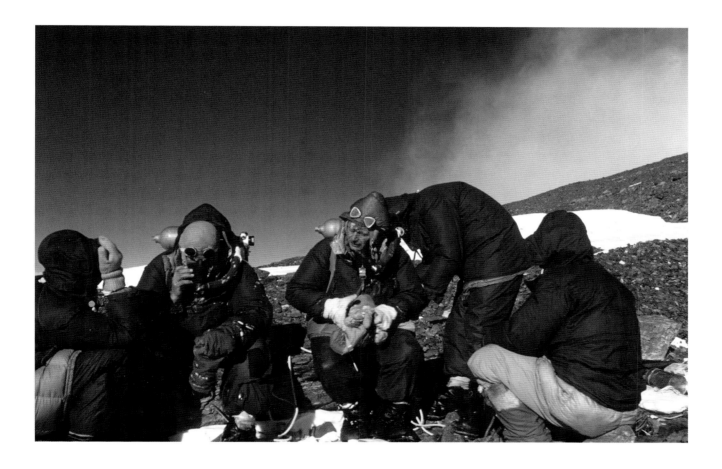

Tom Bourdillon (second L) and Charles Evans (C) are consoled by fellow members of the 1953 expedition on their return to Camp VIII after their failure to reach the Summit of Everest.

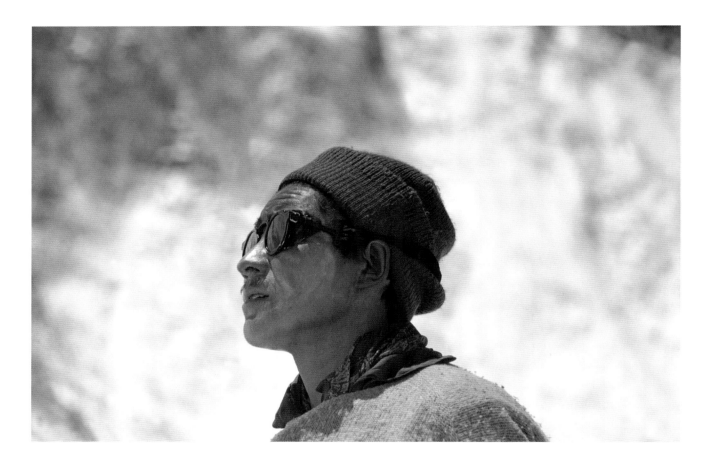

Tenzing Norgay wearing the scarf given to him by Swiss climber Raymond Lambert. The pair had reached 28,200 feet (8,595 metres) on the Southeast Ridge in 1952 before being forced to retreat.

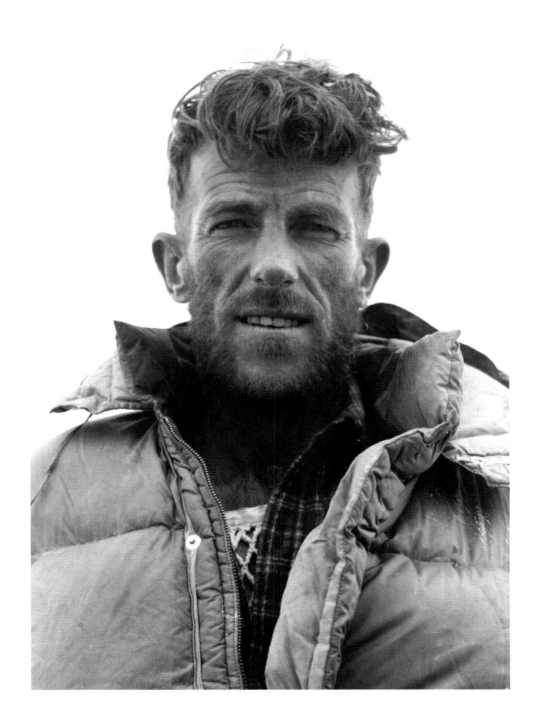

Edmund Hillary, his lined face indicative of an outdoor life and belying his 33 years of age at the time of the ascent. Subsequently, he would dedicate much of his life to the welfare of the Sherpa people through the Sir Edmund Hillary Himalayan Trust.

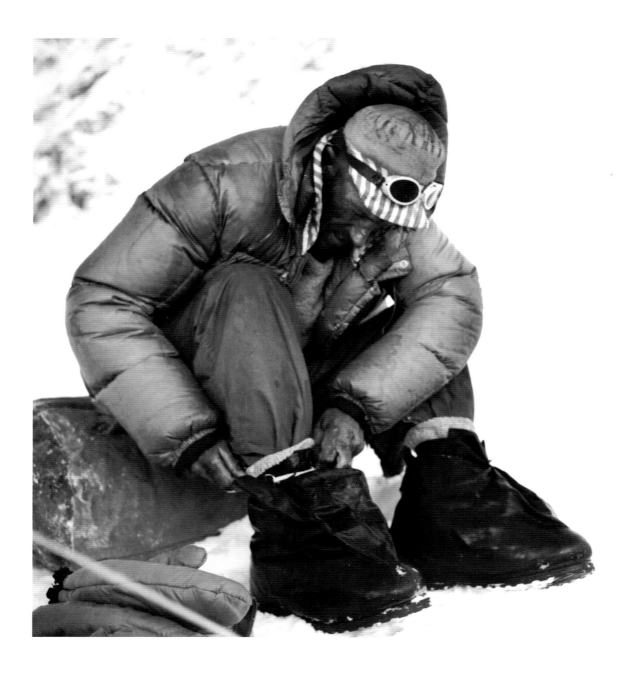

Previous attempts on Everest had been hampered by unsatisfactory footwear that leaked and froze. Here Edmund Hillary puts on the high-altitude boots that were specially designed for the 1953 expedition. However, they did freeze overnight before the successful Summit bid.

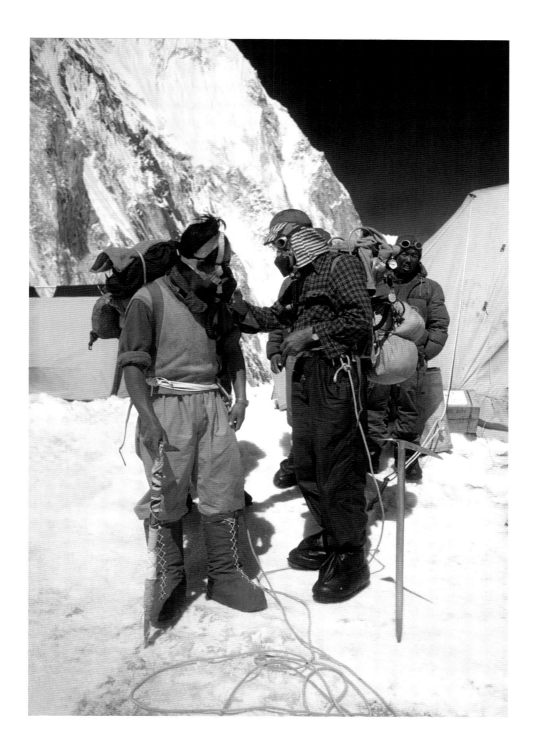

Edmund Hillary (R) and Tenzing Norgay (L) check their oxygen equipment before setting
off from Camp IV on their successful attempt on the Summit of Everest. Note the flags
wrapped around Tenzing's ice axe.

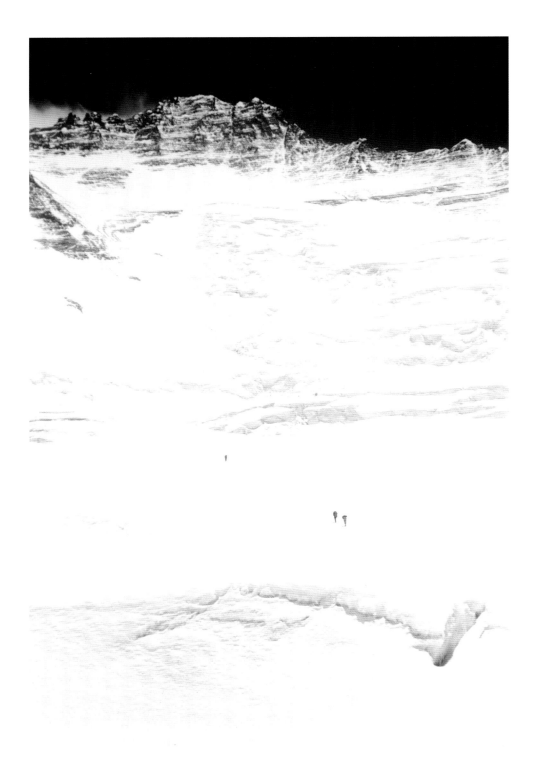

The figures of Edmund Hillary and Tenzing Norgay are dwarfed by the massive Lhotse Face as they depart from Camp IV to make their way up to Camp VIII in preparation for the final assault on the Summit. Note the massive crevasse in the foreground.

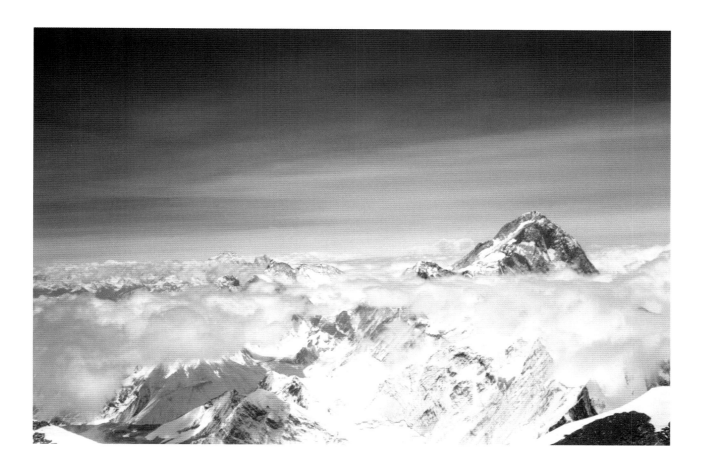

Looking across from the upper slopes of Mount Everest towards its near neighbour, Makalu, emerging above the clouds. At the time, Makalu had not been climbed; it would be another two years before a French team would put climbers on the Summit.

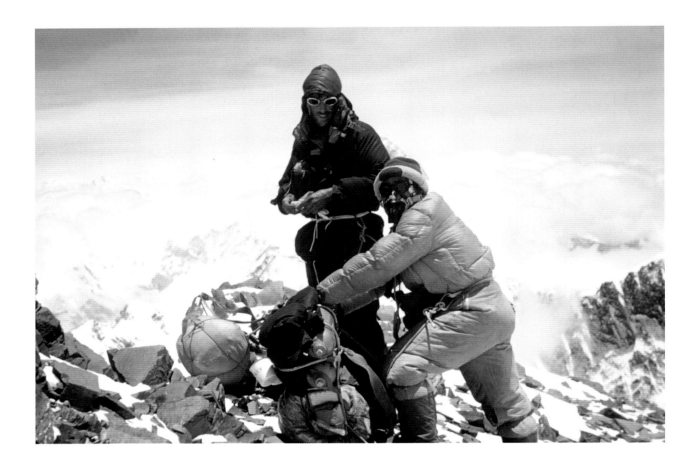

On their way up the mountain with a support team of George Lowe, Alf Gregory and Sherpa Ang Nyima to establish their jumping-off point, Camp IX, Edmund Hillary and Tenzing Norgay pause at about 27,350 feet (8,336 metres), where previously supplies had been left for the camp by John Hunt and Sherpa Da Namgyal.

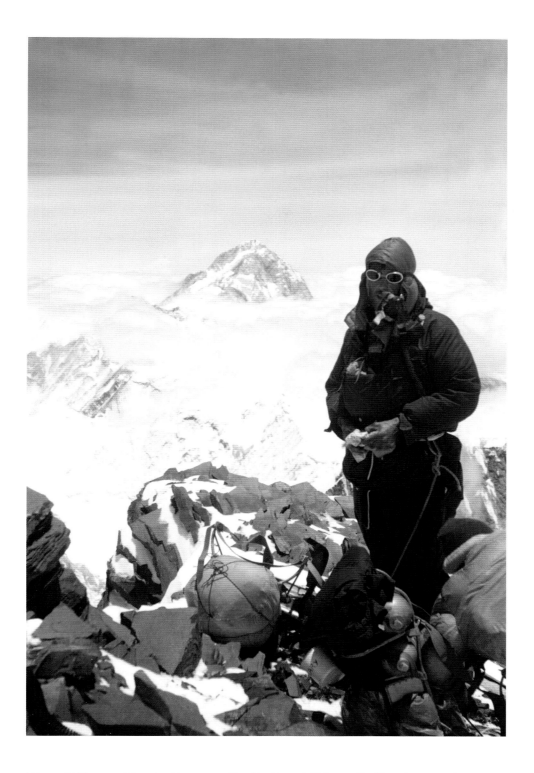

Edmund Hillary and Tenzing Norgay on the Southeast Ridge, collecting stores and equipment left for them by John Hunt and Sherpa Da Namgyal in readiness for the Summit attempt.

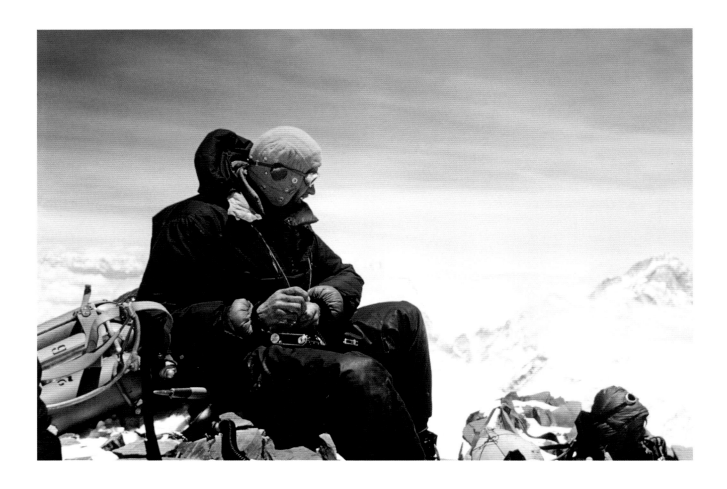

The gloves are off as George Lowe reloads his camera, but they'll soon be back on again: this photograph was taken at about 27,350 feet (8,336 metres), where the temperature seldom exceeds -20°C (-4°F).

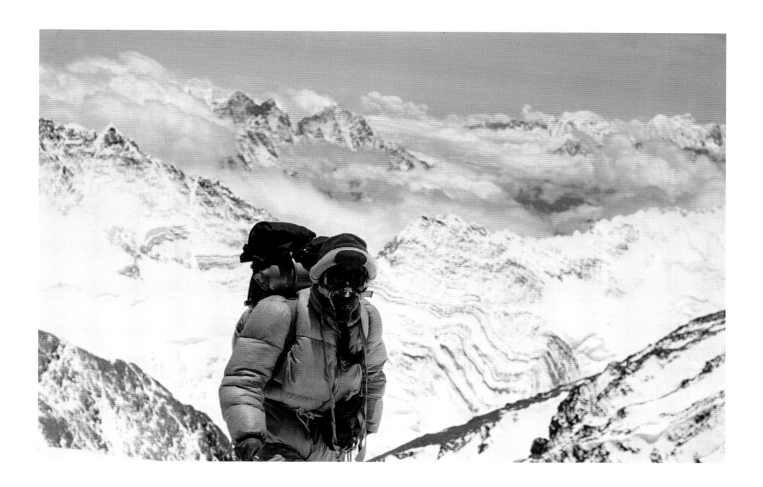

On 28th May, the day before the triumph, Tenzing Norgay stands on the Southeast Ridge of Mount Everest with the Himalayas creating a backdrop behind him. Both he and Edmund Hillary agreed that their successful assault on the Summit would not have been possible without oxygen equipment.

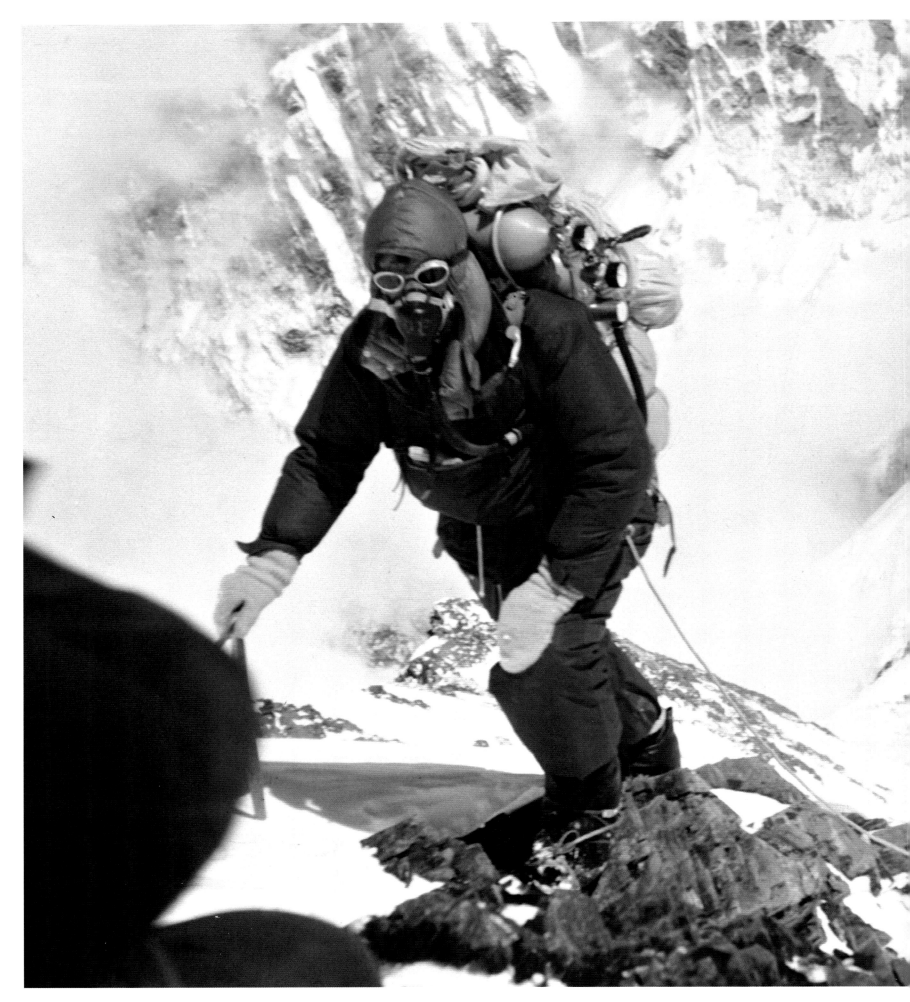

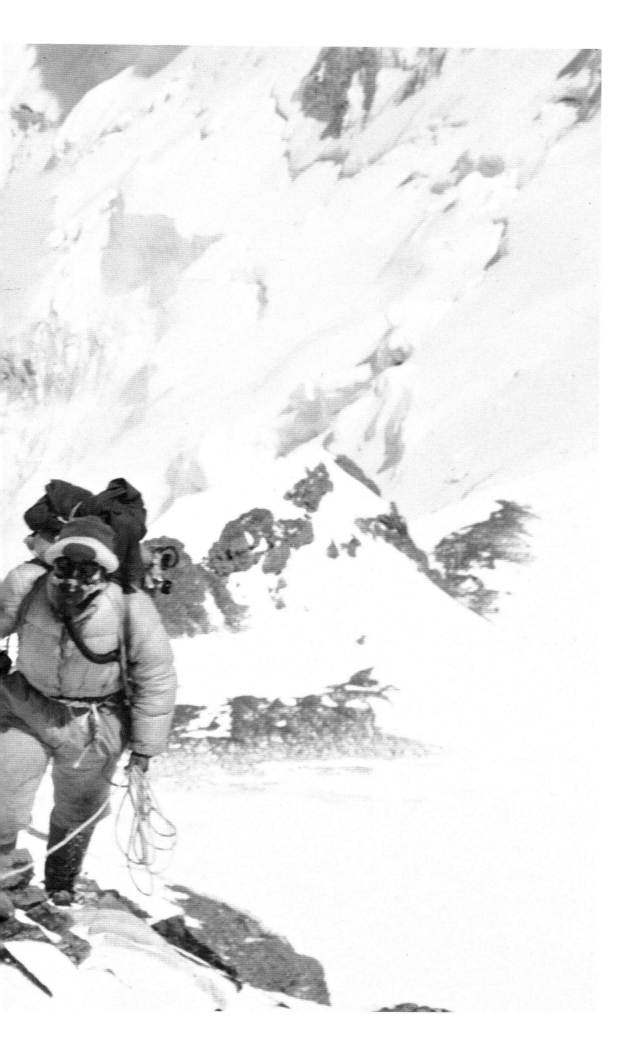

Laden with extra equipment to establish their final camp, Edmund Hillary and Tenzing Norgay approach its site at almost 28,000 feet (8,534 metres). The photograph was taken by Alf Gregory, a member of their support team. From this point, they would be on their own.

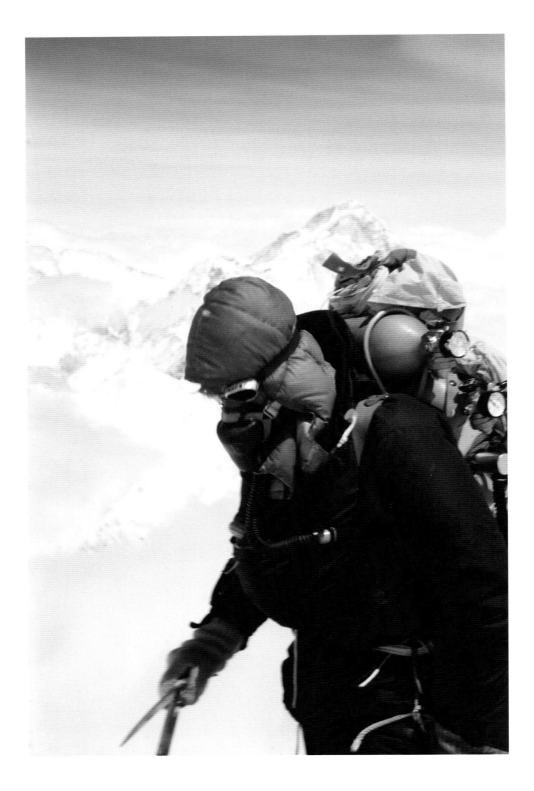

Laden with oxygen equipment and a variety of stores, Edmund Hillary approaches the site
of Camp IX at 27,900 feet (8,504 metres). After saying goodbye to their support team,
Hillary and Tenzing pitched their tent to create the highest camp in the world, settling in
for the night before making their historic assault on Everest's Summit.

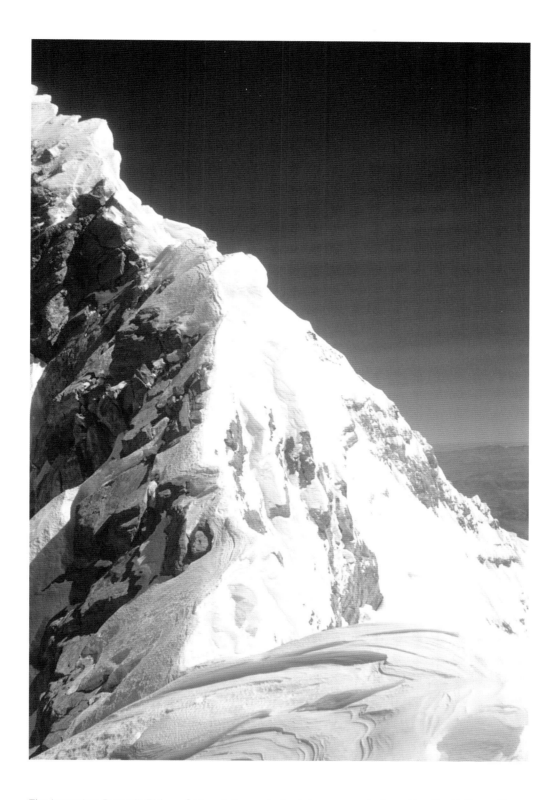

The imposing Summit Ridge of Mount Everest stretches upwards from the South Summit. From this point, the Summit itself was less than 300 feet (91 metres) vertically above Edmund Hillary and his companion, Tenzing Norgay. Later, Hillary wrote, "We looked with some interest at the virgin ridge ahead."

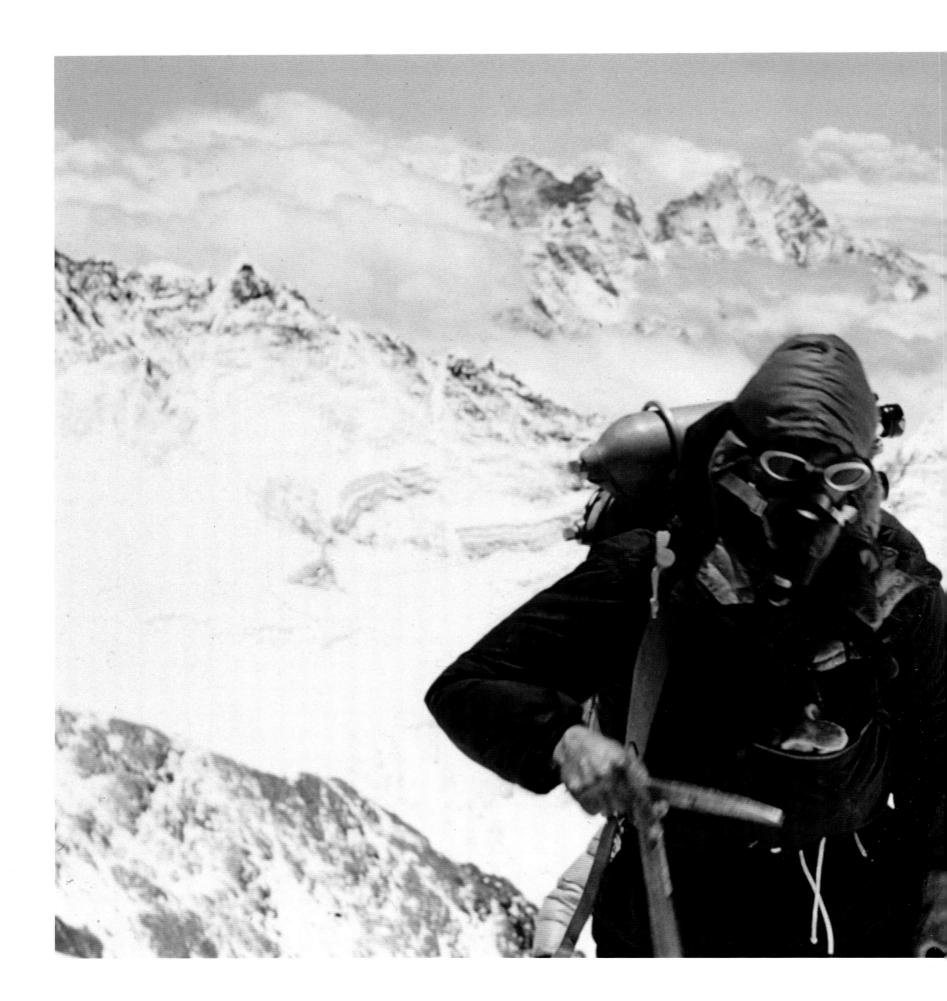

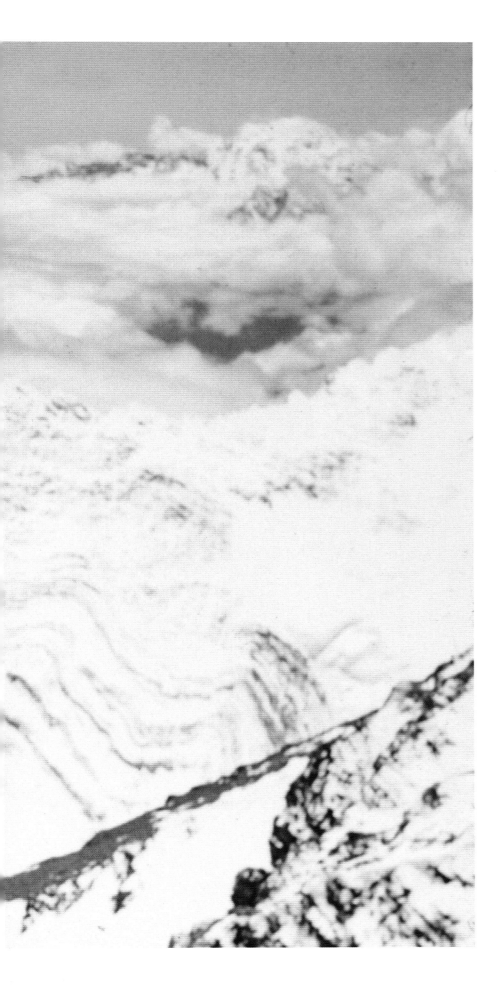

With a backdrop of mountains and clouds, Edmund Hillary makes his way up the narrow Southeast Ridge on the final leg of the climb to the Summit of Everest.

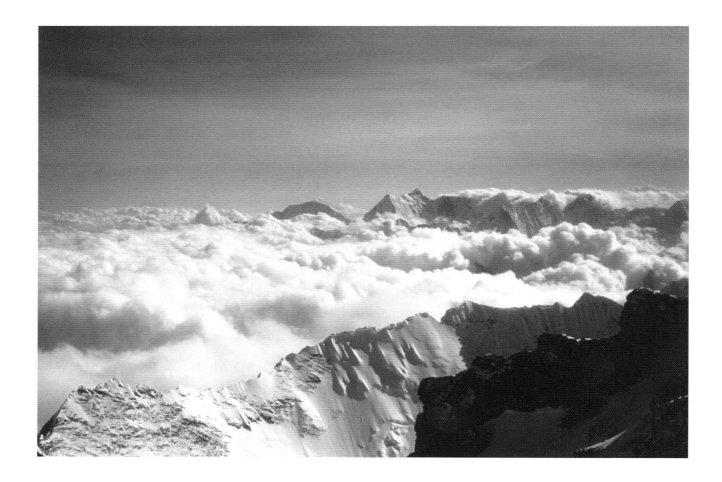

This panorama, taken from the Southeast Ridge of Mount Everest, shows in the distance some of the seven summits of Nuptse (25,791 feet/7,861 metres) protruding above the clouds.

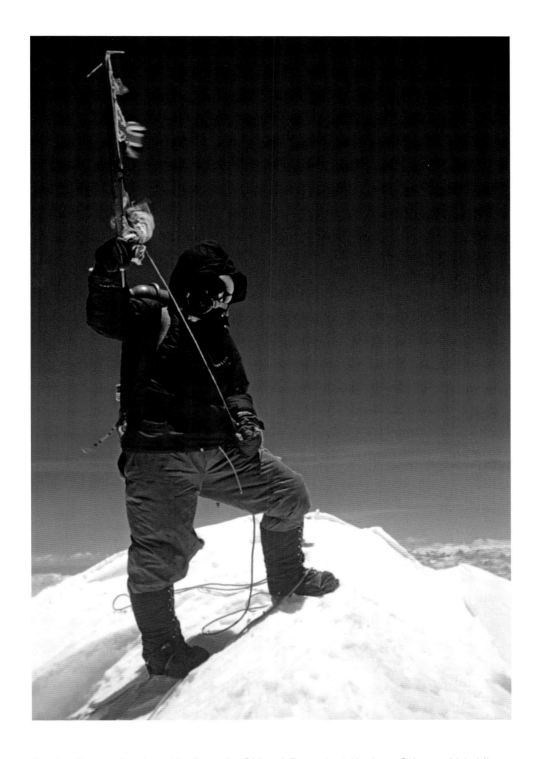

Tenzing Norgay stands on the Summit of Mount Everest, at the top of the world, holding aloft his ice axe, to which are attached the flags of the United Nations, the United Kingdom, Nepal and India.

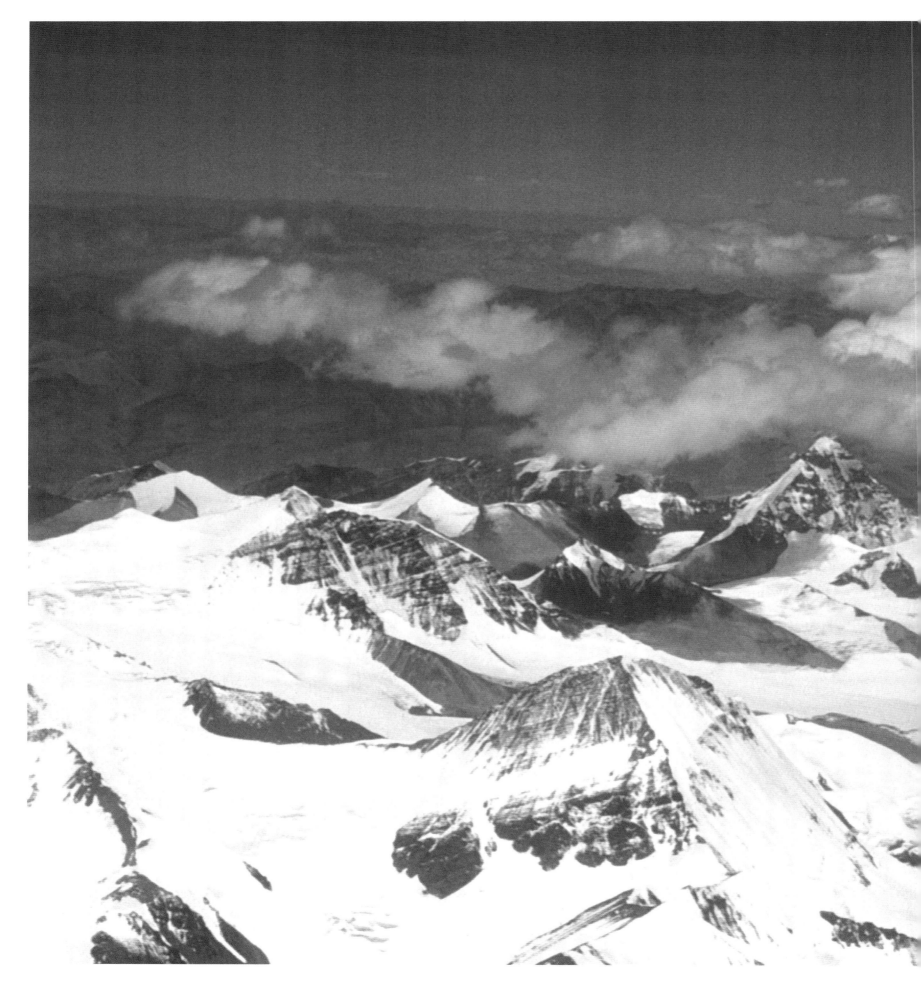

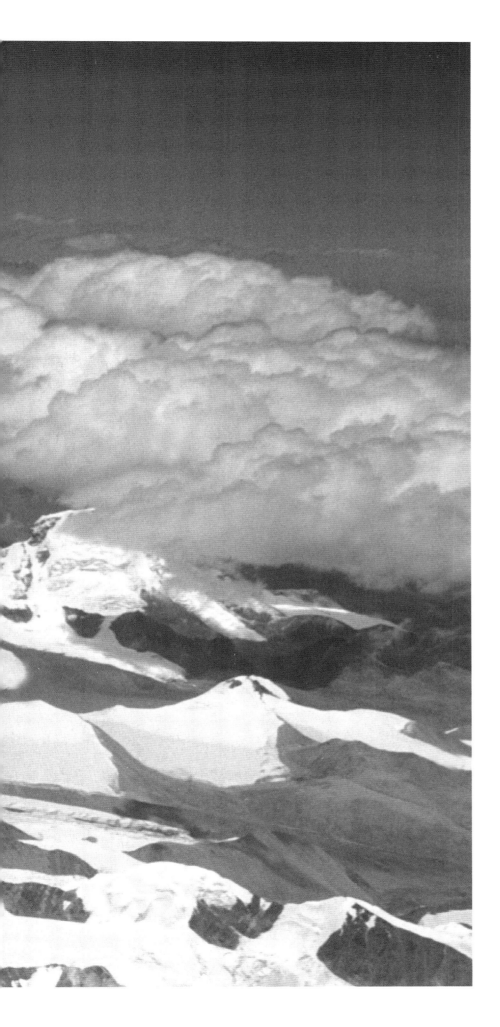

One of a series of panoramic views taken from the Summit of Everest by Edmund Hillary. This is looking towards the northeast.

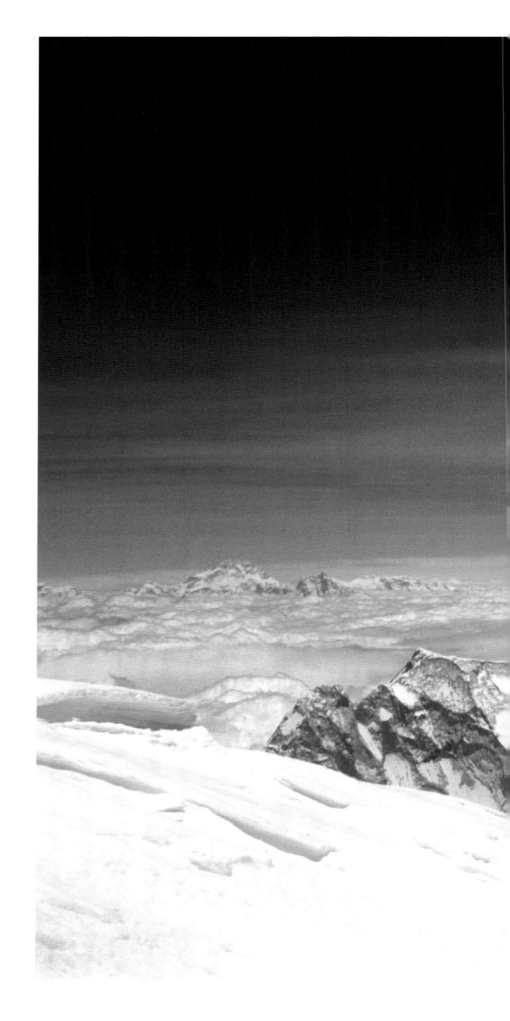

Hillary's view to the east from the Summit of Everest. Prominent in the landscape are Kanchenjunga (far distance), Chomo Lonzo (L) and two of Makalu's peaks (R).

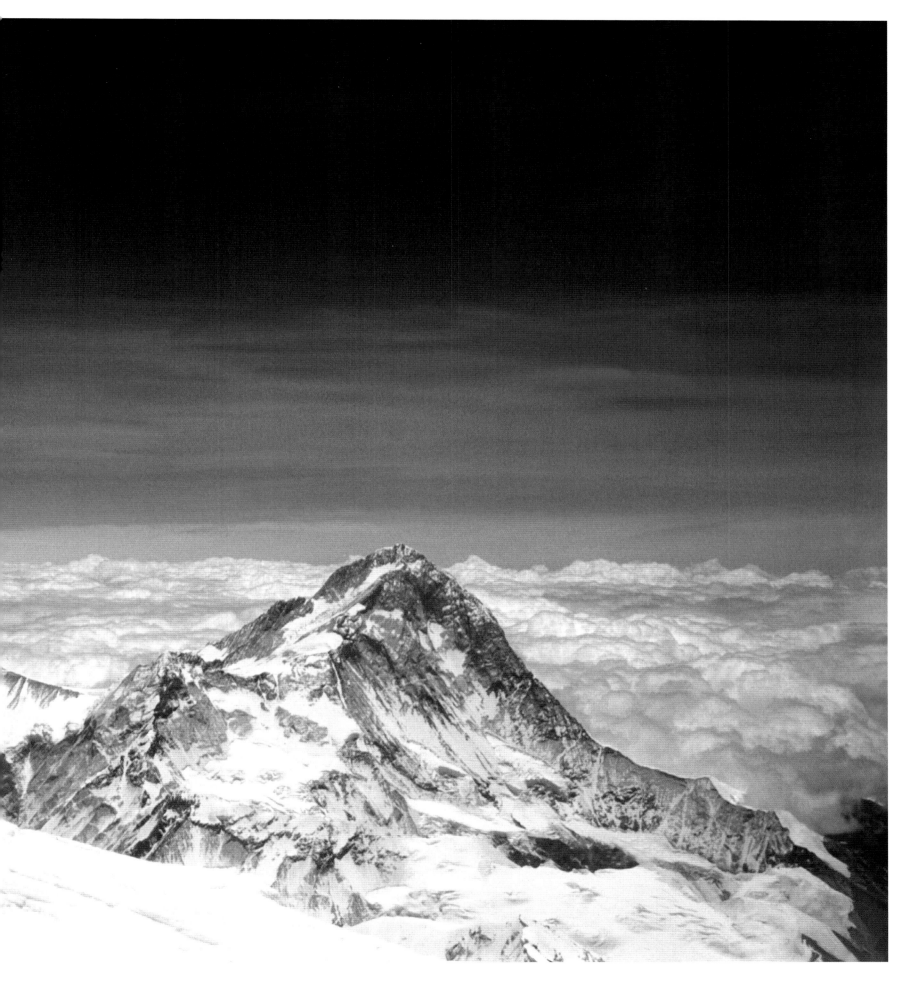

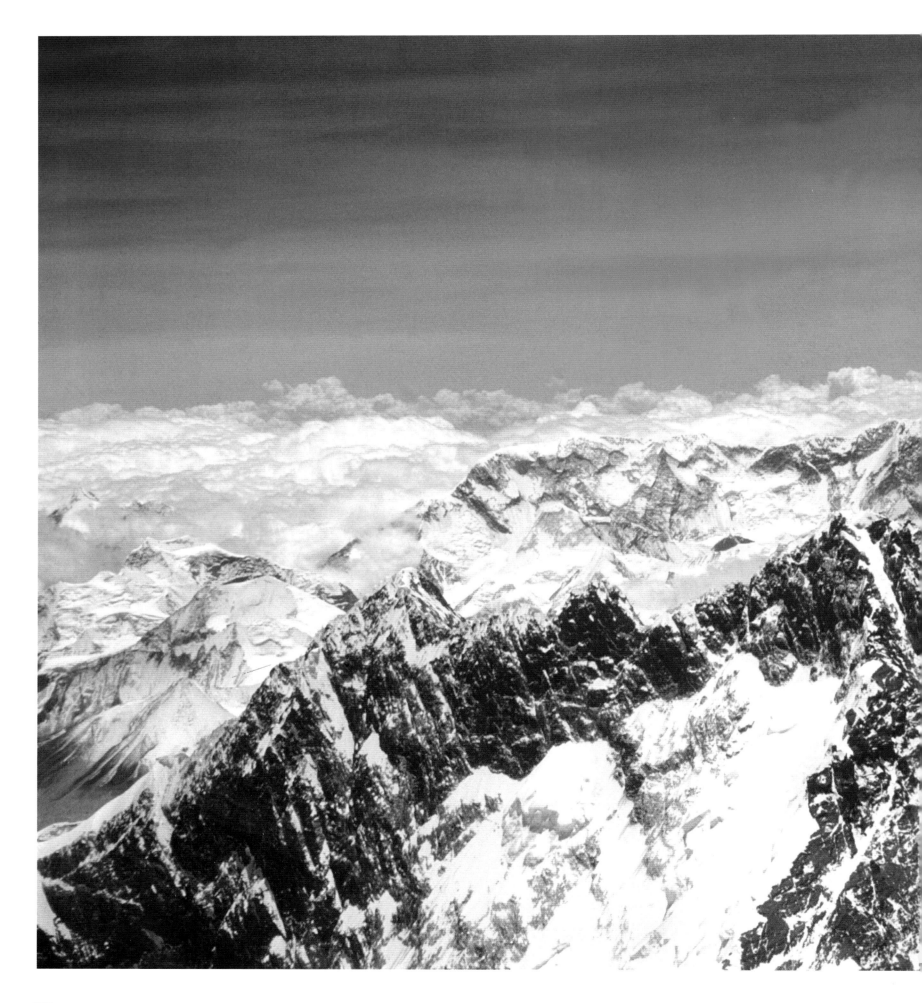

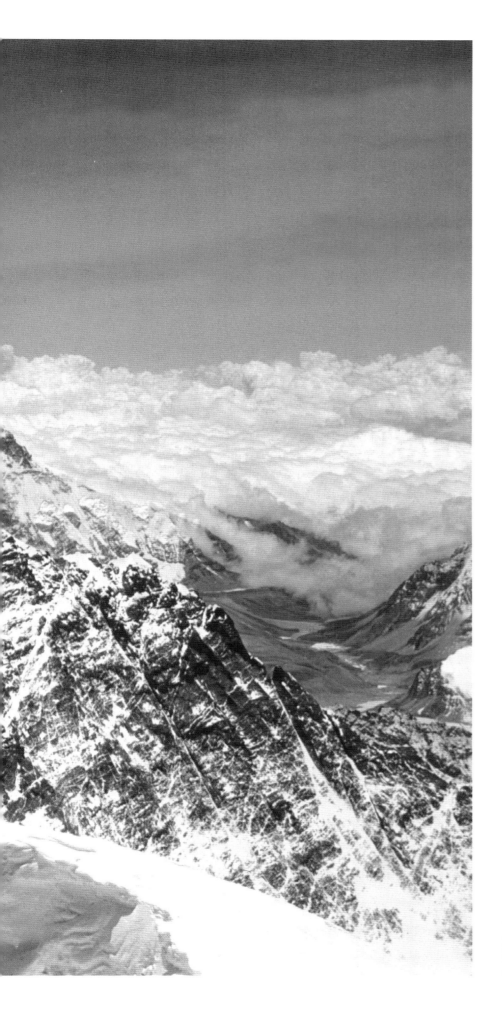

The view towards the south from the Summit of Everest. The mountain in the foreground is Lhotse, fourth highest in the world at 27,940 feet (8,516 metres), while behind is Chamlang. To the right, the Hongu Valley can be seen.

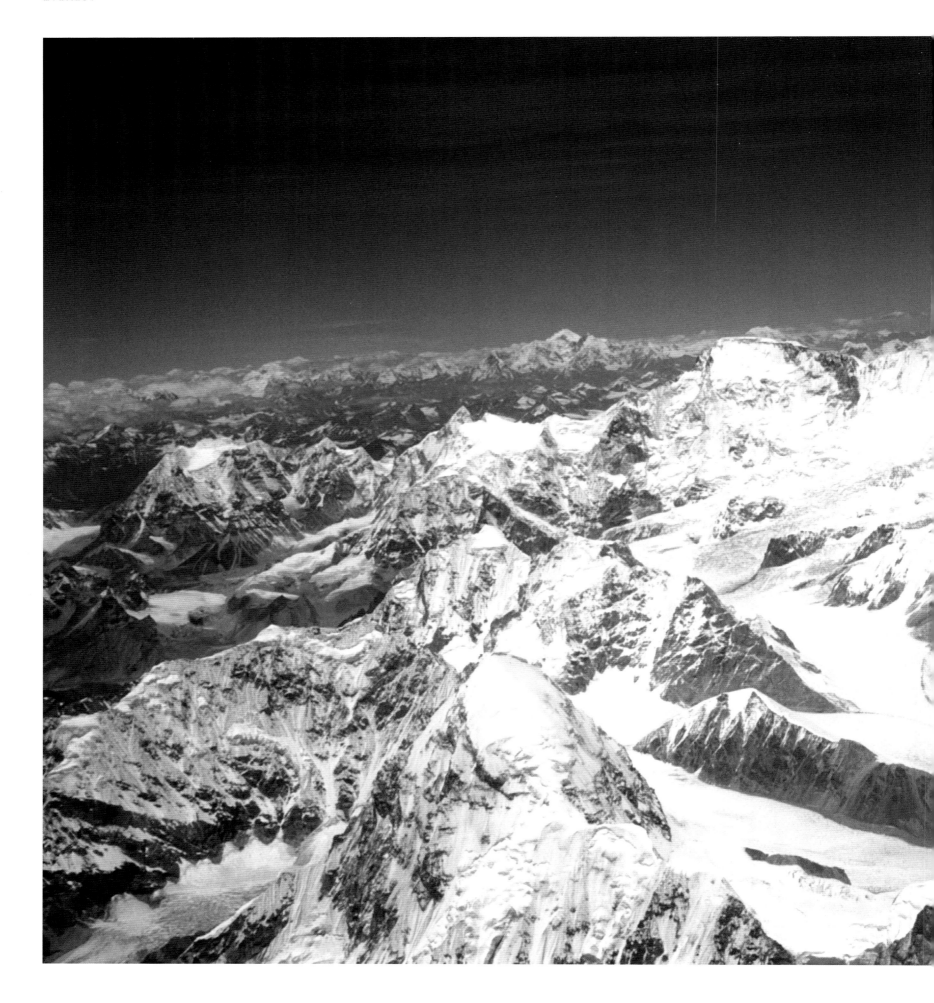

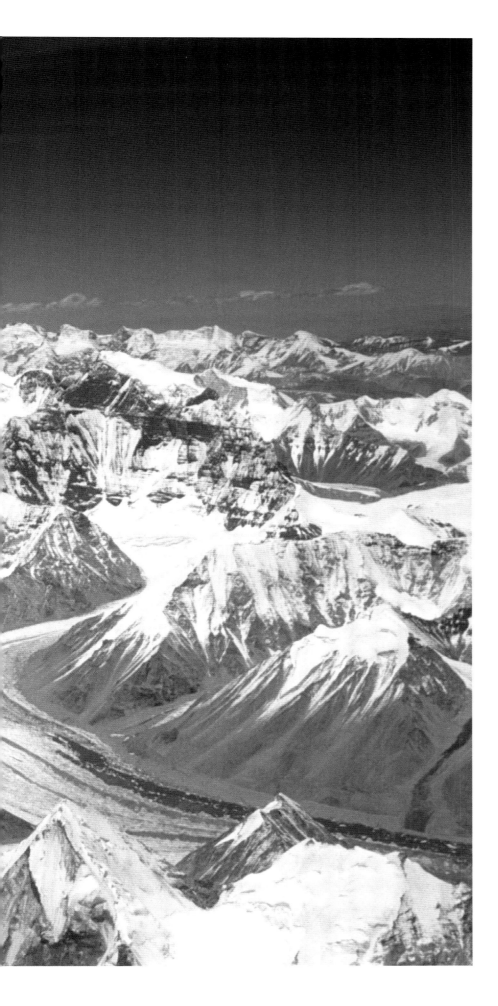

Hillary's view to the west from the Summit, with Pumori in the foreground. Cho Oyu (C) and the West Rongbuk Glacier (bottom R) can also be seen.

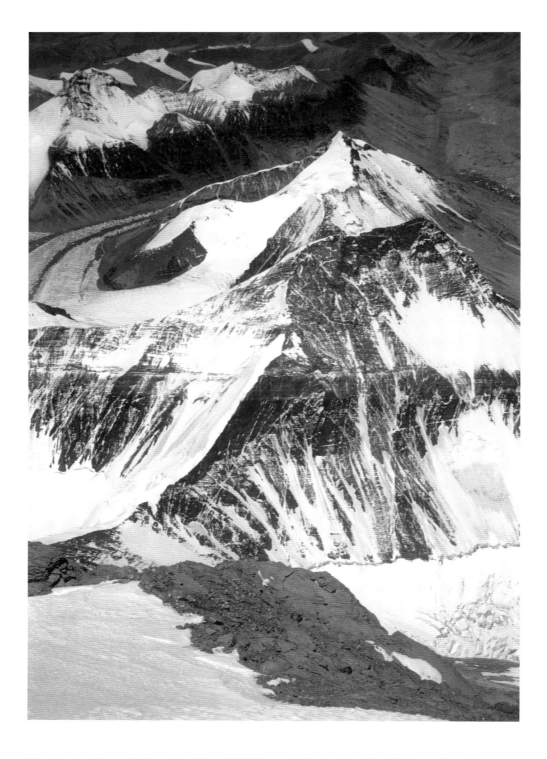

The view to the north from the Summit of Everest. Dominating the photograph is Changtse (24,747 feet/7,543 metres), while curving around the mountain (top R) is the East Rongbuk Glacier. Changtse is connected to Everest by the North Col.

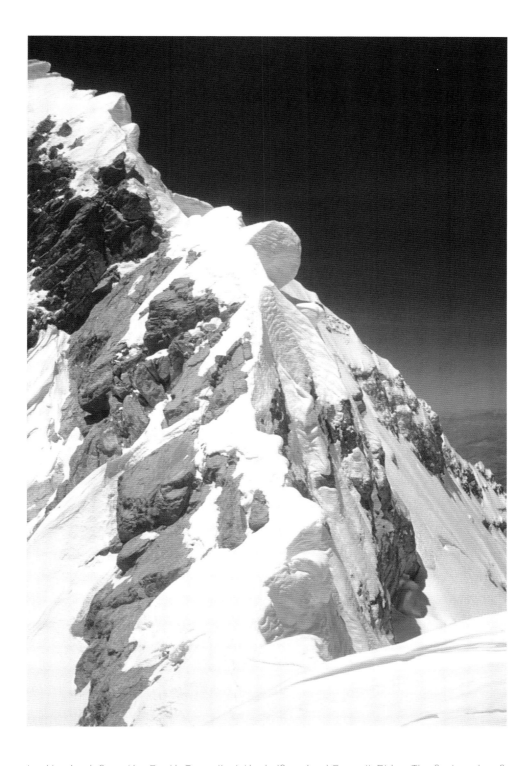

Looking back from the South Summit at the knife-edged Summit Ridge. The footmarks of Tenzing Norgay and Edmund Hillary can be clearly seen in the snow, tracing their progress back from the Summit. On one side of the ridge was an 8,000-foot (2,438-metre) drop; on the other, one of over 10,000 feet (3,050 metres).

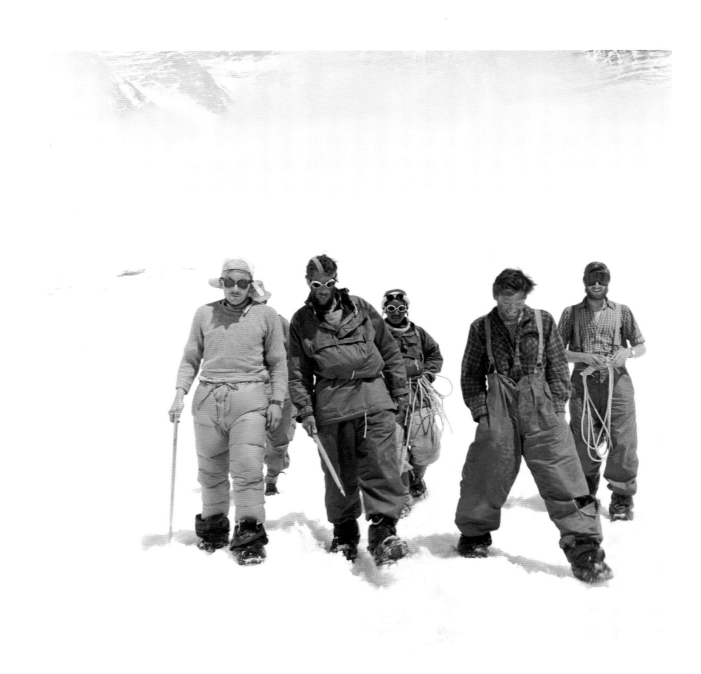

Expedition members on their way back to Camp IV after the triumph of 29th May: (L–R) Charles Evans, Edmund Hillary, Tenzing Norgay, Tom Bourdillon and George Band.

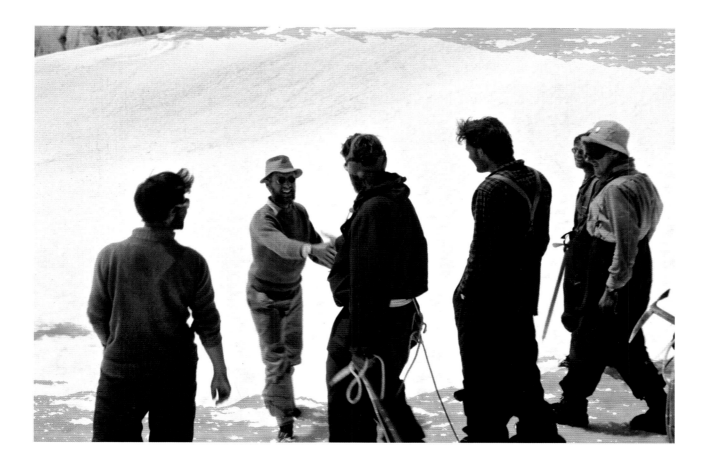

On 30th May, Times correspondent James Morris steps forward to congratulate Edmund Hillary (holding rope) on his and Tenzing Norgay's achievement the previous day. Morris's report appeared in the London newspaper three days later, on Coronation Day.

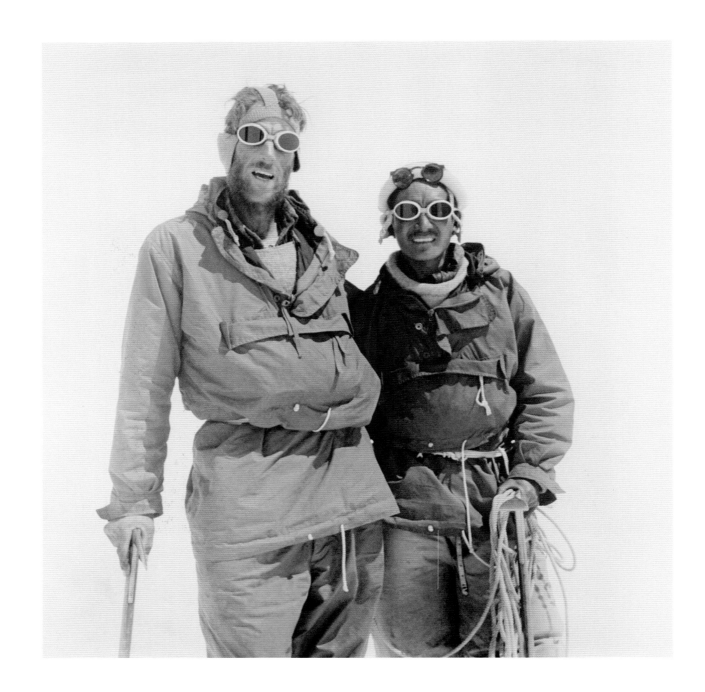

Edmund Hillary and Tenzing Norgay, still roped together, return to Camp IV after conquering the Summit of Everest. Hillary's greeting to his old friend George Lowe was, "We knocked the bastard off!"

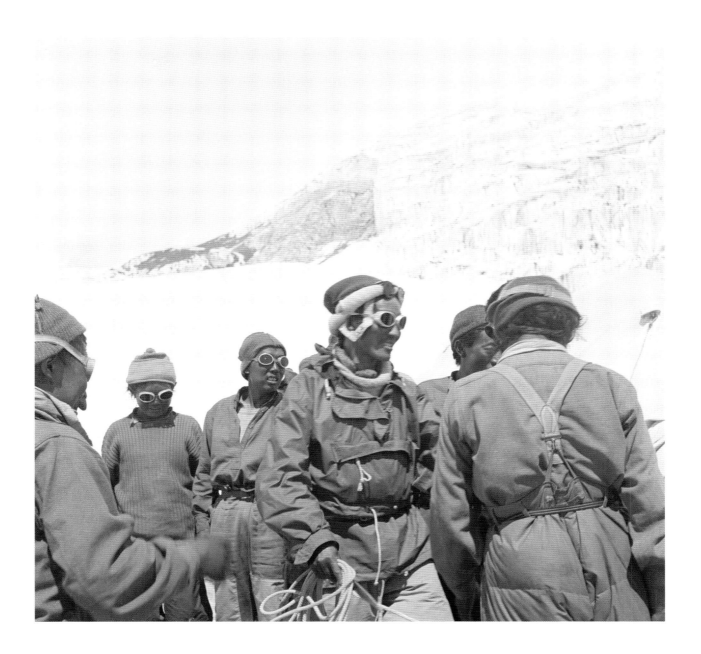

Sherpas at Camp IV congratulate Tenzing Norgay (C) after his ascent of Everest. One of the items he took to the Summit was a scarf given to him by Swiss climber Raymond Lambert, with whom Tenzing had made an unsuccessful attempt at conquering the mountain in 1952.

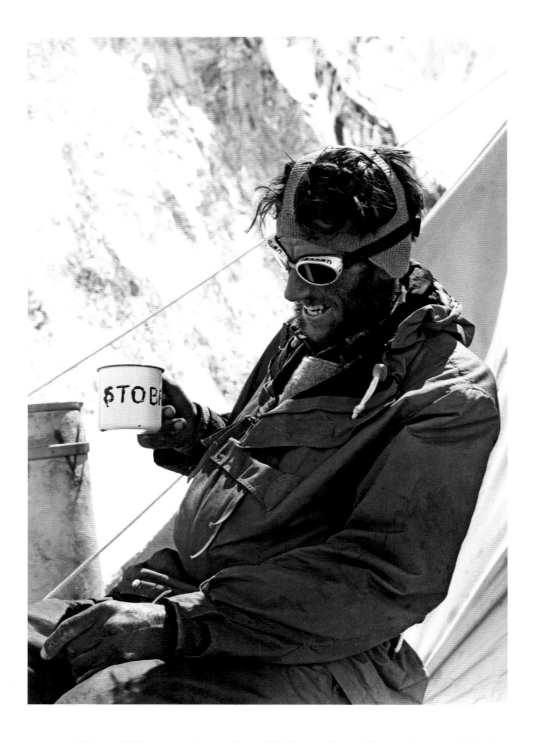

An elated Edmund Hillary takes tea at Camp IV following his and Tenzing Norgay's historic ascent of Everest.

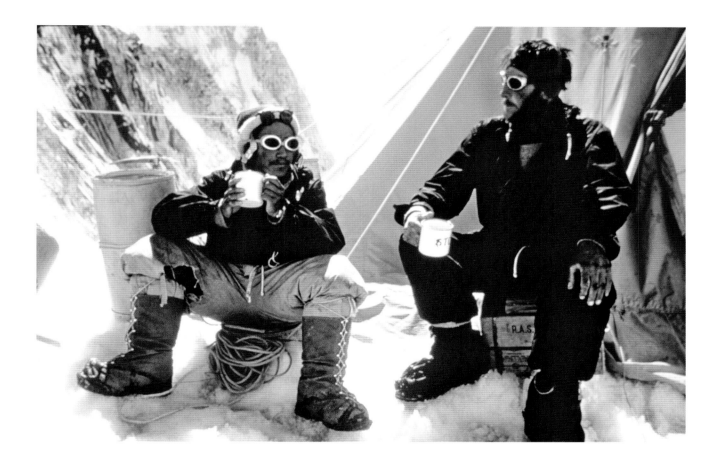

Two days after standing on the Summit of Everest, Tenzing Norgay and Edmund Hillary enjoy a tea party upon their return to Camp IV in the Western Cwm.

Times correspondent James Morris, who accompanied the expedition into the Western Cwm and broke the news, via a coded message to his newspaper, that the Summit had been reached.

THE TIMES
1785
THE TIMES PUBLISHING COMPANY, LIMITED
PRINTING HOUSE SQUARE
LONDON, E.C.4
TELEPHONE: CENTRAL 2000

③

members of the expedition climbed it. So this is how I propose to send the crucial message. I shall begin it with the phrase SNOW CONDITIONS BAD. This will mean to _you_ that Everest has been climbed. Then I shall have to name the climbers concerned. For each climber I have therefore invented a phrase which might reasonably refer to events on the mountain, as follows :—

P.T.O

An extract from a letter written by James Morris, explaining how he would send a coded message to The Times in the event of a successful ascent of Everest.

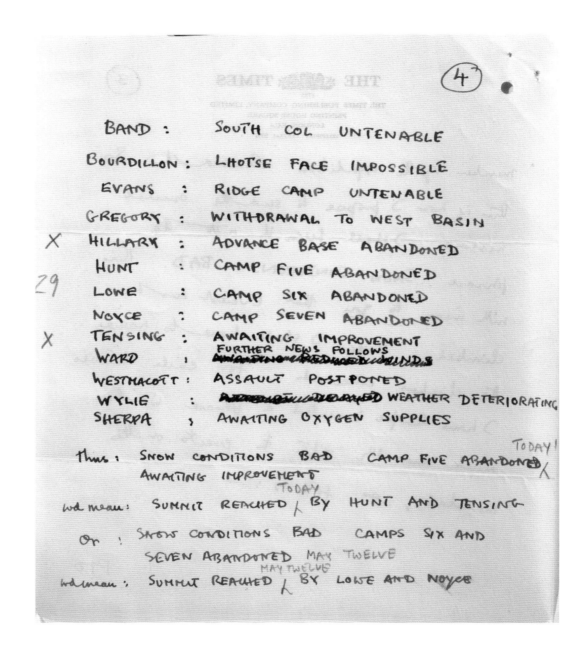

Times correspondent James Morris's code to indicate the climbers involved in the successful ascent of Everest.

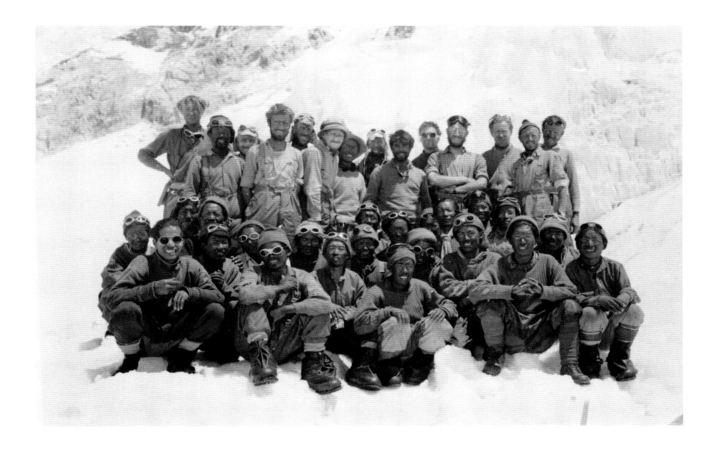

Members of the successful 1953 Mount Everest expedition. John Hunt can be seen in the front standing row (third L). To his left is Tenzing Norgay and immediately behind him, Edmund Hillary.

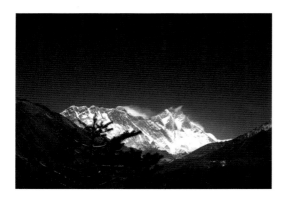

Seen from the acclimatisation camp at Thyangboche, Mount Everest rises against the deep blue sky.

The expedition's camp at Thyanboche. They remained there for three weeks to acclimatise to the region.

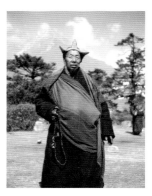

A Buddhist monk at Thyangboche. Note the prayer beads in his hand.

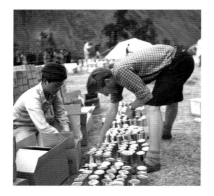

George Band (R) and a Sherpa porter sort through the expedition's supplies of tinned food.

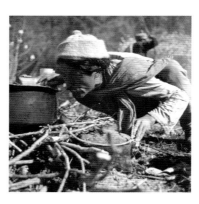

During the trek to base camp, a Sherpa porter kindles a flame to get his cooking fire going.

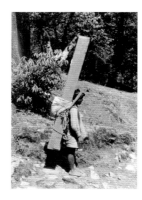

The expedition's porters carried many tons of stores and equipment to Base Camp.

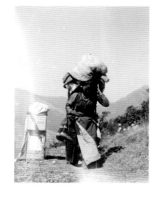

Female Sherpas, Sherpanis, carried at least their fair share of the expedition's loads.

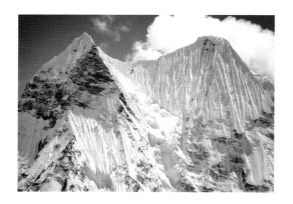

One of many minor, unnamed peaks that line the sides of the Imja Valley on the trek to Everest.

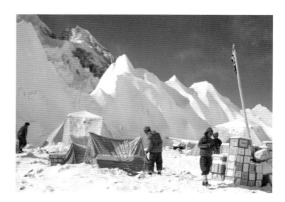

Base Camp in the shadow of an impressive array of ice pinnacles on the Khumbu Glacier.

It was not all derring-do on Everest: George Lowe finds time to darn a jumper.

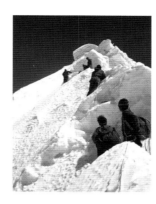

Members of the expedition hone their skills on a lesser peak during the acclimatisation period.

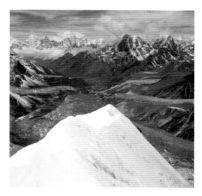

The view from Island Peak at the head of the Imja Valley, climbed for the first time by the expedition.

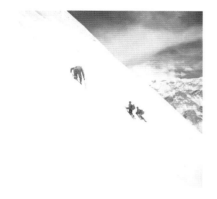

Charles Evans and Sherpas descend after the first ascent of Island Peak.

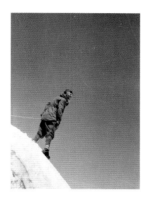

Expedition leader John Hunt on Chukhung Peak during an acclimatisation climb.

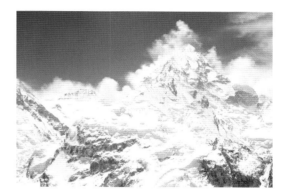

The summits of Lhotse (background L) and Nuptse (R) viewed from neighbouring Pumori.

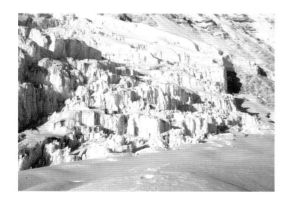

Sérac ice formations of the Khumbu Icefall. These were a major obstacle that had to be overcome.

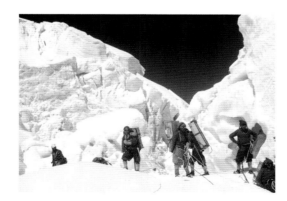

George Lowe and a group of Sherpas take a breather on the way up the Khumbu Icefall.

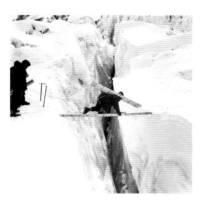

A Sherpa carries a section of ladder across another spanning a crevasse on the Khumbu Icefall.

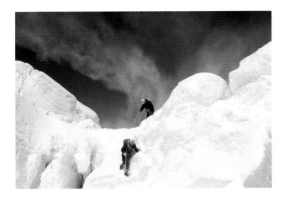

Members of the expedition reconnoitre the Khumbu Icefall before advancing across it.

Flags like this were used to mark safe passages through the Khumbu Icefall and Western Cwm.

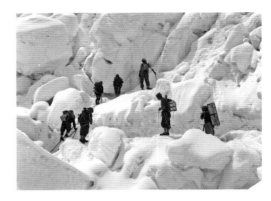

George Band leads a group of Sherpas through the jumble of ice blocks in the Khumbu Icefall.

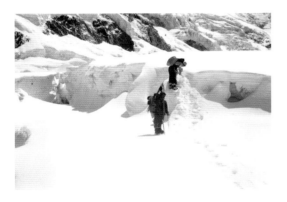

Members of the 1953 expedition pick their way gingerly across the Western Cwm.

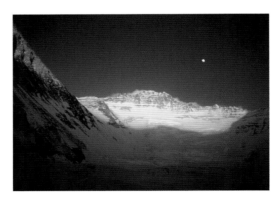

Sunset over Lhotse. The daunting Lhotse Face had to be climbed to reach Everest's South Col.

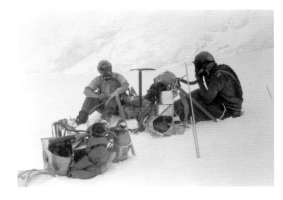

Charles Evans and Tom Bourdillon take a break before tackling the steep Lhotse Face.

Charles Evans checks oxygen equipment at Camp IV. Evans doubled as deputy leader and quartermaster.

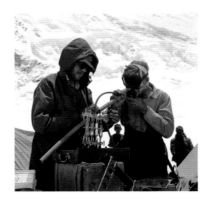

Griffith Pugh (R) and John Hunt carry out an alveoli test at Camp IV. The test measures lung capacity.

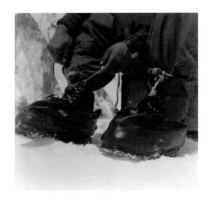

An expedition member dons a pair of the specially-designed high-altitude waterproof boots.

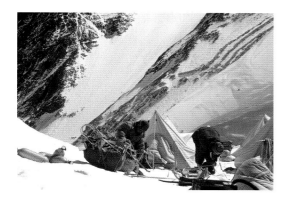

Sherpas prepare equipment at Camp VII on the Lhotse Face before heading for the South Col.

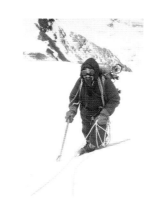

An expedition member makes his way through the snow high on the mountain.

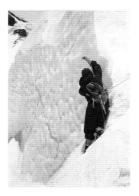

A member of the team negotiates vertical ice on the Lhotse Face above Camp VII.

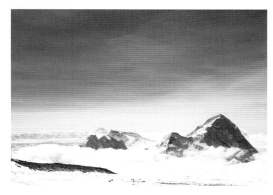

The view from 27,000 feet (8,229 metres) on Everest, looking east towards Makalu.

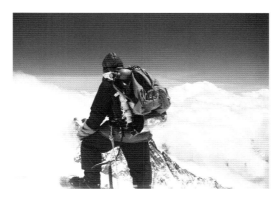

Tom Bourdillon at the South Summit on 28th May, 1953, tantalisingly close to the Summit itself.

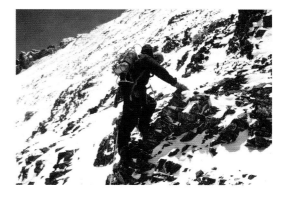

George Lowe sets out from the South Col in support of the final Summit attempt by Hillary and Tenzing.

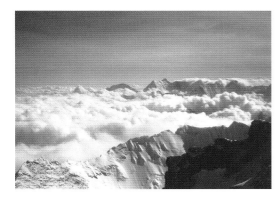

The view over Nuptse from the Southeast Ridge, at the point reached by Tenzing and Lambert in 1952.

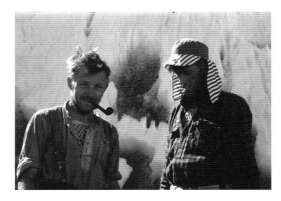

Charles Evans (L) and Edmund Hillary after the latter's conquest of the summit of Everest.

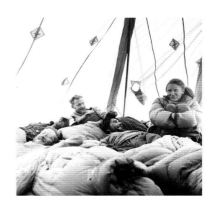

L–R: George Band, Charles Evans, Michael Ward and Tom Stobart "happy on rum" after their celebrations.

Index

Picture Credits

George Band: 143, 247, 284 (C).

Bentley Beetham: 43, 44, 46, 49, 50, 52-53, 54, 56 (centre L), 56 (C), 56 (centre R), 57 (centre L), 57 bot L).

T. A. Brocklebank: 66.

L. V. Bryant: 76, 78, 82, 87, 88 (top C), 88 (top R), 88 (C), 88 (centre R), 88 (bot L), 89 (top L), 89 (centre L), 89 (C), 89 (centre R), 89 (bot R).

Guy Henry Bullock: 25 (top L).

Charles Evans: 238-239, 285 (C).

George Finch: 36.

Alfred Gregory: 2, 9, 136, 137, 139, 141, 142, 144, 145, 147, 148, 152, 153, 154, 156, 159, 160, 163, 164, 165, 166, 168, 180-181, 192, 194, 195, 196, 201, 207, 208, 209, 213, 214, 217, 218, 233, 234, 235, 237, 241, 242, 243, 244, 245, 246, 250, 252, 253, 258-259, 272, 274, 275, 276, 278, 281, 282 (centre L), 282 (C), 282 (bot C), 282 (bot R), 283 (top L), 283 (top C), 283 (top R), 283 (centre L), 283 (centre R), 284 (top L), 284 (bot C), 284 (bot R), 285 (centre L), 285 (bot L), 285 (bot R).

J. de V. Hazard: 56 (top C), 57 (right C).

Edmund Hillary: 170, 179, 196, 198-199, 230, 240, 249, 257, 260, 261, 262-263, 264-265, 266-267, 268-269, 270, 271, 282 (top L), 283 (bot C).

C. K. Howard-Bury: 12, 14, 15, 19, 20, 22-23, 24 (top C), 24 (C), 25 (top C), 25 (top R), 25 (centre L), 25 (bot R).

John Hunt: 157, 189, 283 (C), 284 (centre R).

A. C. Irvine: 48, 51, 57 (top R).

George Lowe: 149, 150, 151, 167, 169, 171, 172, 173, 174, 175, 176, 178, 182, 183, 184, 185, 186, 187, 188, 190, 191, 193, 202, 203, 206, 210, 211, 212, 215, 216, 219, 220-221, 223, 224, 225, 226/227, 228, 229, 231, 232, 236, 248, 251, 254-255, 256, 273, 282 (top C), 283 (bot L), 284 (centre L), 284 (bot L), 285 (top C), 285 (top L), 285 (top R), 285 (bot C).

George Leigh Mallory: 16, 17, 18, 24 (bot R), 25 (bot C), 20, 40 (centre L), 40 (C), 40 (bot R), 41 (top C)

C. J. Morris: 40 (top L), 40 (top C), 40 (centre R), 41 (centre R).

James Morris: 279, 280.

J. B. Noel: 21, 24 (bot C), 27, 30, 31, 32, 33, 34, 35, 37, 40 (top R), 40 (bot L), 40 (bot C), 41 (top R), 41 (C), 41 (bot L), 56 (top R), 56 (bot L), 56 (bot C), 56 (bot R), 57 (top L), 57 (top C), 65.

Noel. E. Odell: 45, 55, 56 (top L), 57 (C).

P. R. Oliver: 94, 96-97, 99, 100-101, 104 (centre L), 109, 120 (top L), 120 (top R), 120 (centre L).

Hugh Ruttledge: 68, 72 (bot L), 73 (top R), 73 (bot C), 92, 98, 104 (top L), 104 (top C), 104 (top R), 104 (centre R), 105 (centre R), 105 (bot C).

Eric Shipton: 59, 70, 73 (bot R), 89 (top C), 134, 135.

W. R. Smyth-Windham: 91, 105 (bot R).

Frank S. Smythe: 60, 61, 62, 63, 64, 67, 69, 71, 72 (top L), 72 (top R), 72 (centre L), 72 (C), 72 (centre R), 72 (bot C), 72 (bot R), 73 (bot L), 95, 102, 103, 104 (C), 104 (bot C), 104 (bot R), 105 (top L), 105 (top C), 105 (top R), 105 (centre L), 105 (bot L).

T. H. Somervell: 28, 38, 41 (top L), 41 (centre L), 41 (bot C).

H. W. Tilman: 121 (bot C).

Michael Westmacott: 140, 283 (bot R).

E. H. L. Wigram: 104 (bot L), 105 (C).

A. F. R. Wollaston: 7, 11, 13, 24 (top L), 24 (top R), 24 (centre L), 24 (bot L), 25 (centre R), 25 (bot L).

Charles Wylie: 138, 146, 155, 158, 162, 177, 203, 282 (top R), 282 (centre R), 282 (bot L), 284 (top R).

Indian Air Force: 123

All remaining images: Unknown.

AMMONITE
PRESS

**Royal
Geographical
Society**
with IBG

Advancing geography
and geographical learning

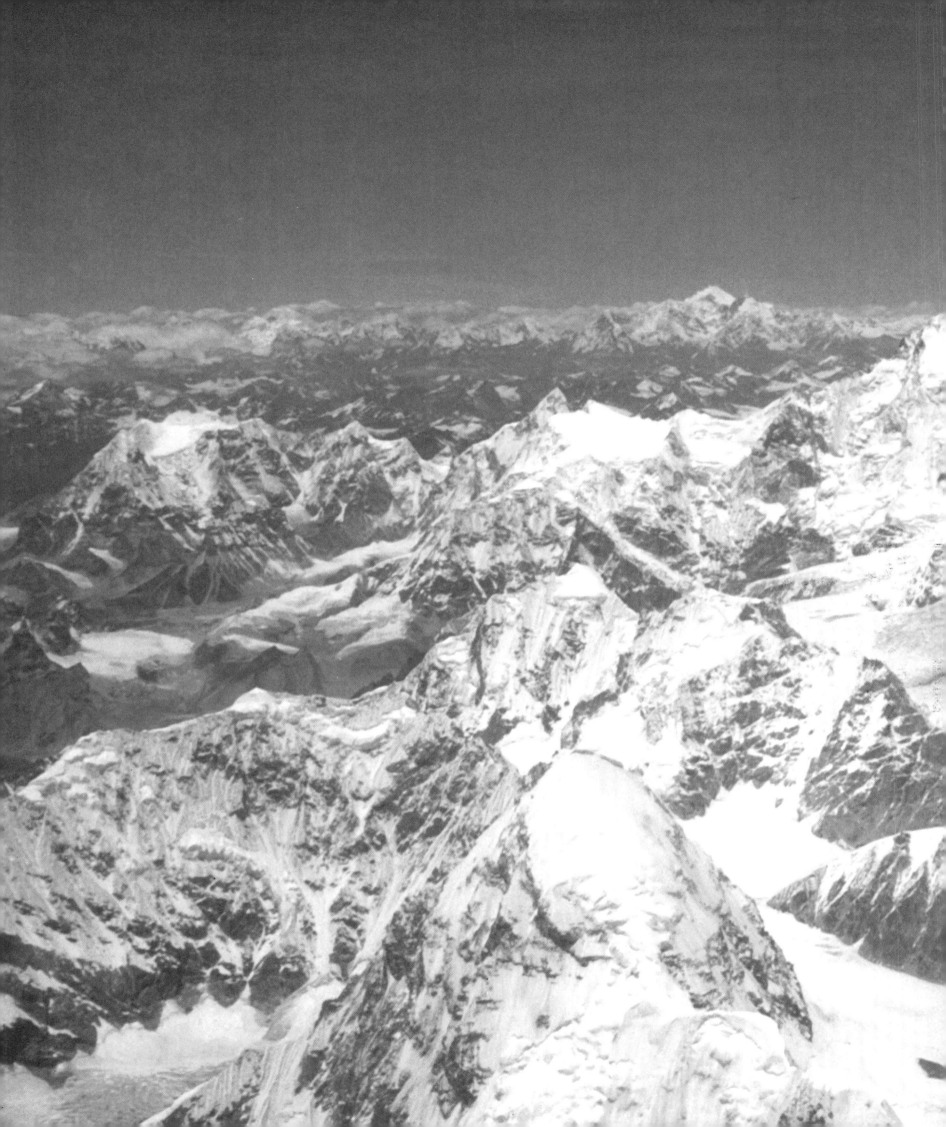